The BIG AWESOME Book of HAND & CHALK Lettering

The BIG AWESOME Book of HAND & CHALK Lettering

Dina Rodriguez

Contents

Lettering Projects at a Glance

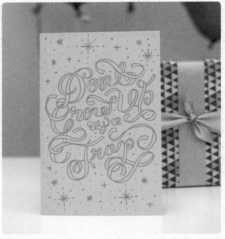

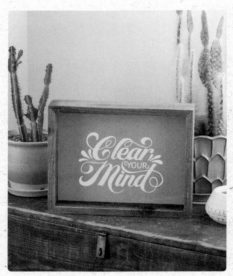

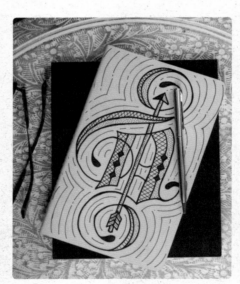

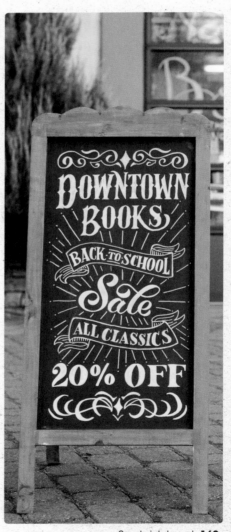

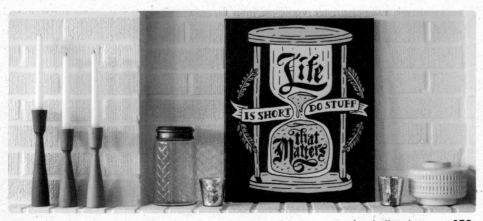

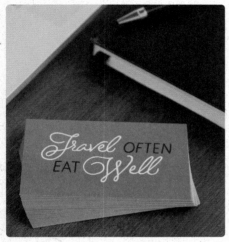

Logo design **166**

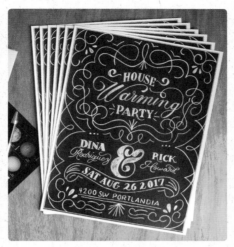

Housewarming invitation **172**

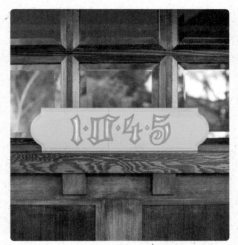

House number **176**

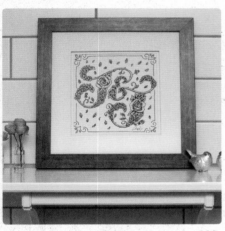

Wedding monogram **182**

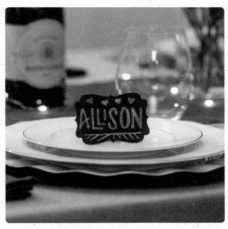

Place cards **186**

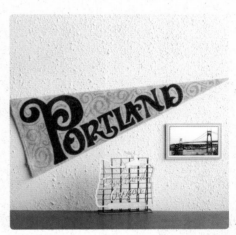

Pennant **190**

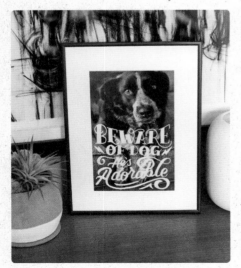

Lettered photo **194**

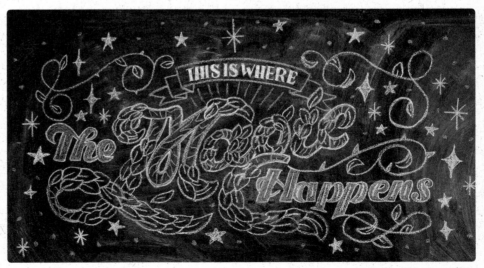

Chalkboard mural **198**

The Essentials of Lettering

Lettering is the illustration of letters created through a sequence of pencil drawings, refinements, redrawing, and final inking. Lettering often gets confused with penmanship, calligraphy, and typography, but it's actually nothing like them.

Calligraphy and penmanship are similar. **Penmanship** focuses on handwriting, while **calligraphy** is often quite stylized. In both cases, you write words using an ink pen or nib from the very start. It's strongly based on the amount of pressure in the pen, rather than on the drawing itself. You press hard as the lines go down and more lightly as the lines curl up, in order to vary the width of different areas of the letters.

Typography is the design of the fonts and typefaces you most often see in advertisements, websites, and printed materials. Lettering often gets mistaken as a font, but it's easy to tell the difference. With fonts, letters look exactly the same each time they're repeated in a sentence. In lettering, on the other hand, the purpose of each letter is to create more visual interest in the overall design, and each letter has its own individual character and personality.

This chapter introduces you to the materials and tools used to execute letters in ink, chalk, and even paint. It also covers the vocabulary used throughout this book so you'll understand the terminology in all the projects, alphabets, and writing prompts. Finally, you'll learn three ways to stretch your fingers and wrists to keep them strong and flexible, so you can draw for longer.

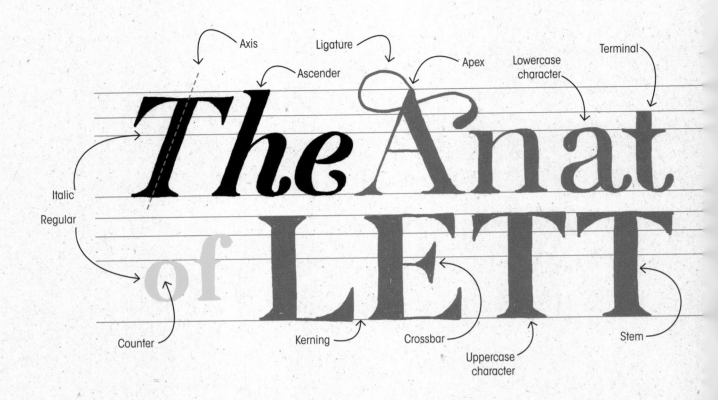

When learning lettering, it's important to understand all the parts that make up each letter and to know the typographical terms for them. Having this vocabulary will help you more easily understand the instructions in this book, so you can grow as an artist.

Aperture
The partially enclosed area of a letter, as in "S" or "n."

Apex
The point at the top of a letter where two strokes meet.

Arm
The upward stroke in letters like "v" and "k."

Ascender
The upward vertical stroke in lowercase letters that extend up past the x-height.

Axis
This guideline indicates the tilt of the letters.

Beak
The sharp spur that comes off of a character, like in "S," "G," and "4."

Bold
Letters that are darker and heavier than the regular weight, so that they have more emphasis.

Bowl
The rounded part of a letter, like in "b" and "g."

Counter
A fully enclosed area within a character, like in "d," "o," and "9."

Crossbar
The horizontal stroke coming off a vertical stem for letters like "A," "E," "F," and "H."

Crotch
The inside angle where two strokes meet, for example in "w" and "y."

Descender
The downward vertical stroke found in lowercase letters that extend down past the baseline, as in "p" and "q."

Italic
A style where all the letters tilt to the right. Non-italic is called "regular."

Kerning
The space between letters. This is frequently adjusted for legibility and optimal usage of negative space.

Leg
The short descending line of a "k" or "R."

Ligature
A flourish coming off a letter. Used to help decorate lettering.

Lowercase character
A letter that goes from the baseline to the x-height.

Regular
A set of letters that are neither very bold nor very thin. This is considered the "standard" weight of a style.

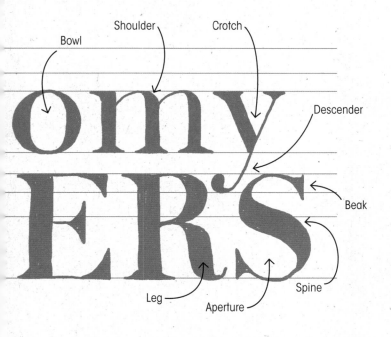

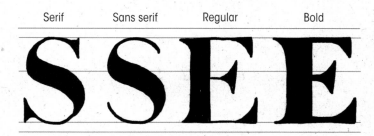

| Serif | Sans serif | Regular | Bold |

Guidelines

Guidelines help you draw a cluster of letters all with the same proportions. The amount of space between guidelines will vary from style to style, but they're always parallel to each other.

To create guidelines, use a ruler to very lightly pencil two lines, one above the other, that are at least 2 inches (5cm) apart. (This distance depends on how large you want your letters, of course.) These are the baseline and cap height. Then draw a line partway up the vertical center. This is the x-height, and its location will vary.

When they're needed, draw the ascender and descender lines above and below the cap height and the baseline, respectively. As with x-height, their location will vary based on the lettering style.

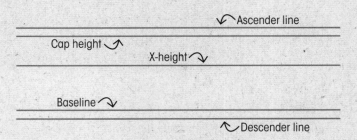

Sans Serif
A style of lettering that does not have serifs.

Serif
An extra stroke or embellishment added to the beginning and end of the main strokes of a character.

Shoulder
A curved stroke going downward from a stem, like the leg of an "m."

Spine
The downward stroke on an "S" and a "2."

Stem
The main vertical or diagonal stroke of a letterform that isn't a leg or an arm.

Tail
A descending stroke that touches the descender line, like in the letter "Q."

Terminal
The end of a stroke that does not include a serif.

Tittle
The dot on top of a letter, like in "i" and "j."

Uppercase character
A letter that goes from the cap height to the baseline.

Ascender line
The line marking the top of an ascender.

Baseline
The line upon which all letters rest.

Cap height
The height of a capital letter measured from the baseline.

Descender line
The line marking the bottom of a descender.

X-height
The height of all lowercase letters.

Tools and Materials for Hand Lettering

To paraphrase a famous saying, tools don't make the craftsperson. But having the right basic tools and materials on hand will certainly make learning lettering easier and more fun.

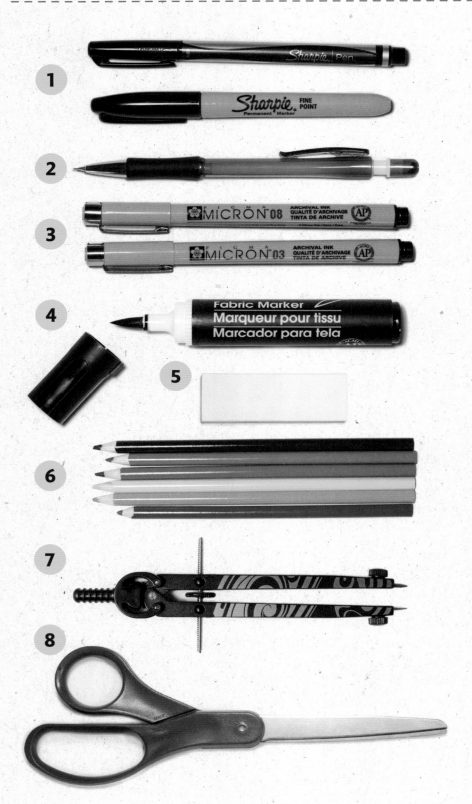

1. Permanent markers

Permanent markers come in a wide range of colors and tip sizes, including ultra-fine point, extra-fine point, fine point, and chisel tip. Combine both thin and thick markers in your lettering. They put a lot of ink on the paper, which causes the ink to bleed and expand. This can give your lettering a desirable worn appearance and an "old-timey" look.

2. Disposable mechanical pencils

The lead in mechanical pencils can be mechanically extended by clicking on the eraser, so you never have to worry about sharpening the point. That means you can focus more on your drawing. You can get refillable mechanical pencils, but disposables are so much simpler. The type of lead in them doesn't matter.

3. Fine-tip markers

These come in a variety of sizes and colors and make inking letters a breeze, with clean lines and minimal bleed. Get a starter pack with various sizes such as 03, 05, and 08.

4. Fabric markers

If you plan to draw on felt pennants, knit T-shirts, or any other kinds of fabrics, use a fabric marker. The material soaks up the ink and it won't wash off.

5. Erasers

A white plastic eraser is best for eliminating any unwanted pencil marks.

6. Colored pencils

Use these to note changes to make in interim drawings, or to add a pop of color to your finished designs.

7. Compass

Yes, the same tool you used in elementary school. When you're drawing arches or circles in your lettering, a compass can guide you so lines stay even and round, keeping the lettering balanced.

8. Scissors

Choose a big, sharp pair with a plastic grip.

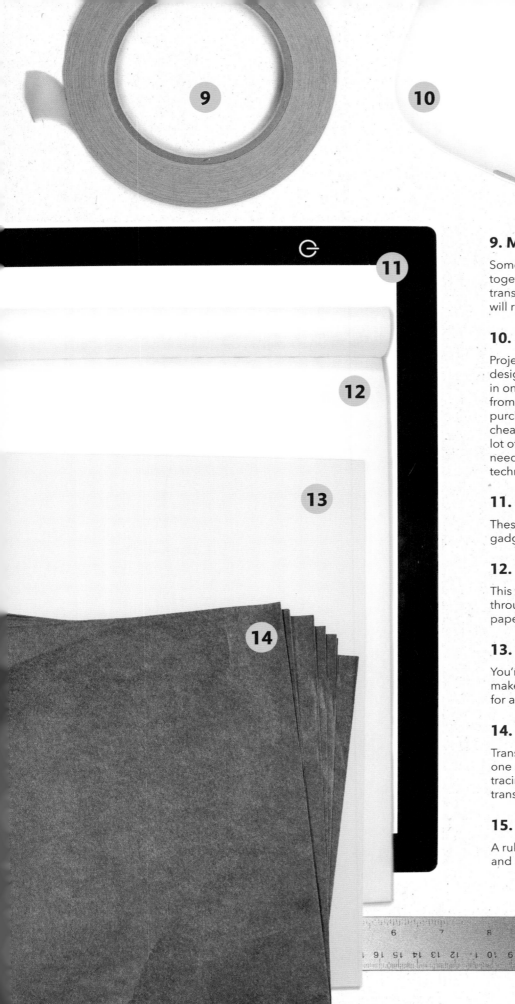

9. Masking tape

Sometimes you need to tape your pages together so your artwork stays aligned during transferring and tracing. The wrong kind of tape will rip your paper. Masking tape won't.

10. Projector

Projectors are super useful for enlarging a design and transferring it to another surface in one easy step. You may be able to rent one from the library or a rent-a-center. You can also purchase them in art supply stores; they're not cheap, but they're worth it if you plan to create a lot of large pieces. If you don't own one, you'll need to enlarge designs using a different technique of your choice.

11. Light box

These optional (and surprisingly affordable) gadgets make tracing super easy.

12. Tracing paper

This thin, translucent paper is easy to see through. During the edit and refine stage, tracing paper is helpful when making small refinements.

13. Printer paper

You're going to go through a ton of paper. It only makes sense to use cheap stuff like printer paper for all your preliminary drafts!

14. Transfer paper

Transfer paper is used to trace an image from one sheet to another. The pressure applied when tracing the drawing transfers the graphite on the transfer paper onto the new surface.

15. Ruler

A ruler is a must for keeping lettering straight and aligned.

Tools and Materials for Chalk Lettering

Break outside the traditional pen and paper to chalk and chalkboard. White lettering on a black background has charm and texture, and takes lettering to the next level.

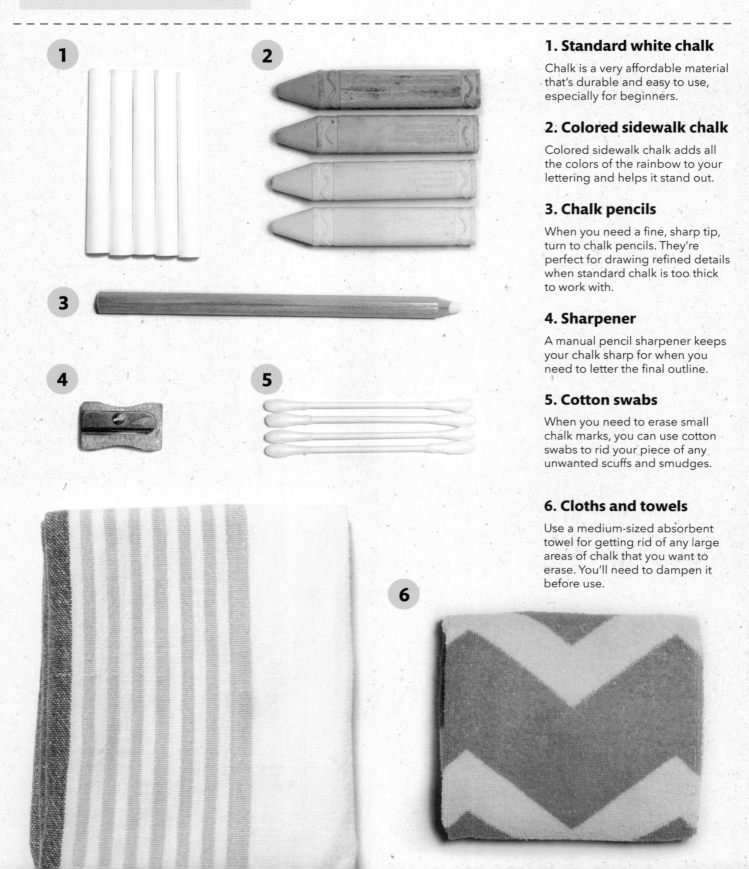

1. Standard white chalk

Chalk is a very affordable material that's durable and easy to use, especially for beginners.

2. Colored sidewalk chalk

Colored sidewalk chalk adds all the colors of the rainbow to your lettering and helps it stand out.

3. Chalk pencils

When you need a fine, sharp tip, turn to chalk pencils. They're perfect for drawing refined details when standard chalk is too thick to work with.

4. Sharpener

A manual pencil sharpener keeps your chalk sharp for when you need to letter the final outline.

5. Cotton swabs

When you need to erase small chalk marks, you can use cotton swabs to rid your piece of any unwanted scuffs and smudges.

6. Cloths and towels

Use a medium-sized absorbent towel for getting rid of any large areas of chalk that you want to erase. You'll need to dampen it before use.

7

8

Workable
Fixatif 1306

- Protects pencil, pastel and chalk drawings
- Prevents smudging and wrinkling
- Allows easy rework
- Acid-free/archival-safe

DANGER! EXTREMELY FLAMMABLE - VAPORS MAY CAUSE FLASH FIRE. CONTENTS UNDER PRESSURE. VAPOR HARMFUL.
Before using, carefully read CAUTIONS on back panel.

Net Wt. 11 oz • 311 g

7. Surfaces

These are the "canvas" for all your chalk work. Chalkboards come in all sizes, from **classroom blackboards** and **sidewalk sandwich boards** to **menu plaques, place cards,** and **display stands.**

Mini chalkboards are great for signage, decor, or events. You can write short messages on them to turn the words into statement pieces.

Chalk paper gives you the same look and feel as a chalkboard, but on thick, black paper that's perfect for flyers, invitations, and more.

You can even turn a wall into a chalkboard by painting it with **chalkboard paint.**

8. Fixative

Make your art smudge-proof by spraying workable fixative on your chalk lettering. You can easily erase it with water when you're ready to write something new on your surface.

How to season a chalkboard

Whether you're working on a new chalkboard or made one using chalkboard paint, you must season it before use. This will make it easier to erase it without leaving behind a faint imprint of the erased drawings.

1 First, clean your new chalkboard with just a splash of water.

2 Once it's dry, rub it with the side of a piece of white chalk, covering the entire board horizontally, and then vertically, with a layer of chalk.

3 Wipe off the chalk with a chalk eraser or dry cloth to remove any excess dust, and, voilà, you're ready to letter.

Tools and Materials for Painting

Painting your lettering allows you to go larger faster and takes you into the realm of sign painting. Signs were once the only way companies could advertise (on buildings and billboards), and sign painters went through long apprenticeships to get into this respected profession.

1. Enamel paint

Most professional sign painters use enamel paint because of its ease of application. You can purchase any brand.

2. Brush cleaner

This essential material removes paint from used brushes so they last longer and don't transfer any previous paint on a new color.

3. Brushes

You'll need round and square brushes of different sizes so you can paint both hard edges and beautiful curves in your lettering, as well as narrow and wide areas.

1

2

TIP

When painting, always put down newspaper or some other protective covering on your desk, floor, and carpet. You don't want paint all over your house!

3

Painting Techniques

Lettering with paint can be a challenge for beginners, so here are a few tips to get you started on your creative journey.

Detailing

Using a small, thin brush, you can add final details during the last stage of painting. These details are usually the lightest parts of the design and used mostly for highlights.

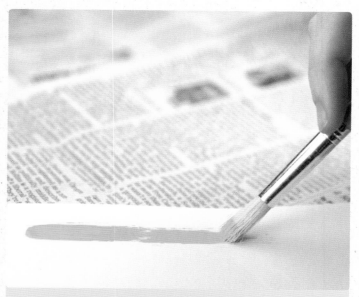

Dry Brushing

To create areas of strong color, use the paint straight out of the can without diluting it. This gives a more textured look.

Cleaning

Always have a disposable cup with some paint thinner in it on hand when painting. Between colors, remove all the paint from the brush before switching to a new shade.

To clean brushes, dip them inside the cup of paint thinner, then rinse them in running water. Dry them with a clean paper towel to make sure all the color is off.

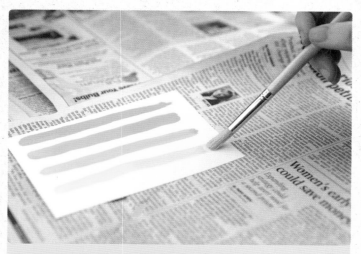

Washes

Dip your brush in water, then in the paint to soften the edges and apply translucent washes to your canvas. This creates beautiful, light backgrounds.

Hand Stretches

Just as you need to warm up before a workout, you need to warm up your hands before you draw. Performing these different stretches will allow your hands to work longer without any discomfort.

The fist and release

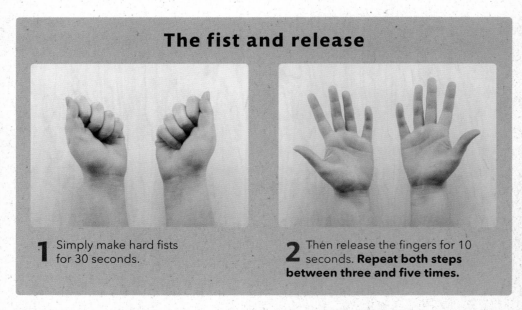

1 Simply make hard fists for 30 seconds.

2 Then release the fingers for 10 seconds. **Repeat both steps between three and five times.**

The thumb touch

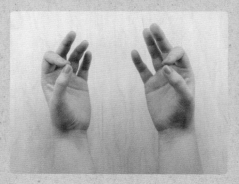
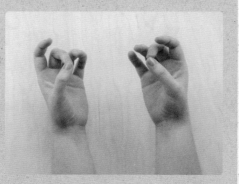

1 Hold your hands in front of you with your palms facing you.

2 Keeping your wrists straight, lightly touch your thumb to your index finger, making a ring with your fingers. Hold for 30 seconds.

3 Touch your thumb to each of your remaining fingers in turn, holding each for 30 seconds. **Repeat steps 2 and 3 to perform the stretch a total of 3 to 5 times.**

The claw

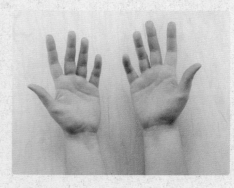
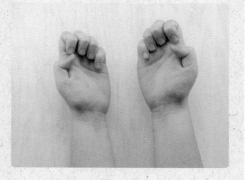

1 Put your hands out with your palms facing you.

2 Without making a fist, bend your fingertips and thumb, touching them toward the center of your palm. Hold for 30 seconds. **Repeat both steps between three and five times.**

TIP

Anytime your hands feel sore or tired, repeat these stretches to prevent feeling pain in your hands after a long drawing session.

How to Practice

Deliberate practice is a process that can help you learn three times faster. In this method, you intentionally set aside time every day to learn the letterforms of different styles. This is the best way to learn because it allows you to memorize styles instead of having to look at visual references every time you want to start a new piece.

1 Begin by finding a typeface you want to learn and print out the alphabet so you have all the letters on one page. Then, using a light box or tracing paper, trace over all the letters in pencil once.

2 Draw guides for your baseline, cap height, and x-height on a blank sheet of paper. Referring to the printout frequently, redraw the same alphabet once, but without tracing it.

3 Now comes the tricky part. Put away all your drawings and the printout of the alphabet. Then draw the alphabet once from memory. If you have to peek, look at the reference for three seconds, then put it away.

4 Once you complete the alphabet, check your lettering against the original printout of the alphabet. Use a different-colored pen to make notes about your errors. Your lettering doesn't have to be picture perfect, but it's important to know what to fix next time you practice.

TIP

Repeat this entire process for each new alphabet you want to learn. Try to go through all four steps at least three times in order to permanently store the memory of how to create all the letterforms.

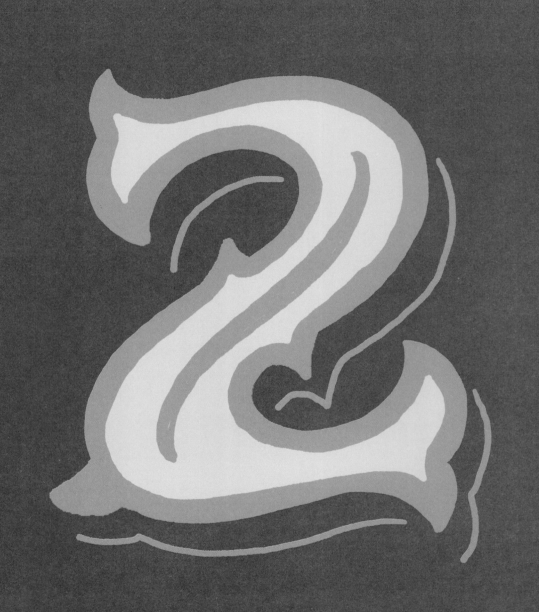

Get Started

This chapter immerses you in the basic techniques of hand lettering. It starts off by teaching two alphabets for beginners step by step, including a serif and a sans-serif style, in pen as well as in chalk. It also shows a lot of different ways to decorate your lettering. These techniques will take your lettering from cool to mind-blowing!

MONOWEIGHT SANS SERIF

STEADY • ASSERTIVE

A monoweight letter has the same weight, or width, everywhere. "Sans serif" means that the ends of the strokes have no serifs. This simple, unembellished type style will teach you the basics of building letters and how to add weight in exactly the right places.

ABCDEFGHI
JKLMNOPQR
STUVWXYZ
1234567890

Setting up guidelines

This is a moderately tall lettering style, so leave plenty of space between cap height and baseline. Place the x-height guideline exactly in the middle.

cap height

x-height

G

baseline

Here's how...

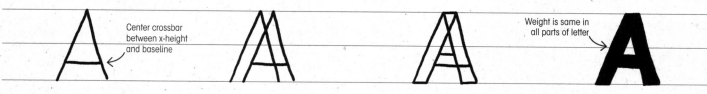

Center crossbar between x-height and baseline

Weight is same in all parts of letter

1 Start the left diagonal stem at the cap height and draw down to the baseline. Draw the right diagonal in the same way. Draw the crossbar.

2 Draw two diagonals exactly as described in step 1, but slightly to the left of the "A."

3 Draw a short horizontal line at the apex and at the bottom of both stems. Draw a horizontal line above the crossbar as well.

4 Fill in the letter and carefully check to make sure the weight is correct.

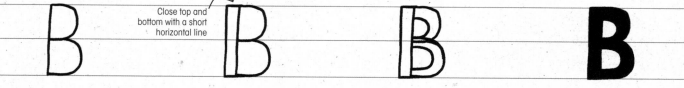

Close top and bottom with a short horizontal line

1 Draw a straight, vertical stem. Draw a bowl between cap height and x-height, then another bowl beneath it, between x-height and baseline.

2 Add weight to the stem by drawing a line to the left of it.

3 To add weight to the bowls, draw curves along the inside that meet slightly above and below the x-height.

4 Fill in the letter and carefully check to make sure the weight is the same in all parts of the letter.

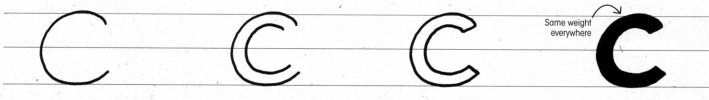

Same weight everywhere

1 Draw a very round "C."

2 Draw a smaller "C" inside of it.

3 Connect the corresponding ends with short diagonal lines.

4 Fill in the "C" and check carefully to make sure the weight looks right.

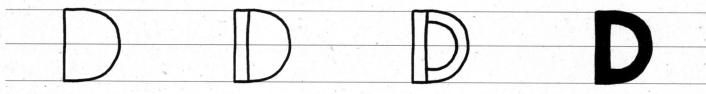

1 Draw a straight, vertical stem. Draw a bowl, starting at cap height and going down to the baseline.

2 Add weight to the stem by drawing a line to the right of it.

3 Add weight to the bowl by drawing a curve inside of it.

4 Fill in the "D" and check carefully to make sure the weight is consistently the same in all parts of the letter.

CONTINUED

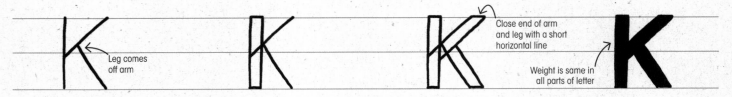

Leg comes off arm

Close end of arm and leg with a short horizontal line

Weight is same in all parts of letter

1 Draw a straight, vertical stem. Starting at x-height, draw an arm that goes up to the cap height. To draw the leg, start on the arm and draw down to the baseline.

2 Add weight to the stem by drawing a line to the right of it. This line should intersect with the spot where the leg comes off the arm.

3 Add weight to the arm by drawing a diagonal beneath it. Add weight to the leg by drawing a diagonal to the right of it.

4 Fill in the "K" and review it to make sure the weight looks right.

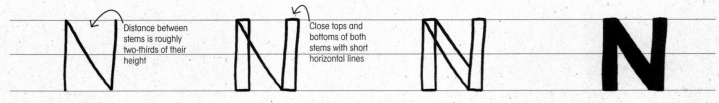

Distance between stems is roughly two-thirds of their height

Close tops and bottoms of both stems with short horizontal lines

1 Draw two straight, vertical stems. Connect them with a diagonal that goes from top left to bottom right.

2 Add weight to the stems by drawing a line to the right of each.

3 Add weight to the diagonal by drawing a diagonal line above it.

4 Fill in the "N" and check to make sure the weight is consistently the same in all areas of the letter.

Center smaller circle inside larger one

1 To make an "O," start by drawing a circle.

2 Draw a smaller circle inside it.

3 Fill it in. Check carefully to make sure the weight looks the same everywhere.

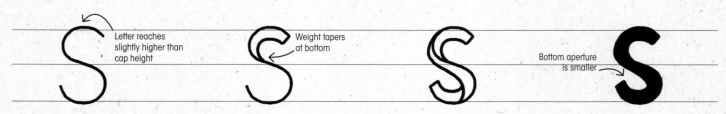

Letter reaches slightly higher than cap height

Weight tapers at bottom

Bottom aperture is smaller

1 Draw an "S."

2 Add weight to the top curve by drawing a curve below it. Close the end with a short diagonal line.

3 Add weight to the rest of the spine as shown, working on the middle section first, and then the bottom one.

4 Fill in the letter. Check the weight. All areas should have the same thickness.

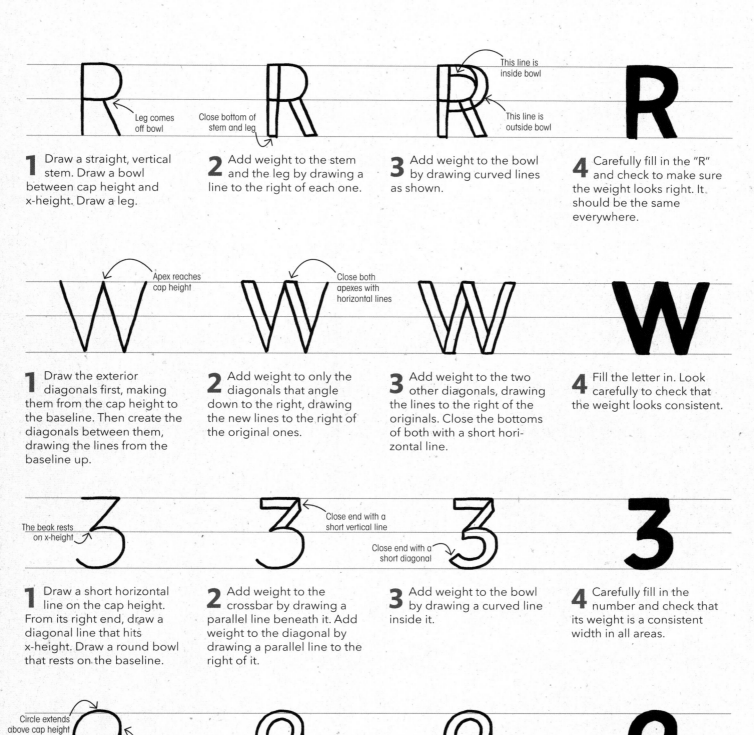

1 Draw a straight, vertical stem. Draw a bowl between cap height and x-height. Draw a leg.

2 Add weight to the stem and the leg by drawing a line to the right of each one.

3 Add weight to the bowl by drawing curved lines as shown.

4 Carefully fill in the "R" and check to make sure the weight looks right. It should be the same everywhere.

1 Draw the exterior diagonals first, making them from the cap height to the baseline. Then create the diagonals between them, drawing the lines from the baseline up.

2 Add weight to only the diagonals that angle down to the right, drawing the new lines to the right of the original ones.

3 Add weight to the two other diagonals, drawing the lines to the right of the originals. Close the bottoms of both with a short horizontal line.

4 Fill the letter in. Look carefully to check that the weight looks consistent.

1 Draw a short horizontal line on the cap height. From its right end, draw a diagonal line that hits x-height. Draw a round bowl that rests on the baseline.

2 Add weight to the crossbar by drawing a parallel line beneath it. Add weight to the diagonal by drawing a parallel line to the right of it.

3 Add weight to the bowl by drawing a curved line inside it.

4 Carefully fill in the number and check that its weight is a consistent width in all areas.

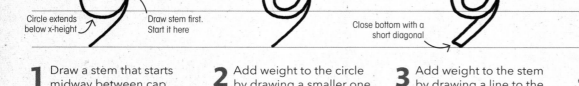

1 Draw a stem that starts midway between cap height and x-height and goes down to the left with a slight curvature. Draw a circle that touches it to its left.

2 Add weight to the circle by drawing a smaller one centered inside it.

3 Add weight to the stem by drawing a line to the left of it.

4 Fill in the "9," then check it to make sure the weight is the same everywhere.

Basic Chalk Techniques

This section explains some basic techniques for working with chalk, from applying pressure to erasing without making a mess. These principles apply whether you're working on a tiny chalkboard or on one about the size you'd find in a classroom.

General recommendations

You probably wrote on a chalkboard in elementary school or on the sidewalk, but that doesn't mean anyone gave you rules of thumb for drawing with it.

Making guidelines

When you first start a new design, hold the chalk just like a pencil, and lightly draw out guidelines using short marks all going in the same direction.

Drawing lines

When drawing a straight line, keep your wrist locked and move your arm downward. If necessary—and if there's no lettering to smear beneath it—anchor your hand directly on the chalkboard.

Creating skeletons

When lettering the skeleton of a word, leave a little extra room between the letters, especially if you plan to add flourishes or dimension to your letters. You can always add weight if the letters are spaced too far apart, but you'll have to erase if the letters turn out to be too close together.

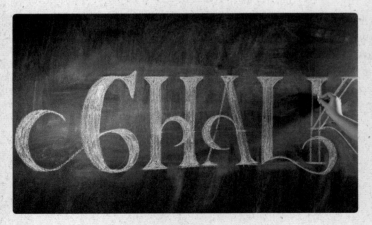

Outlining and filling letters

When filling in your letters, apply less pressure to the chalk than when drawing outlines. For small areas, sharpen your chalk and use just the tip. For larger areas, put the chalk on its side to fill in the space faster.

How to erase marks

Although you could just use your finger to wipe away unwanted marks, you won't have as much control as with towels or swabs.

Removing larger areas

Use a small damp towel to wipe away any unwanted marks. When erasing, be sure to rub with an unused spot on your towel to prevent putting any chalk residue you've already removed back onto the board.

For small areas, wrap the towel just around your finger, while holding the tail of the towel away from your chalkboard.

For larger areas, wrap the damp towel around your palm. Make sure not to drag the towel on any part of the chalkboard you don't want erased.

Blotting small sections

For detail work, use a damp cotton swab to wipe off any unwanted lines. Wipe only once per side, then rotate the swab slightly for the next wipe. This prevents transferring chalk residue from the swab back onto the board.

How to work on large chalkboards

When you're drawing on a large surface, the scale is usually much different than when you're working on sheets of paper. To keep your lettering at the right proportion, follow these suggestions.

Stay front and center

Whenever you draw a letter, make sure the work is at eye level. You don't want to be looking up or down at your letters as you draw them, or your work will look distorted. If necessary, crouch down or climb on a step ladder.

Keep back

When working on larger chalkboards, stand about a foot (30.5cm) away from the board to keep as much of the art within your field of vision.

Step away

After every major addition to your design, step away from the chalkboard and review it to make sure everything is lining up the way you want.

varied weight serif

YOUTHFUL • SERENE

Now that you understand some of the basics of lettering, learn how to add weight to letters and how to draw them in chalk. This varied weight serif style lends an upscale touch to your message while remaining easy to read. (And of course you can ink it instead of drawing it in chalk!)

abcdefghi

jklmnopqr

stuvwxyz

1234567890

Setting up guidelines

The distance between cap height and x-height is identical to the distance between baseline and descender. X-height is almost twice that measurement.

cap height ⤵

x-height ⤵

k

baseline ⤴

⤹ descender line

Here's how...

 Shoulder is smoothly round

 Stem weight is thicker than bowl weight

Use side of chalk to fill large areas, tip for small areas

1 Draw the skeleton of an "a," with a curved stem and a tear-drop-shaped bowl.

2 Add weight by drawing a line inside the existing lines, tapering them at the ends. Draw a ball terminal at the upper left of the "a."

3 Erase any interior marks.

4 Fill in lightly with chalk.

Weight of bowl tapers on top and bottom

Connect tops and bottoms of stems with a horizontal line

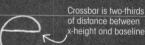

1 Draw the skeleton of the "d" by drawing a straight stem first, then an oval bowl to the left of it.

2 Add weight by drawing a line on the right side of the stem and another inside the bowl.

3 Add a serif on the top left of the stem, as well as on the bottom right.

4 Erase any interior marks. Fill the letter lightly with the pointed end of the chalk.

Crossbar is two-thirds of distance between x-height and baseline

Tapers only at top

Tapers at top and bottom

1 For the skeleton, draw a "c," then add a crossbar.

2 Add weight by drawing lines on the inside of the skeleton.

3 Add a serif on the bottom right of the bowl.

4 Erase any interior marks. Fill the letter lightly with the pointed end of the chalk.

Stem tapers only at top

 Crossbar is on x-height

 Serifs face opposite directions

1 For the skeleton, draw a stem with a curve at the top, like a cane. Then draw a crossbar.

2 Add weight by drawing lines on both sides of the left side of the stem. Then draw a ball terminal where the stem curves, on the right.

3 Add a serif off each end of the cross bar, and on both sides of the bottom of the stem.

4 Erase any interior marks. Fill in the letter lightly with the pointed end of the chalk.

CONTINUED

Descender is shaped like a lasso

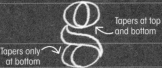
Tapers at top and bottom
Tapers only at bottom

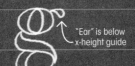
"Ear" is below x-height guide

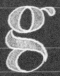

1 Draw a wide oval hanging off the x-height. It's roughly half as tall as the distance between x-height and the baseline. Then draw the descender coming off it.

2 Add weight by drawing lines inside the bowl that taper at the top and bottom. Then add weight to the right side of two of the curves in the descender.

3 Draw an "ear" on the right side of the oval.

4 Erase any interior marks. Fill the letter lightly with the pointed end of the chalk.

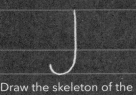

Tapers at bottom

1 Draw the skeleton of the "j" with a stem that goes from the x-height to the descender guideline. At the bottom, it curves left like an upside-down cane.

2 Add weight by drawing a line to the left of the stem. Then draw a ball terminal at the end of the curve. Finally, draw a circle above the stem for the tittle.

3 Add serifs on both sides of the top of the stem.

4 Erase any interior marks. Fill in the letter lightly with the pointed end of the chalk.

Leg comes off arm, not off stem

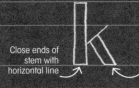
Close ends of stem with horizontal line
Close bottom of leg with horizontal line

1 Draw a straight vertical line from the cap height to the baseline. Then draw the arm, starting it right below the x-height. Draw the leg, leaving a small gap between it and the stem.

2 Add weight to the stem by drawing a parallel line to the left of it. Add weight to the leg by drawing a parallel line to its right.

3 Add serifs on both sides of the top of the stem, and on the top of the arm. Then add just a left-facing serif off the bottom of the stem and of the leg.

4 Erase any interior marks, then finish by filling the letter lightly with the pointed end of the chalk.

Add serif only to left side of top
Enclose ends with horizontal lines

1 Draw a short vertical line between the x-height and the baseline. Draw a curved line coming off the right of this stem, and then another curved line coming off the first one.

2 Add weight to the left of each line, where it goes down. The weight should taper at the top of the two curved lines.

3 Add serifs on both sides of the bottoms of all the lines. Then add just one serif to the left side of the top of the stem.

4 Erase any interior marks. Finally, fill in the letter lightly using the pointed end of the chalk.

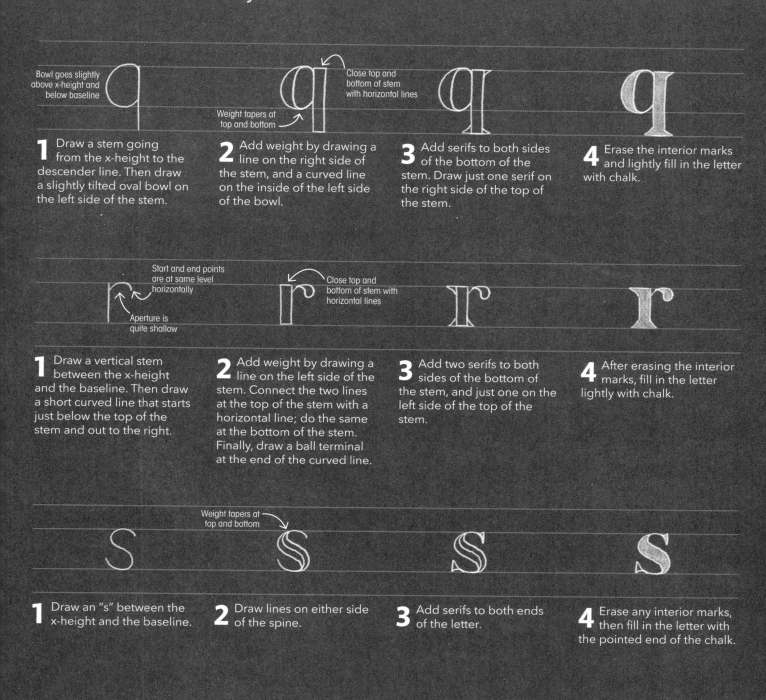

1 Draw a stem going from the x-height to the descender line. Then draw a slightly tilted oval bowl on the left side of the stem.

Bowl goes slightly above x-height and below baseline

2 Add weight by drawing a line on the right side of the stem, and a curved line on the inside of the left side of the bowl.

Close top and bottom of stem with horizontal lines

Weight tapers at top and bottom

3 Add serifs to both sides of the bottom of the stem. Draw just one serif on the right side of the top of the stem.

4 Erase the interior marks and lightly fill in the letter with chalk.

1 Draw a vertical stem between the x-height and the baseline. Then draw a short curved line that starts just below the top of the stem and out to the right.

Start and end points are at same level horizontally

Aperture is quite shallow

2 Add weight by drawing a line on the left side of the stem. Connect the two lines at the top of the stem with a horizontal line; do the same at the bottom of the stem. Finally, draw a ball terminal at the end of the curved line.

Close top and bottom of stem with horizontal lines

3 Add two serifs to both sides of the bottom of the stem, and just one on the left side of the top of the stem.

4 After erasing the interior marks, fill in the letter lightly with chalk.

1 Draw an "s" between the x-height and the baseline.

2 Draw lines on either side of the spine.

Weight tapers at top and bottom

3 Add serifs to both ends of the letter.

4 Erase any interior marks, then fill in the letter with the pointed end of the chalk.

1 Draw an upside-down cane-shaped stem that starts slightly below the cap height and curves at the baseline. Then draw a crossbar on it.

Ascender is below cap height

Crossbar is on x-height

2 Add weight to the letter by drawing a line on each side of the stem.

Tapers at bottom

3 Add two serifs off the crossbar.

Serifs slant down toward stem

4 After erasing any interior marks, lightly fill the letter with the point of the chalk.

CONTINUED ⟶

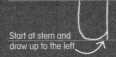 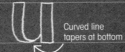

Start at stem and draw up to the left

Curved line tapers at bottom

1 Draw a vertical stem going from the x-height to the baseline. Then draw a curved line, starting on the left side of the stem just above the baseline, and going up to the left.

2 Add weight by drawing lines on the right side of the existing lines. Close the tops and bottom with short horizontal lines.

3 Draw two serifs on both sides of the top of the stem. Draw just one on the left side of the top of the curved line, and one on the right side of the bottom of the stem.

4 Erase any interior marks. Fill the letter lightly with the pointed end of the chalk.

Start second "v" just below left side of first "v"

1 Draw a "v." Then draw another "v" to the left of it, not to the right of it.

2 To add weight, draw a parallel line to the right of both of the diagonal lines on the left side of each "v." Close the tops with short horizontal lines.

3 Add two serifs to the tops of each line, where they reach x-height.

4 Erase any interior marks. Using the point of the chalk, fill the letter lightly.

Lines cross in middle

Close top and bottom with short horizontal lines

1 Draw a diagonal line from the x-height to the baseline, going from left to right. Then draw another diagonal line going in the opposite direction, from right to left.

2 Add weight to the left-hand diagonal line by drawing parallel lines on both sides of it.

3 Draw two serifs on all four of the ends of the letter.

4 After erasing any interior marks, fill in the letter lightly with chalk.

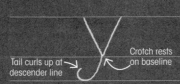 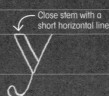

Close stem with a short horizontal line

Tail curls up at descender line

Crotch rests on baseline

1 Draw a diagonal line from the x-height to the baseline, going from left to right. Draw another diagonal line to create a "v." Finally, draw the tail from the point of the "v" down to the descender line.

2 Add weight to the inside of the left-hand diagonal line of the "v," and add a ball terminal to the tail.

3 Draw two serifs on the tops of the letter.

4 Erase the interior marks. End by filling the letter lightly in chalk.

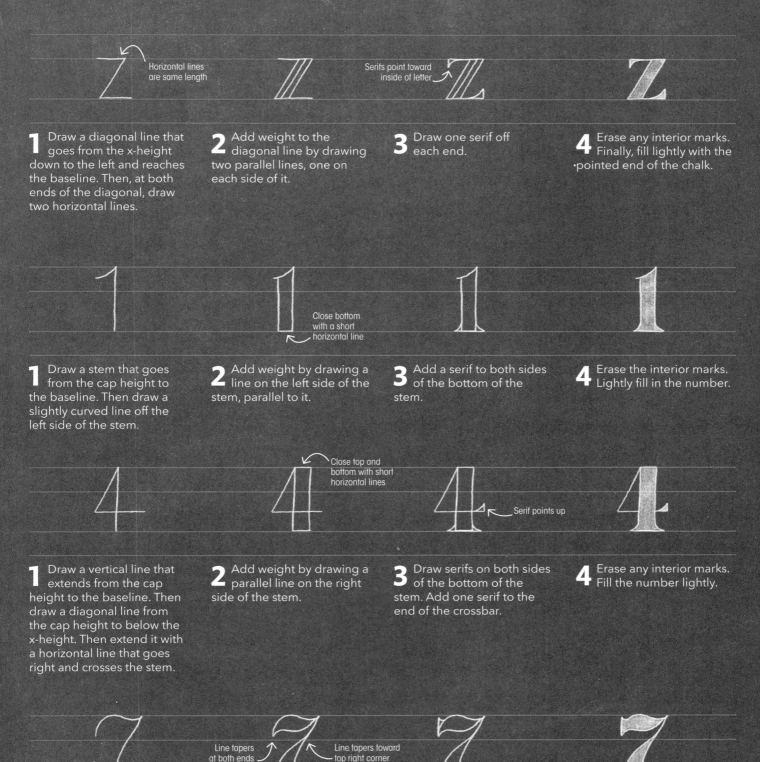

1 Draw a diagonal line that goes from the x-height down to the left and reaches the baseline. Then, at both ends of the diagonal, draw two horizontal lines.

Horizontal lines are same length

2 Add weight to the diagonal line by drawing two parallel lines, one on each side of it.

3 Draw one serif off each end.

Serifs point toward inside of letter

4 Erase any interior marks. Finally, fill lightly with the pointed end of the chalk.

1 Draw a stem that goes from the cap height to the baseline. Then draw a slightly curved line off the left side of the stem.

2 Add weight by drawing a line on the left side of the stem, parallel to it.

Close bottom with a short horizontal line

3 Add a serif to both sides of the bottom of the stem.

4 Erase the interior marks. Lightly fill in the number.

1 Draw a vertical line that extends from the cap height to the baseline. Then draw a diagonal line from the cap height to below the x-height. Then extend it with a horizontal line that goes right and crosses the stem.

2 Add weight by drawing a parallel line on the right side of the stem.

Close top and bottom with short horizontal lines

3 Draw serifs on both sides of the bottom of the stem. Add one serif to the end of the crossbar.

Serif points up

4 Erase any interior marks. Fill the number lightly.

1 Draw a mostly horizontal wave that starts just above x-height and reaches to the cap height. Starting at the right end of that line, draw a slightly curved stem down to the baseline.

2 Add weight by drawing a line beneath the horizontal wave, and another line to the left of the curved stem.

Line tapers at both ends

Line tapers toward top right corner

3 Draw serifs on both sides of the bottom of the curved stem. Then add one that points up off the top left of the "7."

4 Erase marks inside the character, then lightly fill it in.

Transferring a Design from Paper to Chalkboard

It's better to create a design intended for chalk on paper first, then transfer it to the chalkboard. That's because the process of refining a design is faster on paper. On a chalkboard, you would have to keep carefully erasing your previous lines—this method allows you to finish chalk lettering more quickly.

Materials
Printer paper
 with a finished
 lettered design on it
Chalk
Chalkboard
Masking tape

Tools
Colored pencil
 (any shade)
Chalk pencil
Towel
Cotton swabs

TIP

Using colored pencil to trace over the letters shows you which parts of the drawing you've transferred.

1 Using a fair amount of pressure, rub the side of the chalk all over the back of the sheet containing the hand-lettered design. You need to cover it completely in a thick layer of chalk, so this part requires some elbow grease.

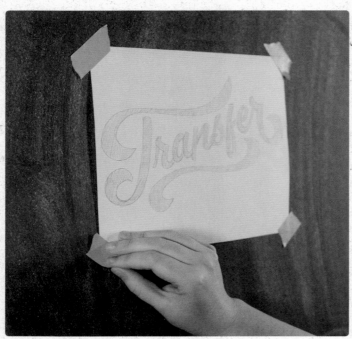

2 Place the sheet of paper where you want it on the chalkboard, with the lettering face up and the chalk-covered side resting against the chalkboard. Hold it in place by taping the corners down with masking tape.

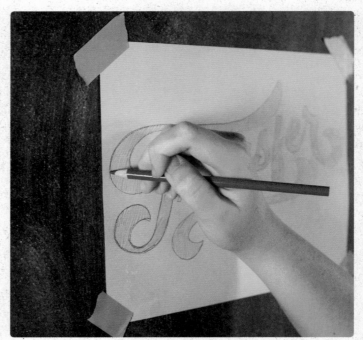

3 Using a colored pencil, trace over the drawing, applying a decent amount of pressure. For better results, draw just the outline of the letters so you can more easily make any desired improvements later.

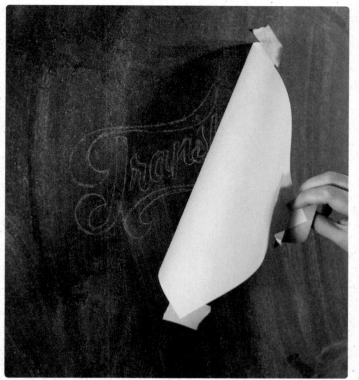

4 Remove your paper. You should see a transfer of the design left behind faintly in chalk.

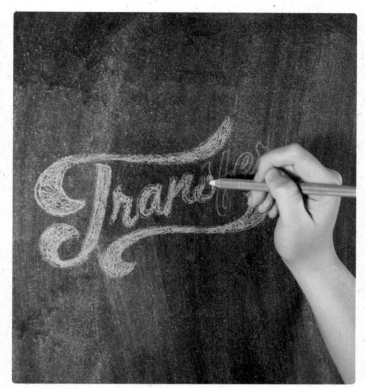

5 Fill in the lettering using the sharp tip of the chalk pencil.

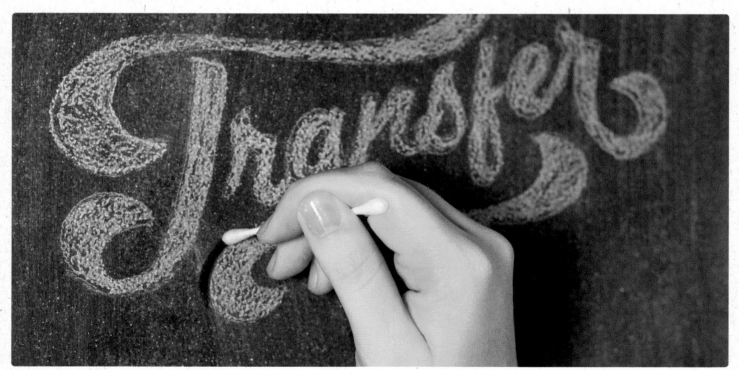

6 Use a damp towel and cotton swabs to clean up any unwanted marks.

How To Build Words

When you first start lettering a new design, you must build each word from the ground up. Following the process described here will help you achieve cleaner lines, neater drafts, and more accurate spacing between letters.

1 Begin by drawing a box—also called a container—inside of which you'll place a word. (Each word gets its own container.) Lettering inside a container keeps the letters aligned and allows you to more easily build out each word.

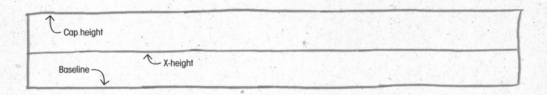

The container should be roughly the right size to contain all the letters in the word—neither too long nor too short. This box would be way too big for a short word like "the," for example.

Containers can be straight like this one—or curved.

2 Draw a guideline inside the container for the x-height. The top of the container will serve as the cap height, and the bottom is the baseline.

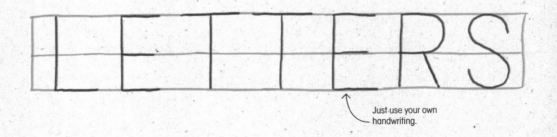

Cap height

X-height

Baseline

3 Draw the skeleton of the letters first, using your own handwriting. This allows you to focus just on the placement of the letters, to make sure that you have an even amount of space between each.

LETTERS

Just use your own handwriting.

Serifs

Serifs are those short, extra strokes added to the beginning and end of the main strokes of a character. There are all kinds of ways to draw them, from the simple line serif in Tattoo lettering to the more ornate Tuscan serif in Western lettering.

Gothic Serif
This serif originated in the flick of the pen of medieval scribes.

Flat Serif
While plain, this serif looks refined and elegant.

4 Next, add weight to the heaviest parts of the letters. Strokes that go straight or diagonally down are always thicker than any other strokes.

5 Add additional style details such as serifs and spurs. These will help the letters—and by extension, the word—look more lively.

At this point, just sketch details in roughly. You'll perfect them at a later stage.

At this point, you might decide these letters are too close and mark them for redrawing at a later stage.

6 Fill in the letters lightly with pencil. Check the weight carefully to make sure that it looks consistent and correct. You can then erase your guides to reveal the final sketch.

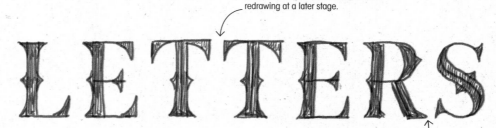

These letters are too close; circle them in colored pencil to redraw later.

Tuscan Serif
Much of the playful character of this lettering comes from the style of its serif.

Line Serif
The thin stroke of this serif is a nice counterpoint to the weight of the stem.

Slab Serif
This serif gives the lettering a feeling of solidity and presence.

Cursive Serif
Don't forget that serifs can be curved or curly!

Frames, Corners, and Borders

Once you've perfected the lettering, draw fun decorative elements around the words. There are many ways to create these enhancements, so here are just a few basic styles to get you started. When you add them, make sure not to include too many embelishments—you don't want to clutter up the design.

Frames

Frames are similar to borders but serve more as a container for the artwork rather than as an additional decorative element along the edges, the way borders do. You can either draw a simple rectangular frame and add decorative lines within it, or create a custom shape inside of which to place your lettering.

Keep the elements and edges of the frame consistent. Do this by drawing one side first. Then use tracing paper to assist you in repeating it for the other sides.

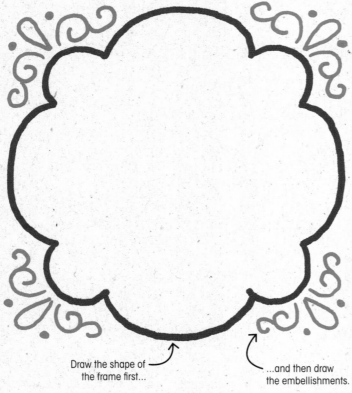

Draw the shape of the frame first...

...and then draw the embellishments.

Draw the frame first, then add the lettering inside of it to help you fill the negative space more fully.

Corners

Corners can help fill the negative space in a drawing, as well as the gaps in frames and borders. Before you add corners, the lettering must be completely finished. If you add corners earlier, you might end up lettering on top of them, which will look all wrong.

Corners can be be slightly different shapes and sizes so they don't cross over the lettering.

Always have the corners point toward the center of the piece, never away from it. This guides the eye into the drawing.

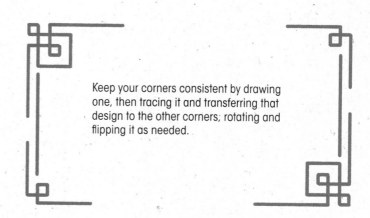

Keep your corners consistent by drawing one, then tracing it and transferring that design to the other corners, rotating and flipping it as needed.

Borders

Borders add an extra layer of detail to lettering and are especially great along the edges of book covers and cards. There are infinite ways to draw them. A few rules of thumb ensure that your designs stay consistent and prevents them from looking cluttered.

Leave a margin at least ½ inch (1.3cm) wide between the borders and the lettering. Having them too close impedes legibility.

Include no more than three different elements in a border—for example dots, straight lines, and curves. More than three kinds of things can look messy.

Borders can be used as corners, too. If you take that approach, always start drawing them at the corners first, and draw from the exterior of the border going in. (In other words, in this example, the curlicues were drawn first, then the lines, and then the dots.) This keeps the elements aligned and parallel.

Banners

Banners are a fun and stylish way to add visual interest to a design, and they do wonders for the visual hierarchy of a phrase by adding emphasis to keywords. There are various ways to execute a banner. Here are three examples, with tips for keeping the perspective looking correct.

- -

Simple banner

Always create the skeleton of the banner first, before adding the ends. This will help the lines stay the same width apart, and it allows you to draw more creative banners.

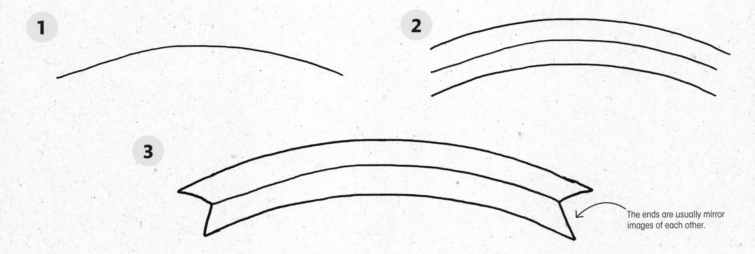

The ends are usually mirror images of each other.

Scrolled banner

Add a little depth to the banner by making the ends look rolled. Use lines or shading on the "back" of the banner to emphasize the illusion that it's three-dimensional.

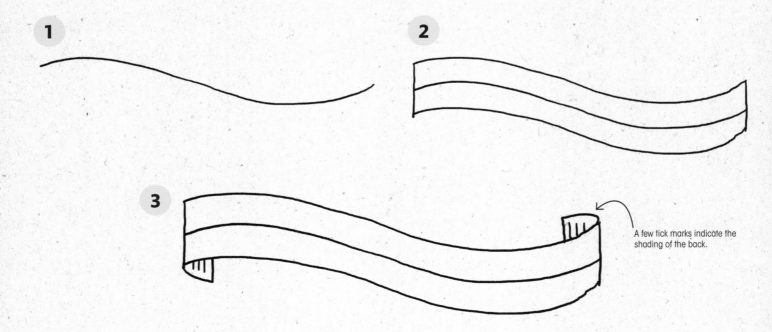

A few tick marks indicate the shading of the back.

Create balance

Ligatures can give a composition better balance. Achieve this by placing swirls that are similar in size and shape on opposite sides of a phrase. These are just a few ideas. Feel free to explore ligatures in every direction!

Ligatures at the top and the bottom of a piece give the words a horizontal balance that feels centered and self-contained. These ligatures point in opposite directions.

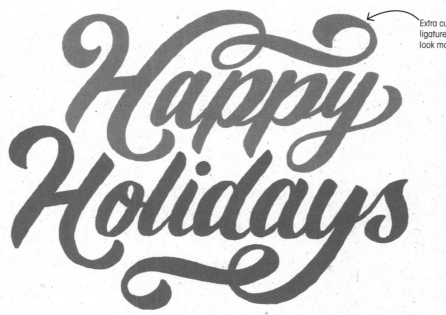

Extra curlicues on the ligature make the phrase look more festive.

A subtle ligature on the first letter and the last one, curling up to point toward the center of the word, ties all the letters between them together.

Fill the "O" with a ligature, too.

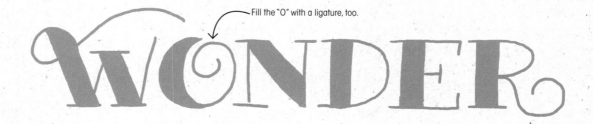

Draw a ligature coming off the last letter, using it to underline the entire word. This draws more attention to the word.

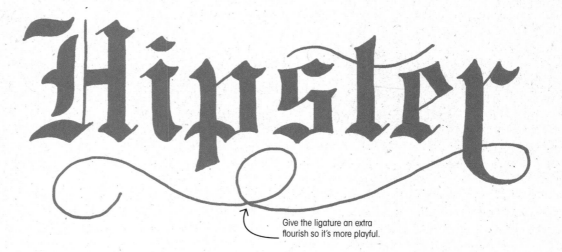

Give the ligature an extra flourish so it's more playful.

Inline Graphics

Inline graphics are the details that you include inside of your letters. You can add things like stars, dots, lines, diamonds, and more to give hand-lettered pieces extra pizzazz. Place inline graphics in an entire word, inside only the drop cap starting a phrase, or in the first letter of capitalized words.

Lines

You'll be surprised at how many different ways you can decorate the interiors of letters with just the stroke of your chalk or pen. These ideas are just to get you started!

Parallel lines can be diagonal—or vertical or horizontal.

Subtle highlight
The most common way to add lines is to draw a stroke in one of the main stems.

Echo
You can redraw the entire letter inside the original one.

Caution tape
Draw parallel lines to fill up the negative space inside the letter.

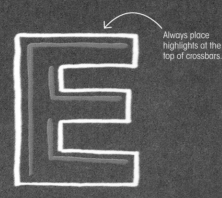

Always place highlights at the top of crossbars.

Partial fill
Fill only the bottom part of the letter with horizontal lines.

Highlight
Draw lines of different lengths. They will look like highlights on the letter.

Shapes

When you want to add something a little more interesting, play with different common shapes like triangles, circles, diamonds, and stars.

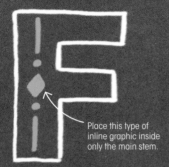

Place this type of inline graphic inside only the main stem.

Trio
Add up to three different shapes in the letter. To do so, draw the most visually interesting shape in the vertical center of your letter, with less complex shapes and lines around it.

Marquee
Add a simple line of dots or stars along the center of the character. Your letters will look lit up like a theater marquee! This technique is especially good for keywords because it draws the eye in.

Minimalist
Draw several shapes that complement one another inside the letter. This example shows a triangle with a "v" below it.

Ornate

Take your lettering to a whole other level by adding more complex lines and decorative elements inside the letters.

Bling
Fill all the negative space inside the letter with filigree and dots.

Mix it up
Add layered spurs to the bottom of the stem, and draw short horizontal lines inside the rest of the letter.

Medieval
For a more dimensional look, add connecting lines to give a beveled effect. You can even add swirls along the stem.

Outline Graphics

Add strokes and drop shadows on the outsides of letters to give them more personality and add visual impact to the overall design. To make outline graphics yet more interesting, you can vary the weight and color of the strokes and fill enclosed areas with a different shade.

Strokes

Drawing different kinds of strokes around the letters makes them stand out more.

Outline
Draw a simple outline around your letter and close to it.

Chiseled
Create a shallow chiseled appearance by drawing a stroke along one side of the letter, parallel to it.

Crafty
Draw a broken line around the letter to give it a "cut and paste" or "stitched" look.

Broadway
Brighten up the letter by adding a line of dots all around the outside.

Heavy/light
To add a sense of depth, play with strokes of different weights. This example shows the letter outlined twice. The outline closest to the E is slightly heavier than the one outside it.

Pow!
Get creative by drawing a unique shape around your letter—this one looks like a cartoon explosion.

Drop shadows

Give some dimension to the lettering by adding various kinds of drop shadows.

Shiny 3D

Draw a few additional shadow lines within the drop shadow, along the corners and curves, and your letter seems to glisten.

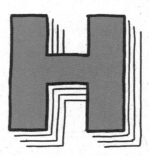

Good vibes

Draw multiple lines parallel to the side of the letter for a vibrating shadow.

Break drop

Draw a completely black drop shadow but leave a small amount of white space between it and the letter. The letter appears to float.

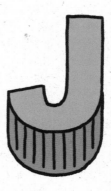

Tall order

Create a really deep drop shadow that lifts up the letter. Add lines to the drop shadow to further emphasize the effect.

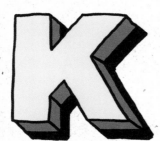

Deco

The more drop shadows, the better. This shadow is extra tall and has been filled with two different colors. The black shadowing serves to visually emphasize the teal.

Colorblocks

In real life, shadows aren't gray or black—they're colored. Fill your shadows in three different shades of one color, making what would naturally be darkest a darker shade, and keeping the lightest areas paler in tone.

Accents

Add some embellishments around your letters to help them stand out. These designs can be as basic as lines or some simple shapes. You can even use a different tint or shade of color to brighten up the design.

The center hump is a bit taller than the ones on either side.

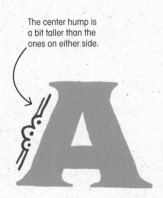

The teardrops radiate out to point in different directions.

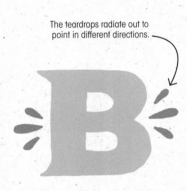

Alternate long and short lines to give a sparkly effect.

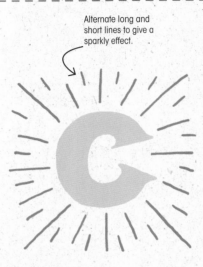

Doodle
Add an accent to just one side of all the letters in a word. This one consists of a few dot-filled humps with two lines coming off each side.

Splash
Draw a trio of teardrops on each side of the letter. In this example, the central drop is larger than the two flanking it.

Shiny
Add emphasis to a letter or to keywords by drawing lines that radiate out all around. These are called line bursts.

Draw them a different color so they stand out more.

Spirals and dotted lines give the appearance of movement.

Geometric
This variation on the teardrop-shaped accents uses triangles instead.

Easy breezy
Spirals combine with lines to almost effortlessly create more visual interest around the drawing.

Underscore
Add a bold underline to your letters to help them stand out.

Filigree

Think of filigree—with its swoops and curls, elegant swashes, and ornate spirals—as bling for your lettering design. Filigree adds beauty all around your letters. It's not about being subtle. With filigree, more is better!

Lightweight
Using just the line weight of your pen, add lots of swashes and curvy lines to decorate around the letter.

Leave some lines with no added weight.

Heavyweight
Add weight to the downward strokes of the curves of filigree. This mixture of thick and thin makes the lettering look more like calligraphy.

Mega splash
Draw teardrop accents between the gaps in the filigree.

Party time
Create a super loopy filigree decoration consisting of spirals with weight added just in the tails. Then add small dots everywhere to help balance the swirls.

The filigree can touch the letter.

Organic
Add vines, leaves, flowers, and thorns coming off the lettering.

Drawing filigree only below the letter makes it look anchored and stable.

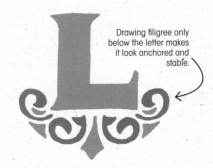

Art deco
Filigree can be more than just curlicues. Vary the line weight of the curls, then draw interesting shapes that fill the negative spaces between the lines.

Adding Dimension

Giving your lettering a dimensional appearance adds drama to the words and grabs the reader's attention. Try any of these methods for creating a three-dimensional effect. Your writing will seem to pop off the page or chalkboard!

Line shadow

This simple technique adds dimensionality with just a single line parallel to the edges of the letter.

1 The arrow at top left represents an imaginary light source pointing in the direction of the "rays" of light. (Your light source can come from any direction.)

2 Imagine that light is shining from the top left and casting a diagonal shadow. Draw a pale yellow line on the right side of the letters, as well as below them, keeping the same amount of space between the lettering and the shadow everywhere in the piece.

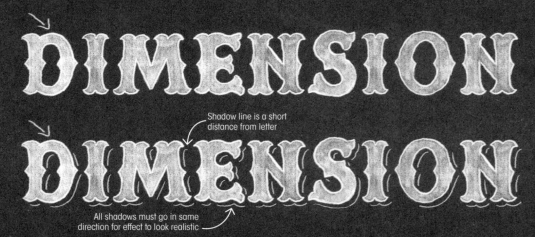

Shadow line is a short distance from letter

All shadows must go in same direction for effect to look realistic

Where to add shadow lines

You'll need to draw arrows as guidelines coming off various points on the letter. Draw them very lightly at exactly the same angle as the imaginary light source. (By the way, in all the examples on this page, the imaginary light source is shining from the top left, but you can place yours on any side of the lettering, pointing in any direction you like.) Eventually, instead of arrows, you can draw guide lines, and before long, you won't need any guides at all.

Side shadows

First, starting from the top, draw arrows (shown in red) coming off any elements of the letter that protrude from its right side—not its bottom. These indicate the top of each shadow line, but don't draw shadows yet. To determine where a given shadow line will end, follow the outline of the letter down from the protrusion. At the innermost point of the outline, draw an arrow (blue). Now draw shadow lines connecting the corresponding pairs of arrows.

Interior shadows

Draw an arrow crossing the inside top right of the letter (red). To find the point where that shadow line ends, follow the outline of the letter down from the arrow. At the innermost point of the outline, draw an arrow (blue). Connect the arrows with a shadow line. Because the example above contains spurs, there's a second shadow line inside the letter. Draw the guidelines for it much as described in "Side shadows," but inside the letter.

Shadows below

Draw an arrow off the leftmost part of the letter (blue). Draw another one off the rightmost side of that part (red). Then connect the arrows with a shadow line. Repeat as needed on any other parts of the letter that touch the baseline.

Shadows on curves

For curved letters, the side and the bottom are combined into one shadow line. Draw an arrow off the leftmost point at the bottom of the letter (blue), and another off the rightmost side (red). Connect them with a shadow line.

Tick shadow

Adding multiple closely spaced lines makes the letters look raised off the page.

1 The arrow at top left represents the light source. It points in the direction of the "rays" of light. Since it's casting a shadow diagonally, draw small tick marks on the right side of each letter and below it, coming off all the straight and rounded edges in the letters. Slant the tick marks in the same direction as the arrow.

Tick marks are short

2 Add more slanted tick marks between the ones you drew in step 1. Where lines curve in on the letter, create shorter and shorter tick marks to mimic how the shadow would be cast.

Tick marks vary in length

Drop shadow

This more complex technique makes each letter look like it was carved from a solid block.

1 Show the light source with an arrow and draw diagonal tick marks coming off all the straight and rounded edges of the letters. The tick marks are at the same angle as the arrow.

Tick marks are fairly long

Tick marks come off inside, too

2 Connect all the ends of the lines, mimicking the curvature of the original letters and keeping the weight of the drop shadow consistent.

Curvature follows shape of letter

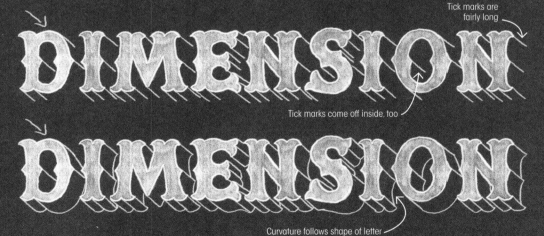

Vibrating shadow

This pulsating effect might seem intimidating to draw, but it's no more complex than creating a drop shadow.

Follow both steps for drop shadow (above). Then draw a line that bisects the shadow area.

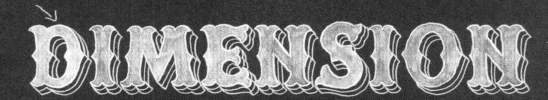

Lettering inside a Shape

One fun way to add large illustrations to your design is by creating a graphic that works thematically with the phrase, and arranging your lettering to fit inside it. This section takes you step by step through an example, and includes some helpful tips.

1 On a blank sheet of paper, draw a few thumbnails to explore different ways to place the words inside the shape.

2 Choose your favorite thumbnail concept. Draw its exterior shape as large as possible in the center of a new sheet of paper. Then draw a narrow margin inside the shape.

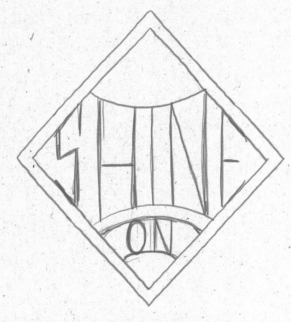

3 Inside the shape, draw the containers for the words. Then, inside those containers, draw the skeletons of the letters.

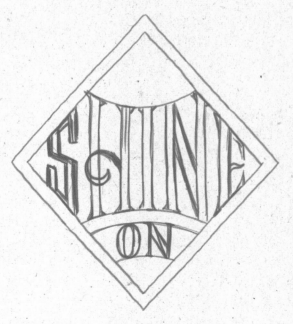

4 Add weight to the letters, making sure to leave space between them.

TIP

If the words are stacked on top of each other, leave some space between each one for legibility.

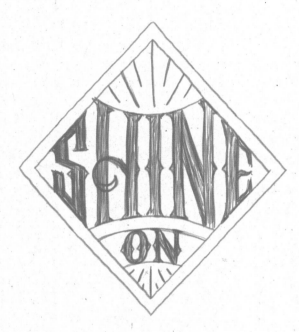

5 Embellish the letters as desired. Then draw filigree or accents inside the shape to fill up any negative space. Finally, fill in the letters to make sure their weight is even.

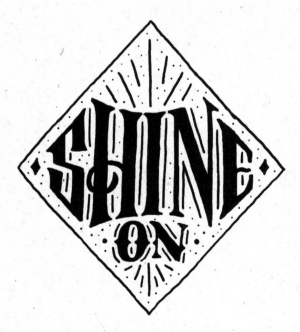

6 Draw over the outline of the pencil drawing (not including the margin) with a thin permanent marker. Then add outline graphics and small illustrations to fill up the space even more.

Hints for including illustrations

Adding illustrations to your work can be challenging at first. These tips will make the experience easier.

When your illustration has a complicated shape...

...draw only its outline so you have as much space as possible inside of which to place the letters.

Always sketch a margin inside the shape, and don't letter outside that margin. This ensures that your phrase remains legible, because the words won't "bump" into the shape.

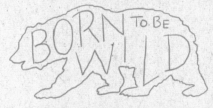

If you're having trouble fitting in your lettering, try stacking the phrase, using your normal handwriting, to see how you can extend the letters to fit the space.

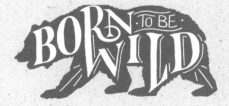

Fill the negative space with color to make the phrase pop off the page.

Adding Impact with Illustrations

Give your phrases more of a visual punch by including illustrations that relate directly to the words themselves—you can surround your words with illustrations, or even make these accents a part of the letters themselves. Brainstorm ideas that would work best with your given topic.

- -

Accents

These are some of the most common illustrative elements used to emphasize the message in lettering.

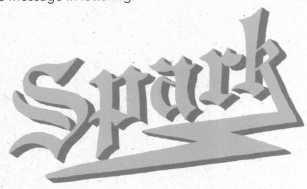

Underline the word with a lightning bolt. Even better—find a way to connect that bolt to the word itself. (For still more fun, draw zig-zag flashes around the word to give it extra spark.)

Surround your letters with stars, dots, diamonds that have concave sides, and twinkly bursts (these are kind of like asterisks, but with lines of differing lengths). They add a sense of wonderment to the work.

Arrows attract the eye and can direct it, too. You have many options: place them underneath words or alongside them, or draw a large outline of an arrow and write a word inside it. Try piercing a word with a thin stem that has feathers at the end.

Representational lettering

Rather than adding illustrations to your drawing, draw texture as part of the letters. That way, the letters themselves paint the picture. You'll find tutorials on achieving these styles elsewhere in this book.

After sketching your skeleton, draw stems and leaves on it. Have them weave in and out of each other, and accent them with flowers here and there. It's a look that's always in season!

Thematic doodles

Whatever the subject matter of your piece, you can include themed details to help tell a story.

What do you associate with the activity in your word or phrase? Going to the movies involves popcorn, soda, tickets, and 3D glasses. The lead actors have a starring role—note the star used as a tittle.

Maybe your word or phrase describes an activity that requires tools or equipment. Draw them around your words. Here, various art supplies—compasses, brushes, pencils—dance around the letters.

Perhaps you have a noun in your lettering that can itself be drawn. When you think of candy, lollipops, sweets, and bonbons in colorful plastic wrappers dance in your head.

Shape your letters so they look like they're made of planks, and add wood grain and nails to emphasize the effect.

Give your lettering a festive appearance by making it look like it was formed out of flowing ribbon.

More Lettering Styles

Now that you know the basics of hand lettering, it's time to play. This chapter contains 13 more lettering styles. They range from simpler scripts to highly ornate black letter, and even represent-ational lettering, where your letters look like they're formed from plants, ribbon, or wood. This is where the fun really starts!

SLAB SERIF

HEAVY • PLAIN

A slab serif is characterized by thick, blocky serifs. Because it's simple and bold, it helps lettering stand out. This varied-width style is commonly used in sports—for example on jerseys, so letters read clearly from a distance to help spectators keep track of players on the field.

ABCDEFGHI
JKLMNOPQR
STUVWXYZ
1234567890

Setting up guidelines

Draw cap height and baseline first. Add the x-height guideline roughly one-third of the way up from the baseline.

Crossbars are slightly narrower than the weight of the stroke used for the letters. Horizontal serifs are slightly narrower than crossbars. Vertical serifs are the same height as the weight of the letters.

cap height

x-height

baseline

F

Here's how...

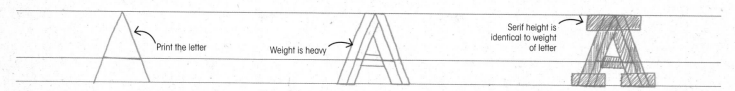

Serif height is identical to weight of letter

Print the letter

Weight is heavy

1 Draw a capital "A," placing its crossbar on x-height.

2 Add weight by drawing lines on each side of the existing lines. Close the apex and the base of both diagonal lines by drawing a short hoizontal line.

3 Draw horizontal serifs on both sides of the apex, and on both sides of the bottom of the diagonal lines. Lightly fill the letter, check the weight, and make any desired adjustments.

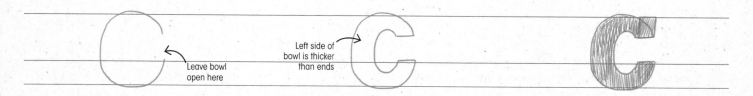

Leave bowl open here

Left side of bowl is thicker than ends

1 Draw an incomplete oval as the bowl of the "C."

2 Draw a line inside the shape, roughly following the original line. Then connect the lines at both ends by drawing horizontal lines.

3 Add a vertical rectangular serif to the top of the "C," then lightly fill in the entire letter. Check the weight and make any necessary adjustments.

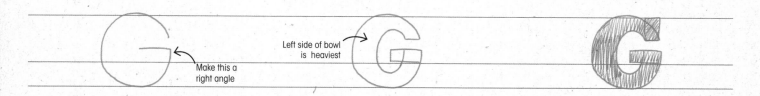

Make this a right angle

Left side of bowl is heaviest

1 Draw a blocky capital "G," placing the crossbar roughly one-third of the way up between the x-height and the cap height.

2 To add weight, draw a line inside the shape, roughly following the original line. Draw the bottom of the crossbar on the x-height. Then connect the lines at both ends with short lines.

3 Add a vertical rectangular serif to the top of the letter, then fill it all in lightly. Check the weight carefully and make any desired adjustments.

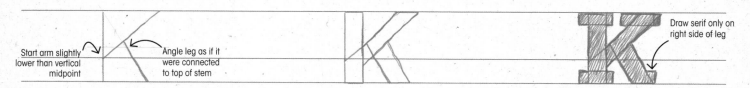

Start arm slightly lower than vertical midpoint

Angle leg as if it were connected to top of stem

Draw serif only on right side of leg

1 Create the skeleton of a capital "K" by drawing the stem first, then the arm (starting from the stem), and finally the leg.

2 Add weight to the stem by drawing a parallel line to the right of it. Draw a parallel line below the arm. Draw a parallel line to the right of the leg. Finally, draw horizontal lines to close up the ends of the stem, arm, and leg.

3 Add horizontal rectangular serifs to the ends of the stem, arm, and leg. Lightly fill the letter, check the weight, and make any necessary adjustments.

CONTINUED

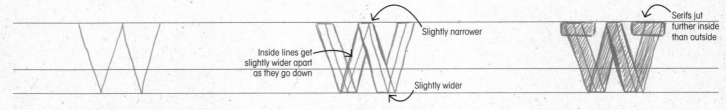

Slightly narrower

Inside lines get slightly wider apart as they go down

Slightly wider

Serifs jut further inside than outside

1 Draw the skeleton of a letter "W." The tops of all the lines should touch the cap height, and the bottoms rest on the baseline guides.

2 Add weight by drawing lines on each side of the original ones.

3 Add horizontal rectangular serifs to the tops of the left and right stems. Fill in the letter lightly. Carefully check the weight of the letter and make any necessary adjustments.

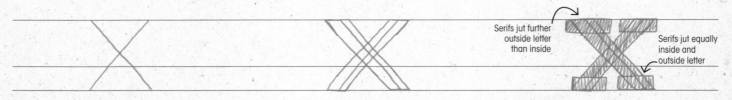

Serifs jut further outside letter than inside

Serifs jut equally inside and outside letter

1 Draw a wide letter "X." The stems cross roughly one-third of the way up between x-height and cap height.

2 Add weight by drawing lines on each side of the original lines.

3 Add horizontal rectangular serifs to the tops and bottoms of the stems. Fill in the letter lightly, check the weight, and make any adjustments.

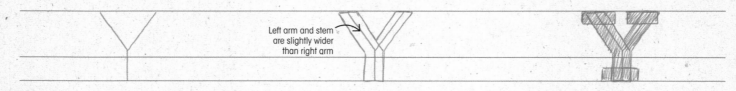

Left arm and stem are slightly wider than right arm

1 Draw the skeleton of a "Y." The crotch is roughly one-third of the way up between the x-height and the cap height.

2 Add weight to the letter by drawing lines on each side of the skeleton and parallel to it.

3 Add horizontal rectangle serifs to the ends of the arms and stem. Fill in the letter lightly. Check the weight and make adjustments if necessary.

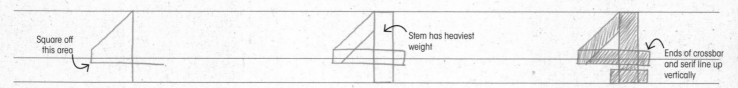

Square off this area

Stem has heaviest weight

Ends of crossbar and serif line up vertically

1 Draw a number "4," but instead of giving it a pointed beak, square it off. The crossbar is just below x-height.

2 Add weight to the number by drawing lines parallel to the existing lines. The weight is blocky.

3 Add a horizontal rectangle serif to the bottom of the stem. Lightly fill in the letter, check the weight, and make adjustments if necessary.

Here's how...

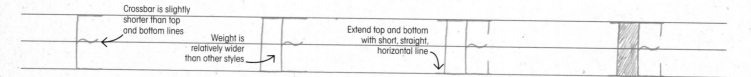

Crossbar is slightly shorter than top and bottom lines

Weight is relatively wider than other styles

Extend top and bottom with short, straight, horizontal line

1 Draw a straight, vertical stem going from cap height to baseline. Draw two crossbars at the top and bottom of the stem. Finally, draw the center crossbar as a short wave on the x-height.

2 Add weight by drawing a vertical line to the left of the stem. Connect the vertical lines with horizontal lines at both top and bottom.

3 Now you'll add serifs. At the top left and bottom left of the stem, extend the existing horizontal line. Then draw two vertical serifs off the right side of the top and bottom crossbars.

4 Color in the stem lightly with a pencil to make sure the weight is even.

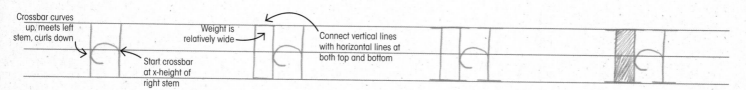

Crossbar curves up, meets left stem, curls down

Start crossbar at x-height of right stem

Weight is relatively wide

Connect vertical lines with horizontal lines at both top and bottom

1 Draw two stems that reach from the cap height to the baseline, at a medium distance apart. Then draw a curved line for the crossbar.

2 Add weight by drawing a line to the left of the stem that's on the left.

3 To make the serifs, draw long, straight, horizontal lines along the tops and bottoms of all the stems.

4 Color in the stem lightly with pencil and double-check carefully that its weight looks right.

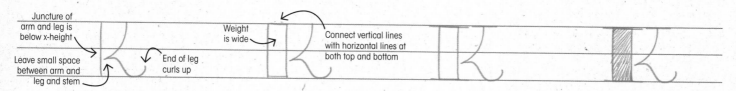

Juncture of arm and leg is below x-height

Leave small space between arm and leg and stem

End of leg curls up

Weight is wide

Connect vertical lines with horizontal lines at both top and bottom

1 Draw a straight stem. Draw the arm, starting near the stem and curving up to cap height. Draw the leg going down into a wave toward the bottom right.

2 Add weight by drawing a line to the left of the stem.

3 To make the serifs, draw long, straight, horizontal lines at the top and bottom of the stem and the top of the arm.

4 Color in the stem of the "K" lightly to make sure that the weight looks even.

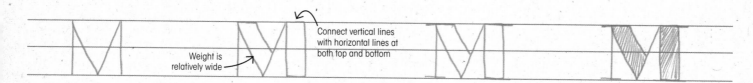

Weight is relatively wide

Connect vertical lines with horizontal lines at both top and bottom

1 Draw a letter "M." The diagonals meet at a point on the baseline.

2 To add weight, draw a line above the left diagonal and parallel to it. Also draw a line to the right of the stem on the right.

3 To create the serifs, draw long, straight, horizontal lines at the top and bottom of all the stems, extending any existing lines.

4 Color in the letter lightly with pencil, to check that its weight looks correct.

CONTINUED ➡

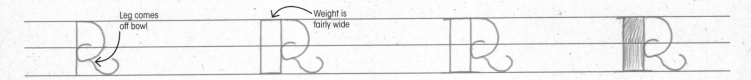

Leg comes off bowl

Weight is fairly wide

1 Draw a stem. Draw a bowl. When it reaches the stem, halfway between x-height and baseline, it curls back in. Draw a leg.

2 To add weight, draw a line to the left of the stem. Connect the tops and bottoms of the stems with horizontal lines.

3 To create the serifs, draw long, straight, horizontal lines at the top and bottom of the stem, extending the existing lines.

4 Fill the stem lightly with pencil to make sure that the weight looks correct.

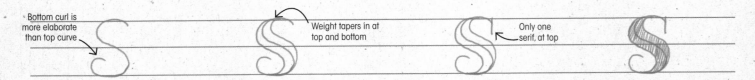

Bottom curl is more elaborate than top curve

Weight tapers in at top and bottom

Only one serif, at top

1 For the skeleton, draw an "S" in one long curve that goes slightly above and below the baseline, with the bottom curve curling in.

2 Add weight by drawing lines on either side of the skeleton, between the cap height and baseline.

3 For the serif, draw a long, straight, vertical line at the end of the top of the line.

4 Color in the spine lightly with a pencil to make sure that the weight looks correct.

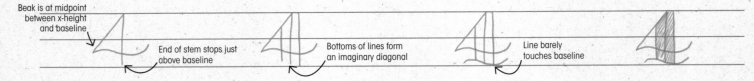

Beak is at midpoint between x-height and baseline

End of stem stops just above baseline

Bottoms of lines form an imaginary diagonal

Line barely touches baseline

1 Draw a straight stem. From its top, draw a diagonal line going down to the left. Then draw the crossbar as a long wave ending near x-height.

2 Add weight by drawing lines on either side of the stem. At the top, draw a short straight line along the cap height to enclose the top.

3 Draw a wave parallel to the crossbar.

4 Lightly color in the stem of the number to make sure its weight looks correct.

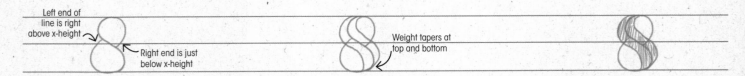

Left end of line is right above x-height

Right end is just below x-height

Weight tapers at top and bottom

1 Create the skeleton of the number "8" by drawing an "S" that curls into itself. Instead of having the lines meet in the middle, stagger them on either side of the spine.

2 Add weight by drawing lines on either side of the spine, between the cap height and the baseline.

3 Lightly fill the spine with pencil to ascertain that the weight looks even.

Take it to the next level...

PARTY ALL NIGHT
SLEEP ALL DAY

When a phrase contains the same word multiple times, style it the same way at each occurrence to help the phrase look unified.

This ligature visually connects the first letter of the phrase to the last.

Music IS MY DRUG

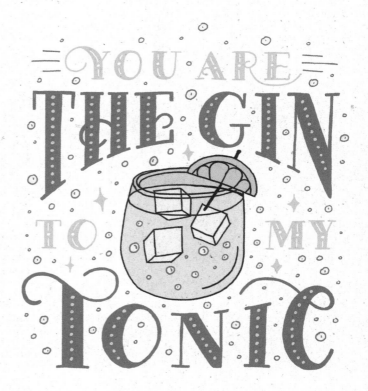

YOU ARE THE GIN TO MY TONIC

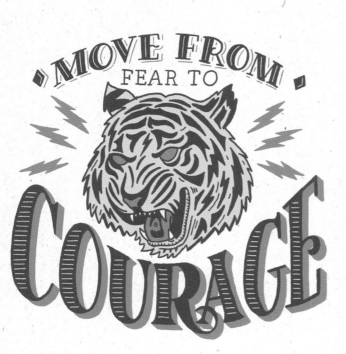

MOVE FROM FEAR TO COURAGE

Here's an idea!

Use this style to draw an eight-letter word (or two four-letter words), then letter them across your knuckles with a non-toxic gel pen.

WESTERN

VINTAGE • ADVENTUROUS

Western lettering is perfect when you need a bold, chunky style with a retro feel. This decorative serif style helps highlight keywords in a phrase and looks great in headings.

ABCDEFGHI
JKLMNOPQR
STUVWXYZ
1234567890

Setting up guidelines

Place the x-height guideline halfway between the cap height and the baseline. Spurs are placed along the x-height in most instances.

cap height

x-height

baseline

Here's how...

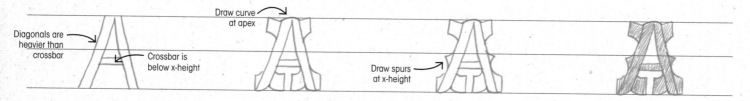

Diagonals are heavier than crossbar

Draw curve at apex

Crossbar is below x-height

Draw spurs at x-height

1 Draw an "A" between the cap height and the baseline. Add weight to it by drawing lines on the exterior of the diagonals, and a line below the crossbar.

2 Add decorative serifs to the bottoms of the diagonals and on both sides of the apex.

3 Draw spurs on each side of the "A."

4 Fill in the "A" lightly with pencil to make sure the weight looks even.

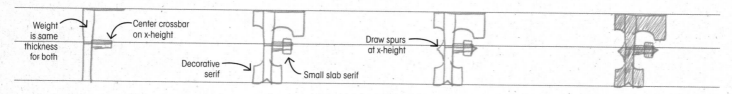

Weight is same thickness for both

Center crossbar on x-height

Decorative serif

Small slab serif

Draw spurs at x-height

1 Draw an "F." To add weight, draw a line to the right of the stem and a line above and below the crossbar on the x-height.

2 Add serifs. The upper crossbar is quite heavy, with a serif on the right side and a small serif on the left side of the stem.

3 Draw two spurs, one on the left side of the stem and the other off the small slab serif on the crossbar.

4 Fill the letter lightly with pencil to make sure the weight looks correct.

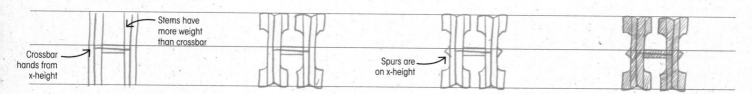

Stems have more weight than crossbar

Crossbar hands from x-height

Spurs are on x-height

1 Draw an "H." Add weight by drawing a line on both sides of each stem and of the crossbar.

2 Draw decorative serifs at the top and bottom of both stems.

3 Draw spurs on the outside of both stems.

4 Lightly fill in the "H" with pencil to check that the weight is even.

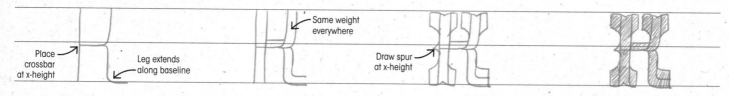

Same weight everywhere

Place crossbar at x-height

Leg extends along baseline

Draw spur at x-height

1 For the "K," draw a stem from the cap height to the baseline. Then draw a crossbar. Finally, draw both an arm and a leg that curve outward from the crossbar.

2 Add weight by drawing a line to the right of the stem, as well as lines inside the arm and the leg.

3 Draw decorative serifs on both ends of the stem and on the end of the arm. Add thickness to the end of the leg. Draw a spur on the left side of the stem.

4 Fill the drawing lightly with pencil and check to make sure the weight of the letter is even.

CONTINUED →

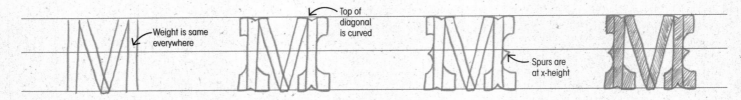

1 Draw an "M." Add weight by drawing a line on the outside of each stem and above both diagonals.

2 Draw decorative serifs at the top and bottom of both stems.

3 Draw spurs on the outside of both stems.

4 Fill in the "M" with pencil to check that the weight looks right.

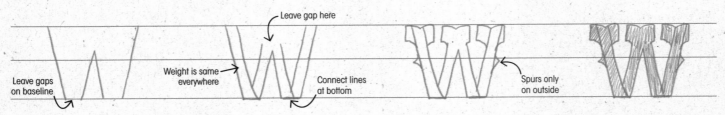

1 Create the skeleton of the "W" by drawing lines as shown above.

2 Add weight by drawing lines inside the outer diagonals, and outside the inner diagonals.

3 Draw decorative serifs at the tops of all the diagonals. Add spurs to the outer diagonals.

4 Fill the letter lightly in pencil to make sure its weight is correct.

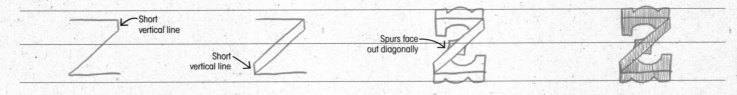

1 Draw a modified "Z." The top crossbar is below cap height, the bottom one is above the baseline, and the diagonal has a short vertical line at the top right end.

2 Add weight by drawing a line above the diagonal. Draw a short vertical line at bottom left.

3 Around both crossbars, draw decorative serifs connected by curved lines. Draw spurs on both sides of the diagonal, at x-height.

4 Lightly fill in the "Z" with pencil to check that the weight is even.

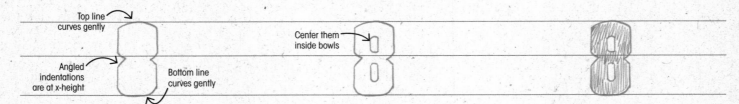

1 Create the skeleton of an "8" by drawing the shape shown above.

2 Draw two vertical rectangles that each have a curved line at the top and bottom.

3 Fill in the "8" lightly to make certain the weight looks even.

Take it to the next level...

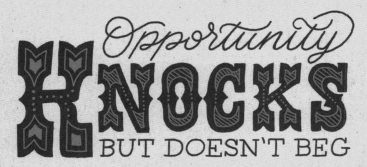

Sticking to only three lettering styles helps this phrase look unified.

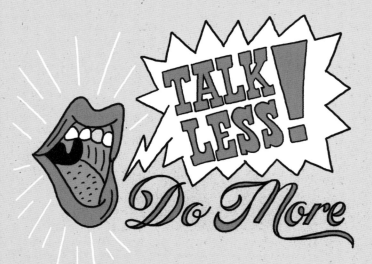

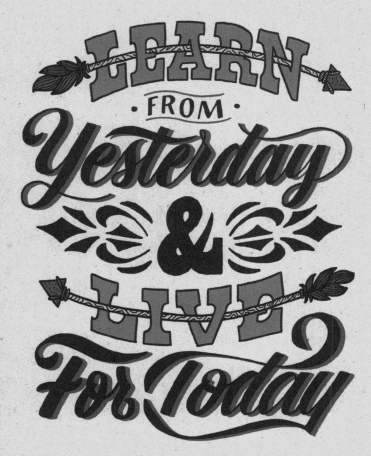

The curved arrows keep bringing the reader's eye back into the phrase.

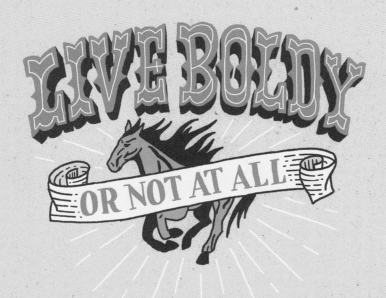

Here's an idea!

Use this style to create a certificate that says "Worlds Greatest Friend." Add your best friend's name and give it as a gift.

CIRCUS

SHOWY • PLAYFUL

Although this ornate style can be challenging for beginners, the effort is worth it because it adds so much visual interest to any hand-lettered composition. Many people describe circus lettering as one of their favorite styles to draw.

ABCDEFGHI
JKLMNOPQR
STUVWXYZ
1234567890

Setting up guidelines

Center the x-height between the cap height and the baseline. To create uniform spurs, add two additional guidelines, one placed slightly above the cap height and the other drawn slightly below the baseline.

serif guideline

cap height

x-height

A

baseline

serif guideline

Here's how...

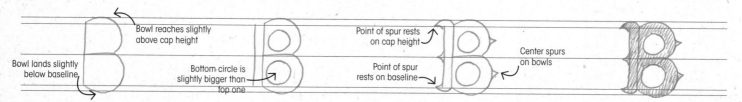

Bowl reaches slightly above cap height

Bowl lands slightly below baseline

Bottom circle is slightly bigger than top one

Point of spur rests on cap height

Point of spur rests on baseline

Center spurs on bowls

1 Draw the skeleton of the "B" with the two bowls meeting at the x-height. The line between the bowls is horizontal, not curved.

2 Add weight to the stem by drawing a parallel line to the left of it. Then draw a circle inside each bowl.

3 Add spurs to the top and bottom of the stem. Then draw one halfway up the left side of the stem, and one on the right side of each bowl.

4 Fill the letter in lightly with pencil to verify that the weight is consistent.

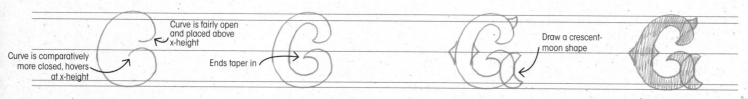

Curve is fairly open and placed above x-height

Curve is comparatively more closed, hovers at x-height

Ends taper in

Draw a crescent-moon shape

1 Draw a curved line with the ends curling in toward the center.

2 Give the letter weight by adding a line roughly parallel to the first, drawing it on the inside of the shape.

3 Draw spurs near both curled ends. Then draw spurs halfway up the left side of the bowl, both on the inside and on the outside.

4 Fill in the "G" lightly with pencil to make sure its weight is consistent.

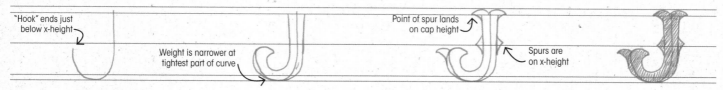

"Hook" ends just below x-height

Weight is narrower at tightest part of curve

Point of spur lands on cap height

Spurs are on x-height

1 Draw the skeleton of a "J."

2 Add weight to the stem by drawing a line on each side of it. Draw the hook with a tapering curl.

3 Add two spurs to the top and two spurs halfway up the stem. Then add a spur pointing to the left on the end of the hook.

4 Fill the letter in lightly with pencil to ascertain that the weight is consistent.

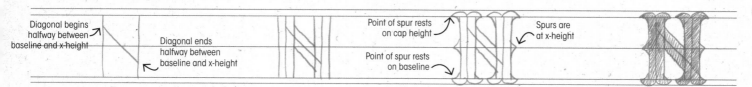

Diagonal begins halfway between baseline and x-height

Diagonal ends halfway between baseline and x-height

Point of spur rests on cap height

Point of spur rests on baseline

Spurs are at x-height

1 Draw the skeleton of a capital "N."

2 Add weight by drawing a line on either side of the existing lines in the skeleton.

3 Draw double spurs on both ends of the stems. Add spurs on the outsides of both stems.

4 Fill the letter in lightly with pencil to make sure the weight is consistent.

CONTINUED →

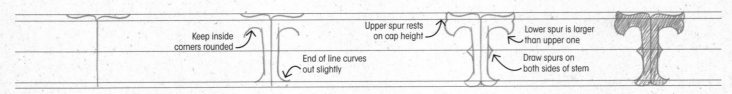

Keep inside corners rounded

End of line curves out slightly

Upper spur rests on cap height

Lower spur is larger than upper one

Draw spurs on both sides of stem

1 Draw a straight, vertical stem, then two wavy lines extending off either side of the top of it to serve as the crossbar of the "T."

2 Add weight to the stem by drawing a line on either side of it. Then extend both upper ends of those lines outward by adding curves to them.

3 Draw double spurs on the bottom of the stem and double spurs at both ends of the crossbar. Then draw spurs halfway up the stem.

4 Fill the letter lightly with pencil to make sure the weight is consistent.

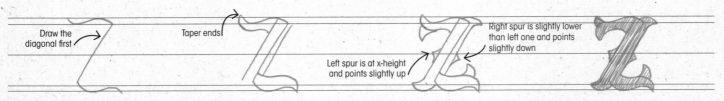

Draw the diagonal first

Taper ends

Left spur is at x-height and points slightly up

Right spur is slightly lower than left one and points slightly down

1 Draw a diagonal line that goes from the cap height to the baseline. Then add two wavy lines starting from the ends of the diagonal and going in opposite directions.

2 Add weight by drawing lines on each side of the diagonal line. Draw a line below the top wave and a line above the bottom one.

3 Draw spurs at the ends of the diagonal. Then draw spurs halfway up it, staggering them since the line is diagonal. Finally, draw spurs at the ends of the wavy lines.

4 Fill in the letter lightly with pencil to make sure the weight is consistent.

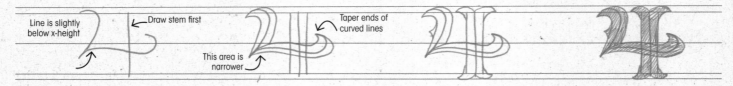

Line is slightly below x-height

Draw stem first

Taper ends of curved lines

This area is narrower

1 Draw the skeleton of the "4" by drawing a straight, vertical line for the stem, then two curved lines that meet in a point.

2 Add weight to the "4" by drawing lines on each side of the skeleton.

3 Add double spurs to both ends of the stem, and one halfway up the leftmost curved line.

4 Fill the letter in lightly with pencil to make sure the weight is consistent.

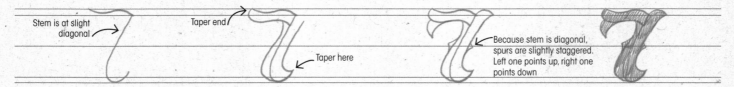

Stem is at slight diagonal

Taper end

Taper here

Because stem is diagonal, spurs are slightly staggered. Left one points up, right one points down

1 Draw the skeleton of a "7" by drawing a horizontal wavy line at cap height and a stem shaped like an upside-down cane.

2 Add weight to the number by drawing a line below the horizontal one, and lines on both sides of the stem.

3 Draw a spur facing down at the left end of the horizontal wave. Add another spur at the top of the stem. Draw spurs on each side of the stem.

4 Fill the letter in lightly with pencil to make certain the weight is consistent.

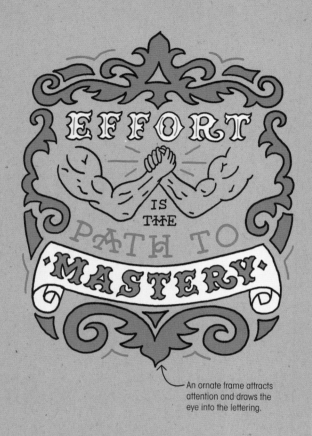

An ornate frame attracts attention and draws the eye into the lettering.

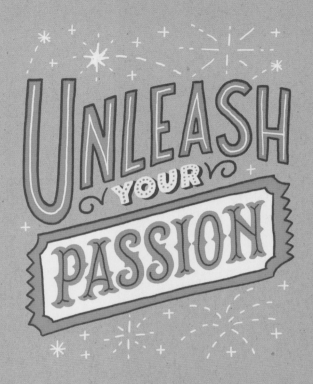

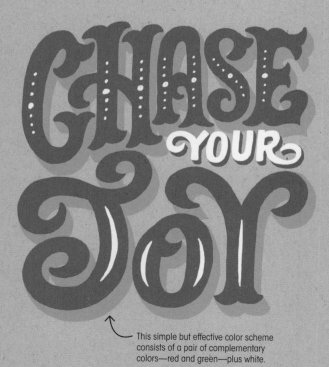

This simple but effective color scheme consists of a pair of complementary colors—red and green—plus white.

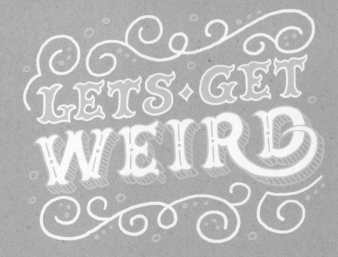

Here's an idea!

Draw the name of your favorite cartoon. Include inline graphics and outline graphics to emphasize a sense of fun.

VICTORIAN

LAVISH • GLAMOUROUS

For an elaborate but delicate look, Victorian is the lettering style of choice. This almost lacy condensed serif typeface has a few tricks up its sleeve, with curls, swirls, spurs, rounded terminals, and a few unexpected hooks. It all adds up to a style that looks historical without seeming dated.

ABCDEFGHI
JKLMNOPQR
STUVWXYZ
1234567890

Setting up guidelines

Place the cap height and baseline lines fairly far apart, as this is a tall style. Center the x-height line exactly between them. Most spurs are on the x-height.

cap height

x-height

baseline

Here's how...

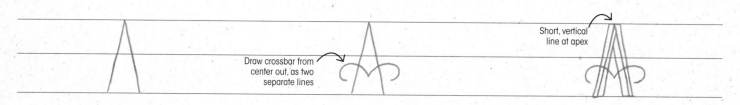

Draw crossbar from center out, as two separate lines

Short, vertical line at apex

1 Draw two diagonal lines that come up from the baseline and meet at a point at the cap height.

2 Draw a decorative crossbar consisting of two curves that are mirror images of each other. Place it on an imaginary line halfway between x-height and the baseline.

3 Draw lines on both sides of the diagonals to add weight. Draw a short, vertical line across the apex of the letter, at the cap height.

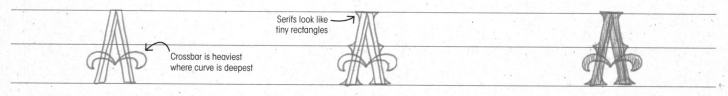

Serifs look like tiny rectangles

Crossbar is heaviest where curve is deepest

4 Add weight to the crossbar by drawing curved lines beneath the existing lines.

5 Draw flat serifs along the top and on the bottom of each stem. Then draw spurs on the exterior of both diagonals, at the x-height.

6 Fill the letter lightly with pencil to check that its weight looks correct.

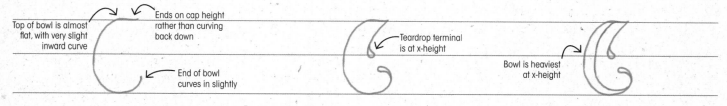

Top of bowl is almost flat, with very slight inward curve

Ends on cap height rather than curving back down

End of bowl curves in slightly

Teardrop terminal is at x-height

Bowl is heaviest at x-height

1 Draw a "C" with a bowl that spans from cap height to baseline.

2 Draw a diagonal line coming off the top end of the bowl; end it just above x-height, and at that point add a teardrop terminal that flares out. Then draw a similar teardrop terminal on the other end of the bowl, but pointing in.

3 Add weight by drawing a curved line on the inside of the bowl, blending the line into the teardrop terminal at the end of the bowl.

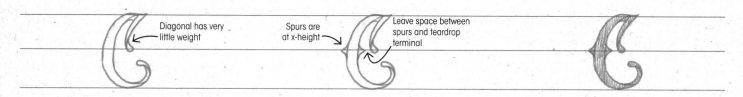

Diagonal has very little weight

Spurs are at x-height

Leave space between spurs and teardrop terminal

4 Draw a line inside the diagonal and roughly parallel to it. Also add weight to the flat top of the bowl by drawing a very short line below it.

5 Draw a spur shaped like a tiny triangle facing out on each side of the bowl.

6 Fill in the letter lightly with a pencil to make sure the weight looks right.

CONTINUED →

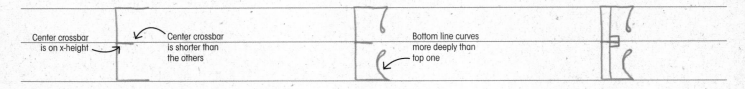

Center crossbar
is on x-height

Center crossbar
is shorter than
the others

Bottom line curves
more deeply than
top one

1 Draw a stem from cap height to baseline. Then draw three crossbars.

2 Draw a curved line coming down off the end of the top crossbar, ending it with a teardrop terminal. Then draw another curved line, bringing it up off the end of the bottom crossbar, and also ending it with a teardrop terminal.

3 To add weight, draw a line to the right of the stem. Add weight to the center crossbar by drawing lines on both sides of it. Connect the three lines at the end of the center crossbar with a short vertical line.

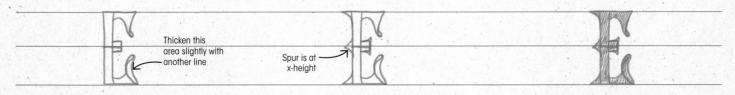

Thicken this
area slightly with
another line

Spur is at
x-height

4 Draw lines that connect the inner corners where the top and bottom crossbars and stem meet to their corresponding teardrop terminals. Also draw a line from the bottom teardrop to the bottom left corner.

5 Draw serifs and a single spur on the left side of the stem. Draw miniscule serifs at the top and the bottom of the center crossbar.

6 Lightly fill the "E" to make certain its weight looks correct.

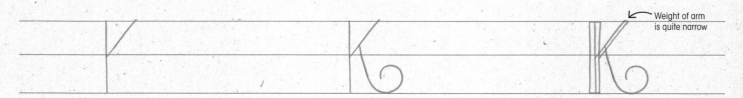

Weight of arm
is quite narrow

1 Draw a stem between the cap height and the baseline. To create the arm, draw a diagonal line from the x-height up to the cap line.

2 For the leg, draw a curve that starts on the arm, a short distance to the right from where it starts at x-height. The line extends to the baseline, then curls back up.

3 To add weight, draw lines on each side of the stem. Connect the lines at the top and bottom of the stem with a short horizontal line. Then draw a line below the arm and parallel to it.

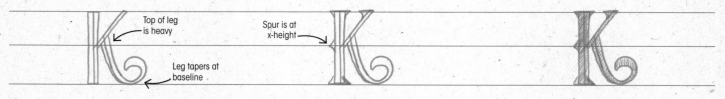

Top of leg
is heavy

Leg tapers at
baseline

Spur is at
x-height

4 Draw curved lines to add weight to the leg.

5 Draw serifs off both sides of both ends of the stem, and one on the left side of the arm. Then draw a spur on the left side of the stem.

6 Fill in the letter lightly to make certain the weight looks right.

This line reaches almost to x-height

1 Draw a stem going from the cap height to the baseline, then draw a horizontal line along the baseline.

2 Add a curved line off the end of the horizontal line.

3 Add weight by drawing a line to the left of the stem. Connect the top of the stems with a short horizontal line. Also connect the bottoms of the stems with a short horizontal line.

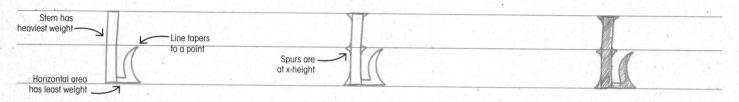

Stem has heaviest weight

Line tapers to a point

Horizontal area has least weight

Spurs are at x-height

4 Add weight to the curved line coming off the end of the horizontal line, and in the same stroke add weight to the horizontal line itself.

5 Draw serifs off both sides of the top of the stem, and one on the left side of the bottom of the stem. Then draw a spur on each side of the stem.

6 Lightly fill the letter with a pencil and check carefully to make sure the weight looks correct everywhere.

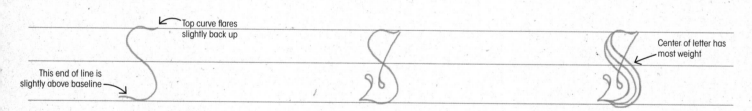

Top curve flares slightly back up

Center of letter has most weight

This end of line is slightly above baseline

1 Draw a stylized "S" that spans from cap height to baseline. The top and bottom curves are slightly flattened.

2 Draw a diagonal that starts at the top right, crosses the spine, and curves slightly right, ending in a teardrop terminal. Then draw a curved tail coming up off the other end of the "S" and ending in a teardrop terminal.

3 Add weight by drawing lines on both sides of the spine.

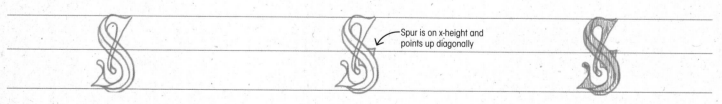

Spur is on x-height and points up diagonally

4 Add weight to the diagonal and the tail, making sure to blend these lines with the ones on the outsides of the spine.

5 Draw spurs on both sides of the spine. The spur on the left is placed to the right of the diagonal, and it points diagonally down.

6 Pencil in your letter lightly to make sure the weight looks correct.

CONTINUED ⟶

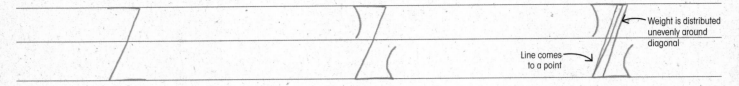

1 Draw a diagonal line going from cap height to baseline. Then draw a crossbar at cap height and another one on the baseline.

2 Draw short, slightly curved lines coming off each of the crossbars.

3 Add weight to the diagonal.

Line comes to a point

Weight is distributed unevenly around diagonal

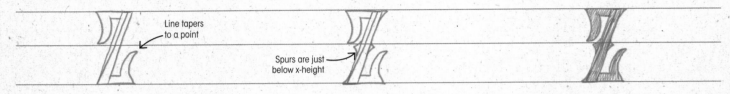

Line tapers to a point

Spurs are just below x-height

4 Add weight to the curved lines coming off the crossbars. In the same stroke, connect these areas to the diagonal using short horizontal lines.

5 Draw serifs at the top right and bottom left of the diagonal, and spurs on both sides of it.

6 Lightly fill in the letter with pencil to check that its weight looks correct.

Drop Caps

A drop cap is a large, decorative letter placed at the beginning of a block of text in a normal, non-ornate style. It's usually highly intricate, colorful, and filled to the brim with inline and outline decorations. The goal is to make drop caps as bold and beautiful as possible.

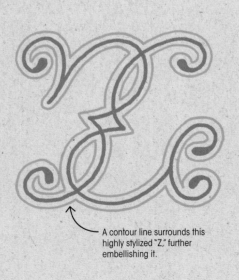

A contour line surrounds this highly stylized "Z," further embellishing it.

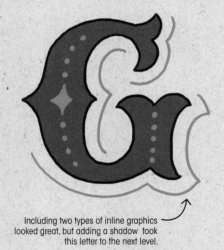

Including two types of inline graphics looked great, but adding a shadow took this letter to the next level.

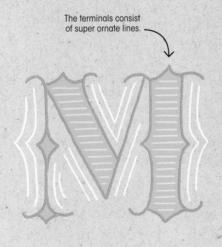

The terminals consist of super ornate lines.

Take it to the next level...

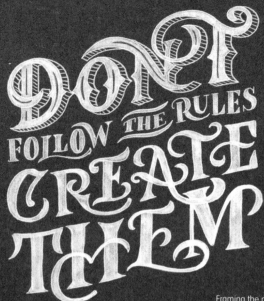

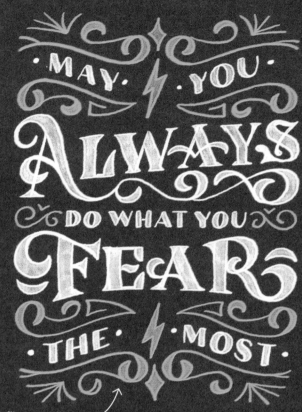

Framing the phrase inside an illustration adds extra layers of meaning.

The filigree around the words acts as a sort of banner.

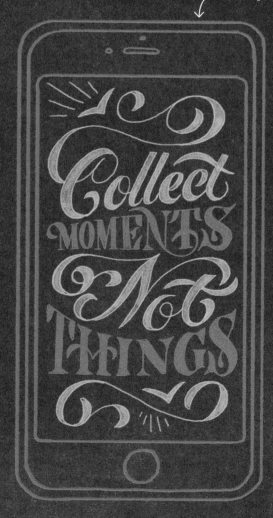

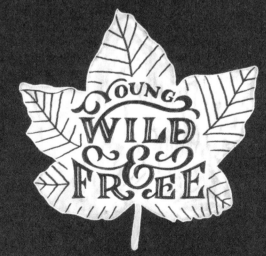

Here's an idea!

Use this style to create a certificate that says "World's Greatest Friend." Add your best friend's name and give it as a gift.

Monoweight Script

DELICATE ● UPBEAT

Monoweight means an alphabet has the same weight throughout. This particular style is formed only of single lines, with no weight, so it's quick to draw. With its swirls and curls, it feels youthful and lighthearted. It will give you a good foundation in crafting scripts.

A B C D E F G H I
J K L M N O P Q R
S T U V W X Y Z
1 2 3 4 5 6 7 8 9 0

a b c d e f g h i
j k l m n o p q r
s t u v w x y z

Since this style is best suited to combining uppercase and lowercase letters, both are shown here.

Setting up guidelines

The distance between cap height and x-height—as well as between baseline and descender line—is roughly one-third the distance between cap height and baseline.

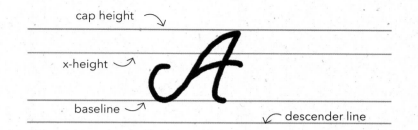

cap height

x-height

baseline

descender line

Here's how...

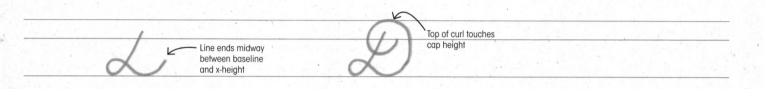

Line ends midway between baseline and x-height

Top of curl touches cap height

1 Starting right above the x-height, draw a diagonal line going down to the left. When it reaches the baseline, it curls to the left, crosses over itself, and continues along the baseline.

2 Starting at the x-height, draw a curl around the top of the diagonal line, then continue it down to meet smoothly with the end of the first line.

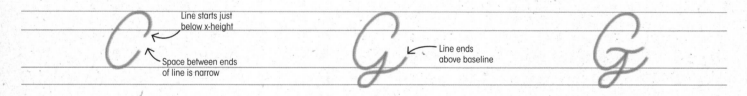

Line starts just below x-height

Space between ends of line is narrow

Line ends above baseline

1 Draw a condensed "C" between the cap height and the baseline.

2 Add a descender that goes from the end of the first line down to the descender line and then curls back over itself.

3 Draw a wavy crossbar.

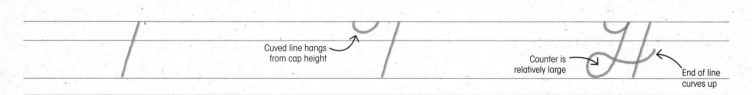

Cuved line hangs from cap height

Counter is relatively large

End of line curves up

1 Draw a diagonal line between cap height and baseline.

2 To the left of the diagonal, and at a distance equivalent to the distance between cap height and x-height, draw a tightly curved line.

3 From the right end of the tightly curved line, draw a diagonal line going down to the left. When it reaches the baseline, it curls to the left, crosses over itself, and continues to cross over the original diagonal.

CONTINUED

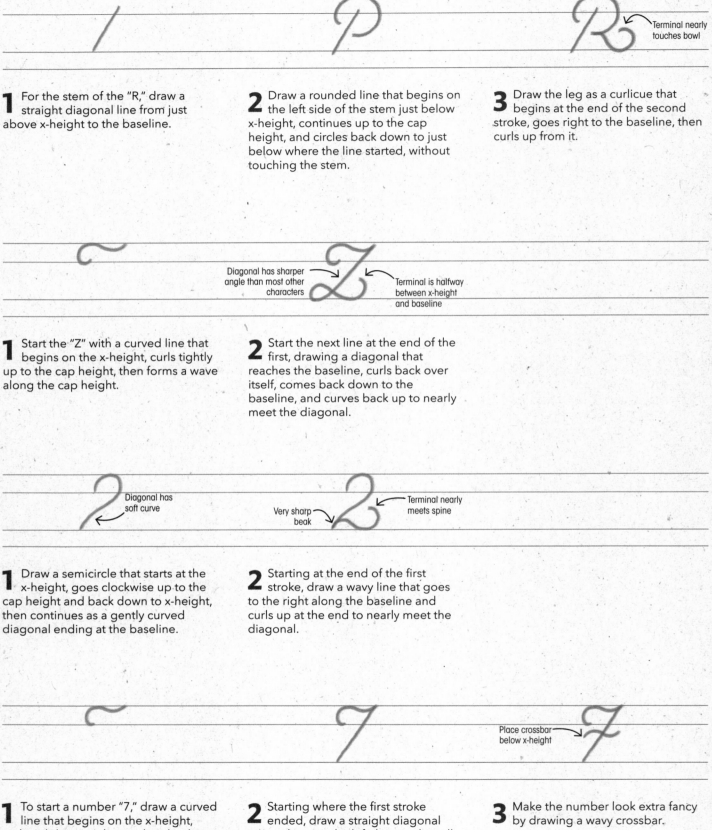

Terminal nearly
touches bowl

1 For the stem of the "R," draw a straight diagonal line from just above x-height to the baseline.

2 Draw a rounded line that begins on the left side of the stem just below x-height, continues up to the cap height, and circles back down to just below where the line started, without touching the stem.

3 Draw the leg as a curlicue that begins at the end of the second stroke, goes right to the baseline, then curls up from it.

Diagonal has sharper angle than most other characters

Terminal is halfway between x-height and baseline

1 Start the "Z" with a curved line that begins on the x-height, curls tightly up to the cap height, then forms a wave along the cap height.

2 Start the next line at the end of the first, drawing a diagonal that reaches the baseline, curls back over itself, comes back down to the baseline, and curves back up to nearly meet the diagonal.

Diagonal has soft curve

Very sharp beak

Terminal nearly meets spine

1 Draw a semicircle that starts at the x-height, goes clockwise up to the cap height and back down to x-height, then continues as a gently curved diagonal ending at the baseline.

2 Starting at the end of the first stroke, draw a wavy line that goes to the right along the baseline and curls up at the end to nearly meet the diagonal.

Place crossbar below x-height

1 To start a number "7," draw a curved line that begins on the x-height, curls tightly up to the cap height, then forms a wave along the cap height.

2 Starting where the first stroke ended, draw a straight diagonal going down to the left that reaches all the way to the baseline.

3 Make the number look extra fancy by drawing a wavy crossbar.

Take it to the next level...

Add drips to letters—just to be playful!

Forever IS A LONG TIME **But** I WOULD SPEND IT WITH YOU

DON'T WORRY *Everything* IS GOING TO BE *Amazing*

This ligature scrolls three times to eventually end as a tittle.
Script styles are especially well-suited to adding ligatures.

I *Love* THE *Smell* OF POSSIBILITY IN THE *Morning*

Here's an idea!

Choose a phrase that motivates you to reach your goals. Draw it in monoweight script, using both capital and lowercase letters on a tilted axis.

varied weight script

REFINED • COMPACT

This italic script is one of the most common styles in hand lettering because it adds an element of elegance and sophistication to any phrase. Once you master it, you'll be able to successfully try your hand at almost any form of script.

a b c d e f g h i

j k l m n o p q r

s t u v w x y z

1 2 3 4 5 6 7 8 9 0

Setting up guidelines

The distance between baseline and descender line is half the distance between x-height and baseline. The distance between the x-height and cap height is just a bit taller than the distance between baseline and descender line.

Because this script style has a tilted axis, you should pencil a diagonal line on the guidelines before you draw each letter to help them all lean at the same angle.

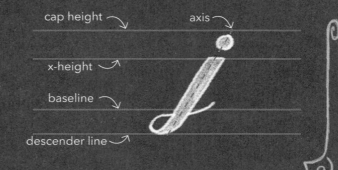

cap height ⟶ axis ⟶

x-height ⟶

baseline ⟶

descender line ⟶

Here's how...

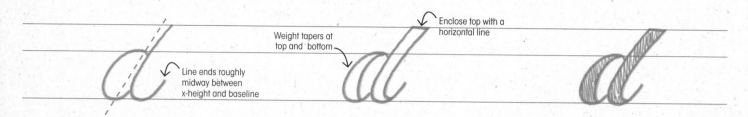

Enclose top with a horizontal line

Weight tapers at top and bottom

Line ends roughly midway between x-height and baseline

1 Draw a narrow "c" between x-height and baseline. To the right of it and touching it, draw a diagonal stem that starts at cap height, goes down and left to reach the baseline, then curls back up to the right.

2 Add weight to both strokes. For the "c," draw this line inside the counter. For the diagonal, draw the line to the right of the stem.

3 Lightly color in the letter with pencil and check that the weight looks right.

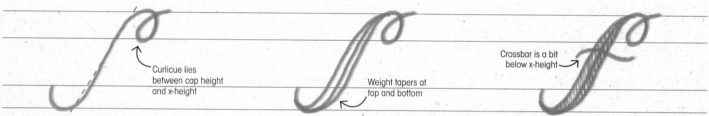

Crossbar is a bit below x-height

Curlicue lies between cap height and x-height

Weight tapers at top and bottom

1 Starting at cap height, draw a diagonal line that goes down and left to the descender line, then curls back up to the left and ends at the baseline. Then draw a curlicue hanging off top of the diagonal.

2 Add weight to the down stroke by drawing lines on both sides of it.

3 Draw a slightly curved crossbar. Finally, lightly color in the "f" with pencil and carefully check that the weight looks correct.

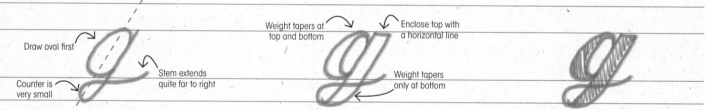

Draw oval first

Counter is very small

Stem extends quite far to right

Weight tapers at top and bottom

Enclose top with a horizontal line

Weight tapers only at bottom

1 Draw a tilted oval between the x-height and the baseline. Then, on the right side of the oval, draw a diagonal stem that goes from x-height to the descender line and then curls back over itself.

2 Add weight. Do so by drawing a line inside the counter of the oval, and another to the right of the straight part of the stem.

3 Lightly color the letter with a pencil to make sure the weight looks consistent.

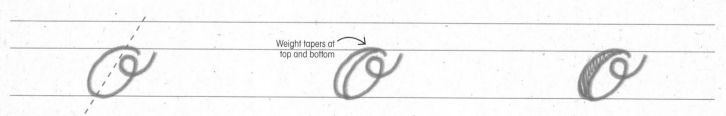

Weight tapers at top and bottom

1 Draw a tilted oval that's open at top right and lies between x-height and the baseline. At the end of the line, draw a tight curl.

2 Add weight to the oval by drawing a line inside the left side of the oval.

3 Fill the "o" lightly with pencil to make sure the weight looks right.

CONTINUED →

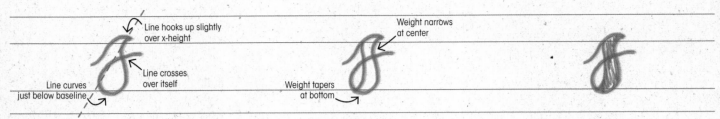

Line hooks up slightly over x-height

Line crosses over itself

Line curves just below baseline

Weight narrows at center

Weight tapers at bottom

1 Draw a loose cursive "s," starting your line at a point midway between the x-height and baseline. The line hooks up slightly over the x-height.

2 Add weight by drawing a line to the left of the spine.

3 To make sure the weight appears correct, fill the letter with pencil.

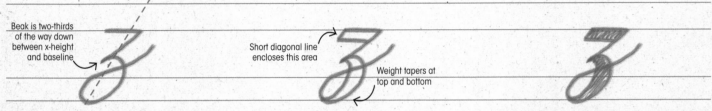

Beak is two-thirds of the way down between x-height and baseline

Short diagonal line encloses this area

Weight tapers at top and bottom

1 Draw a cursive "z" placed between x-height and the descender line. The end of the line lands on a point one-third of the way down between the x-height and the baseline.

2 Add weight by drawing a horizontal line below the one on the x-height. Then add weight to the left side of the descender.

3 Color the letter lightly in pencil and check it carefully to make sure the weight was drawn correctly.

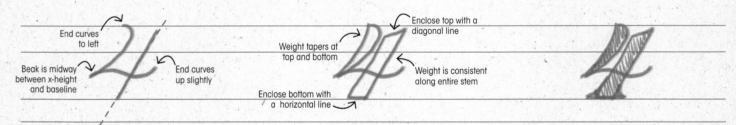

End curves to left

Beak is midway between x-height and baseline

End curves up slightly

Enclose top with a diagonal line

Weight tapers at top and bottom

Weight is consistent along entire stem

Enclose bottom with a horizontal line

1 Draw a "4" with plenty of curves. Draw the beak first, then the diagonal stem.

2 Add weight to both downward strokes, drawing these lines to the left of the skeleton.

3 Draw serifs on both sides of the bottom of the stem. Then, use pencil to lightly fill the number and make sure the weight looks right.

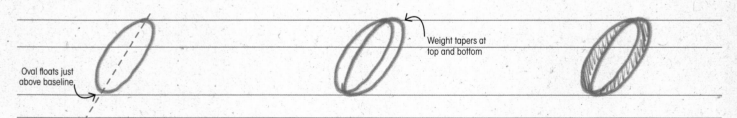

Oval floats just above baseline

Weight tapers at top and bottom

1 To create a zero, start by drawing a tilted oval between the cap height and the baseline.

2 To add weight, draw another tilted oval, offsetting it slightly to the right of the first and slightly below it.

3 Lightly color in the number using a pencil to make sure the weight is correct and looks consistent.

Take it to the next level...

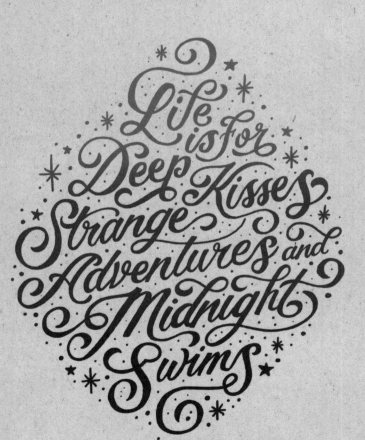

Good **MORNING** *Beautiful*

Life is for Deep Kisses Strange Adventures and Midnight Swims

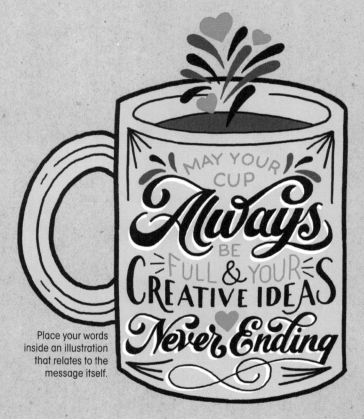

HEART

Follow Your

Layer smaller words atop a large one. The script "wraps around" the word beneath it.

MAY YOUR CUP *Always* BE FULL & YOUR CREATIVE IDEAS *Never Ending*

Place your words inside an illustration that relates to the message itself.

Here's an idea!

Using varied weight script, letter some of your favorite song's lyrics. Select an excerpt with at least three to five words.

brush script

GRACEFUL • PRETTY

In this weighted script style, inspired by one used for sign painting, the edges of the letters pull and push as if they were hand painted. Keep track of which edges are rounded and which have flat edges. This is what creates a soft, organic appearance.

a b c d e f g h i

j k l m n o p q r

s t u v w x y z

1 2 3 4 5 6 7 8 9 0

Setting up guidelines

Draw the x-height and baseline guides first. The distance between cap height and x-height—as well as between baseline and descender line—is half the distance between x-height and baseline.

This style is italicized, so you should pencil a diagonal axis line on the guidelines before you draw each letter to help them all lean at the same angle.

cap height ↘ axis ↙

x-height ↗

g

baseline ↗

descender line ↗

Here's how...

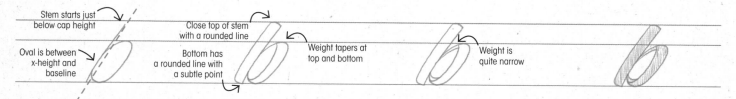

Stem starts just below cap height

Close top of stem with a rounded line

Weight tapers at top and bottom

Weight is quite narrow

Oval is between x-height and baseline

Bottom has a rounded line with a subtle point

1 Draw a diagonal stem that ends on the baseline. To the right of it, draw an oval that touches the stem and lies on the same axis as it.

2 Add weight to the stem by drawing a line to the left of it. Draw a line inside the right side of the bowl.

3 Add weight on the interior of the left side of the bowl, at both the top and the bottom.

4 Lightly fill the letter in with pencil to make sure the weight looks correct.

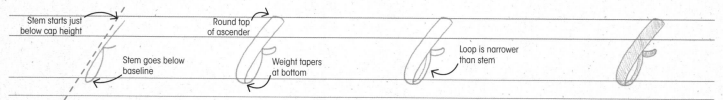

Stem starts just below cap height

Round top of ascender

Loop is narrower than stem

Stem goes below baseline

Weight tapers at bottom

1 Draw a diagonal stem. When it reaches to just below the baseline, loop it back up to connect to the stem. Draw a short, curved crossbar at the intersection of the loop and the stem.

2 Add weight by drawing a line to the left of the stem. Also add weight to the crossbar, drawing the line beneath the original one.

3 Add weight to the loop.

4 Fill in your letter with a pencil to make sure the weight looks right.

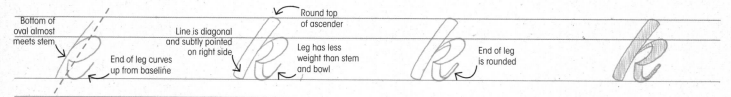

Bottom of oval almost meets stem

Line is diagonal and subtly pointed on right side

Round top of ascender

End of leg curves up from baseline

Leg has less weight than stem and bowl

End of leg is rounded

1 Draw a diagonal stem that starts just below cap height. Draw an open oval between x-height and a point halfway between x-height and the baseline. Draw a leg off the oval.

2 Add weight to the left of the stem and close its top and bottom. Draw a line inside the bowl that tapers at the top and bottom. The weight of the leg tapers as the line swoops downward.

3 Add weight to the top left of the bowl, where it doesn't yet have any, and to the leg.

4 Lightly pencil in the letter to make sure the weight looks correct.

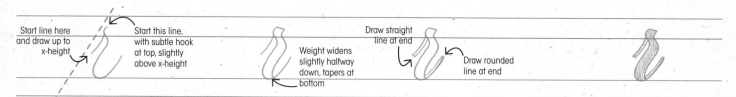

Start line here and draw up to x-height

Start this line, with subtle hook at top, slightly above x-height

Draw straight line at end

Weight widens slightly halfway down, tapers at bottom

Draw rounded line at end

1 Draw a modified cursive "r." Most of the letter rests between the x-height and the baseline.

2 Draw a line to the right of the downward stroke to add weight to it.

3 Add narrow weight to the lines that have none.

4 Lightly fill in the letter with pencil to make sure the weight looks right.

CONTINUED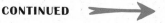

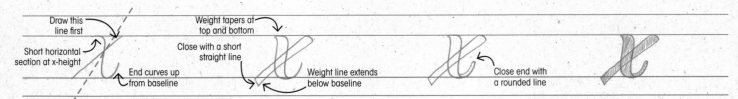

Draw this line first

Short horizontal section at x-height

End curves up from baseline

Weight tapers at top and bottom

Close with a short straight line

Weight line extends below baseline

Close end with a rounded line

1 Draw a diagonal line going from the x-height down to the left, and stopping at the baseline. Then draw a wavy line that crosses the diagonal.

2 Add weight to the wavy line by drawing a line to the left of it. Then add weight to the diagonal.

3 Add weight to the area of the curved line that curves up from the baseline.

4 Lightly fill the letter in with pencil. If the weight doesn't look correct, make any necessary adjustments.

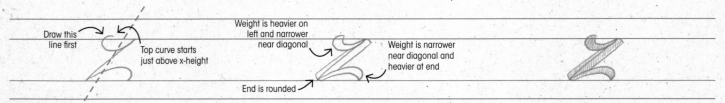

Draw this line first

Top curve starts just above x-height

Weight is heavier on left and narrower near diagonal

Weight is narrower near diagonal and heavier at end

End is rounded

1 For the "z," draw a curved crossbar along the x-height. Then draw a diagonal line that goes down to the left and stops at the baseline. Finally, draw a curved crossbar that starts at the bottom of the diagonal and ends further right along the baseline.

2 Add weight to the top crossbar by drawing a line above it. Then add weight to the diagonal by drawing lines on both sides of it. Close the ends of the diagonal with short, rounded lines. Finally, add weight to the bottom crossbar by drawing a line above it.

3 Lightly fill in your letter with pencil to make sure the weight looks correct.

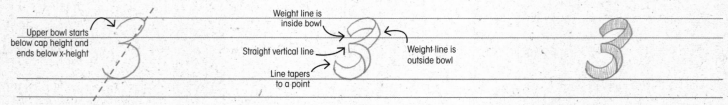

Upper bowl starts below cap height and ends below x-height

Weight line is inside bowl

Straight vertical line

Line tapers to a point

Weight line is outside bowl

1 Draw a "3."

2 To add weight, draw lines both inside and outside the top bowl. Draw weight lines inside the bottom bowl. Close the ends.

3 Fill in the number lightly with pencil to make sure the weight looks correct. If it doesn't, make any adjustments necessary.

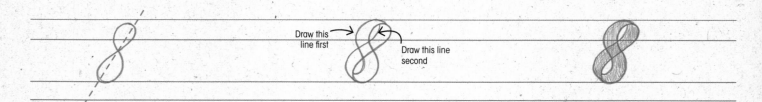

Draw this line first

Draw this line second

1 Draw a tall, narrow "8" as shown.

2 To add weight, draw an "S"-shaped line to the left of the spine. Then draw a line to add weight to the other side of the number.

3 Fill in the number lightly with pencil to make sure the weight looks correct and tapers in the areas where it's supposed to.

Take it to the next level...

Lines of primary color placed very close together give a vibrating effect.

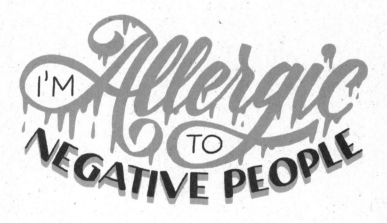

Although both "Never"s are drawn in the same lettering style, they have different ligatures and dissimilar inline and outline graphics. This makes the drawing more interesting.

Here's an idea!

Draw the name of your favorite band in brush script, including at least one ligature to give it as much visual interest as possible.

SIGN PAINTERS

SERENE • CASUAL

This style was made famous in the early 1900s as the go-to for sign painters, who hand painted signs, advertisements, and windows for local businesses. Create each stroke of the letter as if you were painting it with a brush, to get a handmade feel.

ABCDEFGHI
JKLMNOPQR
STUVWXYZ
1234567890

Setting up guidelines

Leave a moderate distance between cap height and baseline. This script style has a tilted axis so, before you draw each letter, pencil a diagonal line on the guidelines to help them all lean at a consistent angle.

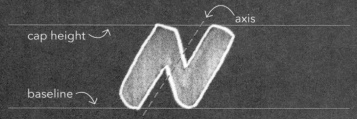

cap height

axis

baseline

Here's how...

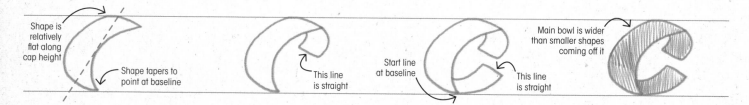

Shape is relatively flat along cap height

Shape tapers to point at baseline

This line is straight

Start line at baseline

This line is straight

Main bowl is wider than smaller shapes coming off it

1 Draw a shape like a lopsided crescent that will serve as the left side of the bowl of the "C."

2 To create the right side of the bowl, draw a shape coming off the top right corner of the crescent.

3 For the bottom right of the bowl, start a line at the tapered point, going up and right as if drawing the rest of the circle. Then angle sharply to the left, and finally curve back down toward the bowl.

4 Lightly fill in the letter to make sure its weight looks correct.

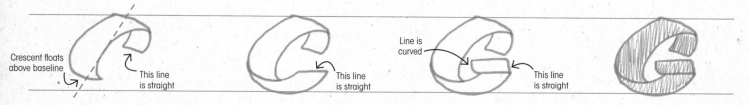

Crescent floats above baseline

This line is straight

This line is straight

Line is curved

This line is straight

1 For the top left side of the bowl of the "G," draw a sort of crescent. Then draw a shape coming off the top right corner of it to create the right side of the bowl.

2 For the bottom of the bowl, start a line at bottom left, going up as if drawing the rest of the circle, then angle sharply to the left, and finally curve back down to the tapered point.

3 Draw a crossbar.

4 Fill in the letter to make sure the weight is correct.

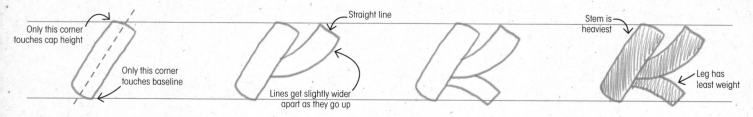

Only this corner touches cap height

Only this corner touches baseline

Straight line

Lines get slightly wider apart as they go up

Stem is heaviest

Leg has least weight

1 The stem of the "K" consists of two parallel diagonal lines. Connect the ends with curved lines.

2 Draw the arm. It consists of two lines that start at the center point of the stem and curve up to the right. These lines are not parallel. Connect their ends at the top with a straight line.

3 To create the leg, start by drawing a line slightly underneath the arm, arching it down toward and past the baseline. Then make a short upward diagonal, and finally arch up to the left to connect with the arm.

4 Lightly fill in the "K" and check to make sure its weight looks right.

CONTINUED ⟶

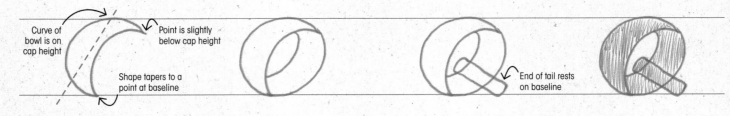

Curve of bowl is on cap height

Point is slightly below cap height

Shape tapers to a point at baseline

End of tail rests on baseline

1 Draw a shape like a crescent moon that spans from the cap height to the baseline. This will serve as the left side of the bowl of the "Q."

2 For the right side of the bowl, draw a line from the top point that curves down and connects to the bottom point. Then draw a curved line parallel to it and inside it.

3 Draw the tail as a slender, tilted rectangle. Both of its narrow ends should be slightly arched.

4 Lightly fill in the letter to make sure the weight appears correct. Both sides of the bowl should have the same weight.

Draw this curve first

Start line here

1 Draw the top of the "R" as a sort of curved rectangle hanging from the cap height.

2 To draw the bottom of the bowl, start your line on the top right corner of the rectangle. Come down to the right, draw a short diagonal, then curve back up to the starting point.

3 To create the stem, start your line from the top rectangle and come down diagonally to the right. At the baseline, make a short diagonal to the left, then another diagonal up.

4 Draw a leg coming off the bowl. Finally, lightly fill in the "R" and check to make sure the weight looks right.

Curve of bowl rests on cap height

Bottom is arched

Top corner is pointed

1 Draw a spine that looks something like a flame and spans from the cap height to the baseline.

2 Draw a shape that hangs from the top of the spine and curves slightly inward.

3 To create the bottom of the "S," draw a gently curved shape coming off the left side of the bottom of the spine.

4 Lightly fill in the letter to make sure the weight looks correct.

Start drawing line here

1 To create a "U," start by drawing a shape that looks roughly like a wide upside-down cane tilted at an angle.

2 Starting at the point of the cane, draw a line that goes up to the cap height, continues rightward as a short diagonal, then curves back down to meet the cane.

3 Lightly fill in the letter and check that the weight looks correct.

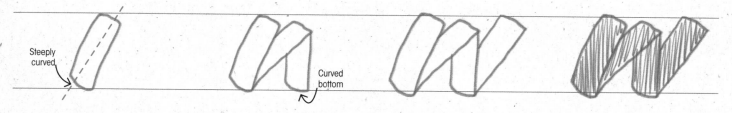

1 The first stem of the "W" consists of a roughly rectangular shape on a diagonal axis.

2 Draw a shape coming off the rectangle at an even steeper incline. Then draw a vertical shape coming off that one.

3 Draw the final stem.

4 Fill the "W" in lightly with pencil, then check it carefully to make sure its weight is consistently the same everywhere.

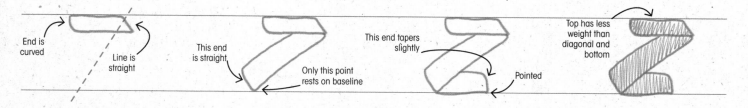

1 For the letter "Z," start by drawing a sort of parallelogram that hangs from the cap height.

2 Draw a shape that drops from the right corner of the parallelogram. Place it on a diagonal axis.

3 Draw a shape that tapers ever so slightly coming off the diagonal and resting on the baseline.

4 Fill the letter in lightly. Review it to make sure its weight looks correct.

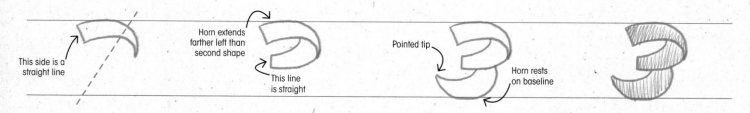

1 To make a "3," start with a shape that hangs down from the cap height and looks like a horn turned on its side.

2 Draw a shape coming off the point of the horn. This shape curves gently inward.

3 Draw a horn coming off the second shape.

4 Lightly fill in the number, then examine it carefully to make sure the weight looks right.

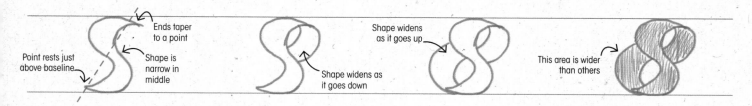

1 Draw a shape that looks roughly like an "S." It fits between the cap height and the baseline.

2 Draw a curved shape hanging off the top right end of the "S." It connects to the center of the spine.

3 Draw another shape that curves up off the baseline and meets the lower edge of the upper spine of the "S."

4 Lightly fill in the "8" with pencil. Check all areas of the number to make sure the weight looks correct.

CONTINUED

Take it to the next level...

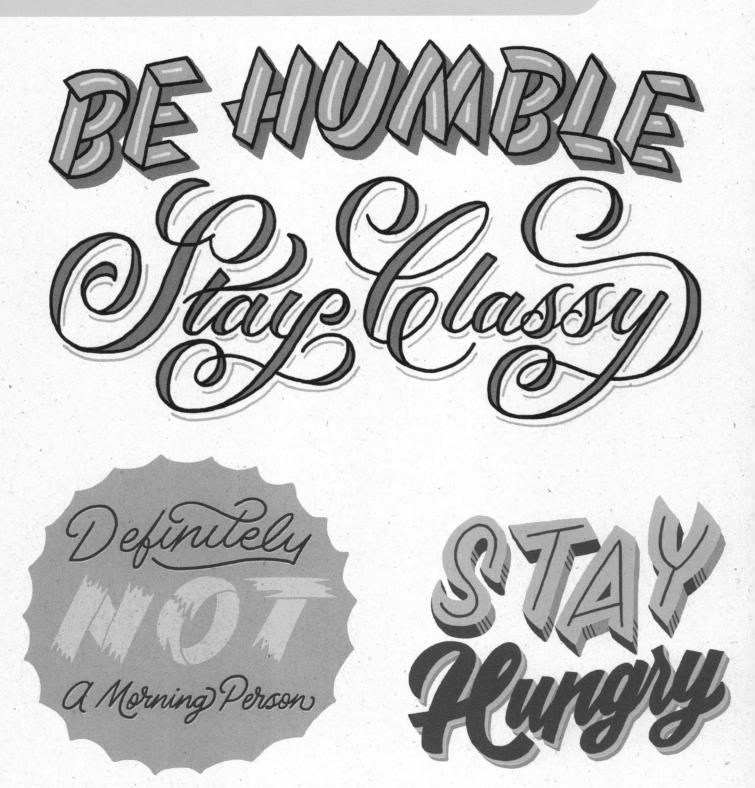

To make things more interesting, you can alter a style any way you like! This version of sign painters has shredded-looking ends.

SUPPORT LIVING ARTISTS THE DEAD ONES DON'T NEED IT

The subtle inline graphics in the keywords look like highlights and cause the letters to appear as if they're made of shiny plastic. The illustrations filling the negative space can be as simple as "X"s, "O"s, and dots, yet they still add a lot of personality.

Here's an idea!

Using sigh painters style, draw a "Now Open" sign fo your favorite restaurant, just as if you were painting it directly on its storefront window.

WOOD

RUSTIC ⊗ OUTDOORSY

Wood letters are blocky and appear to be made out of straight
and curved boards nailed together. This style lets you get creative
with details like wood grain and splits at the ends of the boards.

Setting up guidelines

Draw the guideline for the x-height halfway between the
guidelines for the cap height and the baseline.

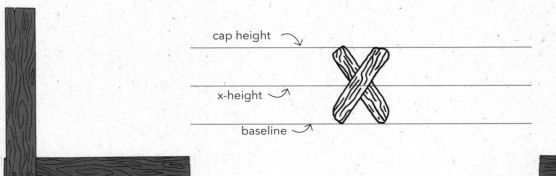

Here's how...

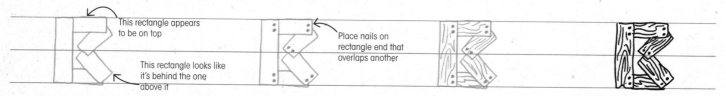

1 To create a "B," draw rectangular shapes oriented as shown above. Pay special attention to making sure the rectangles appear to be in front of or behind each other.

2 To represent nails, draw two dots side by side on each shape except the horizontal one at the bottom, sitting on the baseline.

3 Draw short, squiggly lines going lengthwise on each rectangle to represent wood grain. Use a mixture of shorter, longer, curved, and straight lines for the texture.

4 As you trace over your pencil drawing with ink, add nicks and subtle waves to the exterior of the boards so they look more natural.

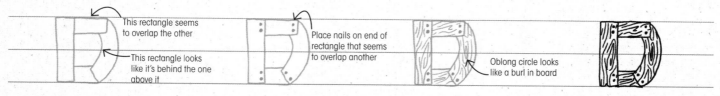

1 To make a "D," start by drawing overlapping rectangular and curved shapes oriented as shown above. The shapes should appear to be in front of or behind each other.

2 To represent nails, draw two dots side by side on each shape except the horizontal one at the bottom.

3 Draw squiggly lines going lengthwise on each rectangle to represent wood grain. Create wood texture with a mix of short, long, curved, and straight lines.

4 Add nicks and subtle waves to the exterior of the boards as you trace over your pencil drawing with ink, so it looks more organic.

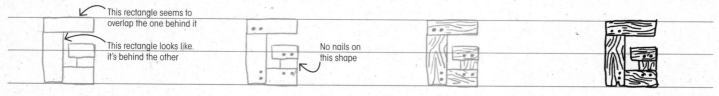

1 Draw rectangular shapes as shown above. Pay special attention to making sure the rectangles appear to be in front of or behind each other.

2 Draw two dots side by side on all but one rectangle to represent nails. They belong on the end of the rectangle that seems to overlap the one beneath it.

3 To represent wood grain, draw squiggly lines going lengthwise on each rec-tangle. This wood texture is also achieved through a mix of short, long, curved, and straight lines.

4 When tracing over the pencil drawing with ink, draw subtle waves on the exterior of the boards so they look more natural.

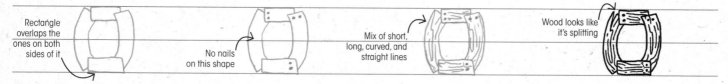

1 Draw overlapping rectangular and curved shapes oriented as shown above. Make sure the shapes appear to be in front of or behind each other.

2 On three of the shapes, draw two dots side by side. These represent nails. The nails belong on the end of the shape that looks like it overlaps a shape beneath it.

3 Create wood grain by drawing long and short squiggly lines going lengthwise on each shape.

4 When you outline the boards in ink, add "cuts" and subtle waves for an organic look.

CONTINUED

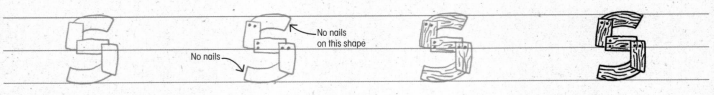

1 Draw overlapping rectangular and curved shapes oriented as shown above. The shapes should appear to be in front of or behind each other.

2 On three of the shapes, draw two dots side by side to represent nails. These belong on the end of the shape that looks like it overlaps a shape beneath it.

3 Create wood grain by drawing squiggly lines going lengthwise on each shape. Use a mixture of short, long, curved, and straight lines.

4 Add nicks and subtle waves to the exterior of the boards as you trace over your pencil drawing with ink, so it looks more organic.

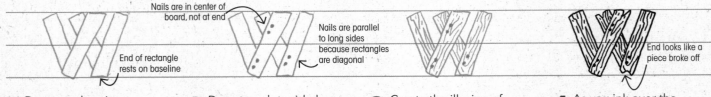

1 Draw overlapping rectangular shapes as shown above. Be certain the shapes appear to be in front of or behind each other.

2 Draw two dots side by side to represent nails, placing them on any areas of a rectangle that look like they overlap a rectangle beneath it.

3 Create the illusion of wood grain with a mix of short, long, curved squiggly lines and straight ones.

4 As you ink over the pencil drawing, add nicks and subtle waves to the exteriors of the boards so they look more naturalistic.

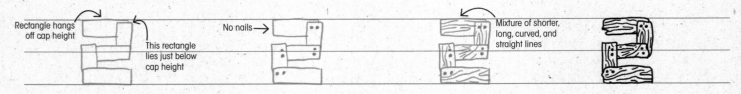

1 Start the number "2" by drawing overlapping rectangular shapes as shown above. Make sure the shapes appear to be in front of or behind each other.

2 To represent nails, draw two dots side by side on all but one of the rectangles. Draw these on the ends that appear to overlap another.

3 Draw short, squiggly lines going lengthwise on each rectangle. These represent wood grain.

4 As you trace over your drawing with ink, add nicks and subtle waves to the exterior of the boards.

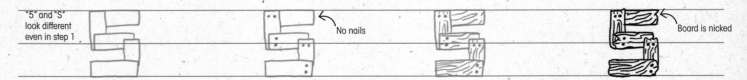

1 For the number "5," start by drawing overlapping rectangular shapes as shown above. Make sure the shapes appear to be in front of or behind each other.

2 Draw two dots side by side to represent nails. Place them on the end of any rectangle that looks like it overlaps a shape beneath it.

3 Add lengthwise squiggly lines to represent the wood grain.

4 When it's time to ink the drawing, add nicks to the ends of the boards and subtle waves to the longer exterior lines.

Take it to the next level...

These accent lines resemble a sunrise. They create a positive vibe, which emphasizes the message of the phrase.

The top word and part of the illustration have the same texture. This repetition ties them together visually.

Here's an idea!

What would a sign at your favorite park say? (Not sure? Go take a stroll around the grounds to get some ideas.) Now draw it!

RIBBON

ROMANTIC • ELABORATE

This curvy script style is considered representational lettering since every letter is meant to look like it was made from a piece of ribbon. Drawing it can be a bit challenging at first, but with a little practice you will nail it.

A B C D E F G H I J
K L M N O P Q R
S T U V W X Y Z
1 2 3 4 5 6 7 8 9 0

Setting up guidelines

Draw lines for the cap height and baseline first, making the distance between them fairly tall. The x-height guideline is one-third of the way down from cap height. The distance between the ascender line and cap is half of the distance between cap height and x-height. (Same goes for the distance between baseline and descender line.)

Because this script style has a tilted axis, you should pencil a diagonal line on the guidelines before you draw each letter to help them all lean at a consistent angle.

ascender line axis
cap height
x-height
baseline
descender line

B

Here's how...

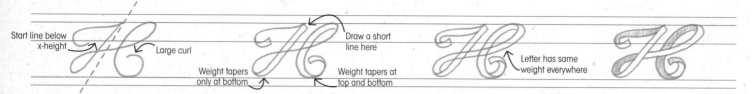

Start line below x-height
Large curl
Draw a short line here
Weight tapers only at bottom
Weight tapers at top and bottom
Letter has same weight everywhere

1 Draw a cursive "H" between the cap height and baseline.

2 Add weight by drawing a line to the right of both stems. Also add tapered weight to the curved ends of the "H." Close the ends of those with short lines.

3 Draw a line under the crossbar and parallel to it to add weight.

4 Erase some of the lines in the crossbar, as shown. Then lightly fill in every other section to make it look like the ribbon has two sides.

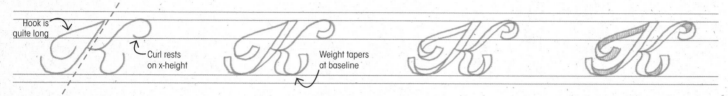

Hook is quite long
Curl rests on x-height
Weight tapers at baseline

1 Draw a cursive "K" between the cap line and the baseline.

2 Add weight to the stem by drawing a line to the right of it. Add weight to the leg with a line to the left of it. Add tapering weight to all four terminals, and close their ends with short lines.

3 Add weight to any parts of the letter that don't yet have any. Draw the same weight everywhere.

4 Erase the end of the arm and leg where they cross over the stem. Lightly fill in every other section to add a sense of depth and give the illusion of twisting ribbon.

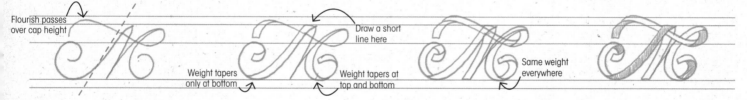

Flourish passes over cap height
Weight tapers only at bottom
Draw a short line here
Weight tapers at top and bottom
Same weight everywhere

1 Draw a cursive "M" between the cap height and baseline. Then draw a wide flourish coming off the right shoulder.

2 Add weight to both outer stems by drawing lines to the left of them. Then add tapering weight at the ends of the outer stems and at the end of the flourish. Close the ends with short lines.

3 Add weight to all the parts of the "M" that don't yet have any.

4 Erase some of the lines in and around the flourish, as shown. Then fill in every other section to add a sense of depth and make it appear that the ribbon has a front and a back.

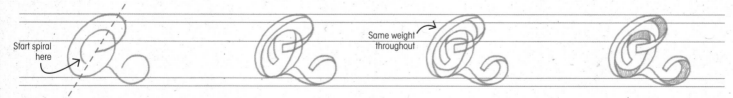

Start spiral here
Same weight throughout

1 Draw a large, swooping spiral that crosses over itself at the end. Then draw a tail that almost, but not quite, touches the descender.

2 Add weight as shown. For the spiral, draw these lines on the inside. For the tail, draw them inside the curve of the line.

3 Add weight to all the parts of the "Q" that don't yet have any.

4 Near the end of the spiral, erase the horizontal parallel lines. Then fill in every other section so it looks like the ribbon has a front and a back.

CONTINUED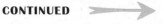

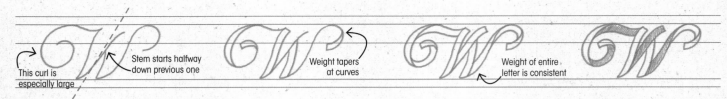

This curl is especially large

Stem starts halfway down previous one

Weight tapers at curves

Weight of entire letter is consistent

1 Draw a highly ornate cursive "W."

2 Add weight by drawing lines to the right of the first and third stem. Also add weight to both curled terminals, drawing the weight inside the curves.

3 Add weight to all the parts of the "W" that don't yet have any.

4 Lightly fill in every other section to add a sense of depth and make it appear as if the ribbon has two sides—a front and a back.

Weight tapers at curve

Weight is consistent throughout

1 Draw a highly ornate cursive "Z."

2 Add weight to the diagonal, to the bottom line, and to the ends of both of the curled terminals.

3 Add weight to all the parts of the letter that don't yet have any.

4 Along the diagonal, erase lines as shown. Then lightly fill in every other section with pencil to make it seem like the ribbon has a front and a back.

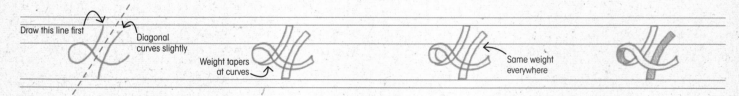

Draw this line first

Diagonal curves slightly

Weight tapers at curves

Same weight everywhere

1 Starting at the cap height, draw a curvy line that crosses over itself. Then draw a diagonal that starts just below cap height.

2 Add weight to all of the lines in the "4," except inside the tightest part of the curve.

3 Add weight to the curve.

4 In the crossbar, erase the lines that cross. Lightly fill in the stem and the area at the center of the curl to give the number dimensionality.

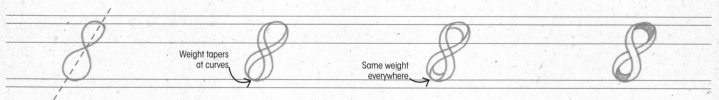

Weight tapers at curves

Same weight everywhere

1 Draw an elongated "8" between the cap height and baseline.

2 Add weight by drawing lines outside both downward strokes.

3 Add weight to all the parts of the number that don't yet have any.

4 At the center of the "8," erase two of the short lines. Fill the deepest part of both curves with pencil to give the appearance of a twisting ribbon.

Take it to the next level...

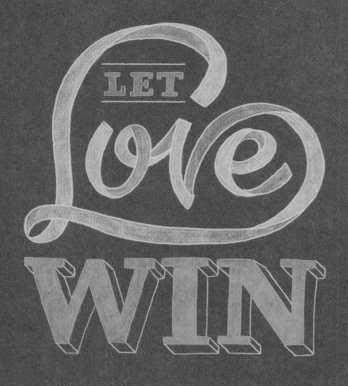

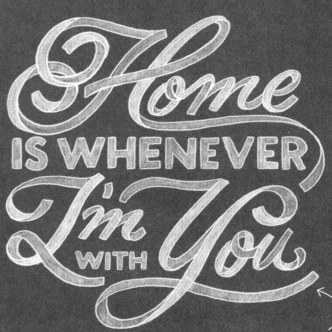

In a drawing that has "love" as the primary keyword, it only makes sense to fill the negative space with little hearts.

The large keywords frame the rest of the words, which are stacked compactly between them, resulting in a very harmonious composition.

Here's an idea!

Write the names of the three most important people in your life using this fun ribbon style. Wow them with your drawings next time you see them.

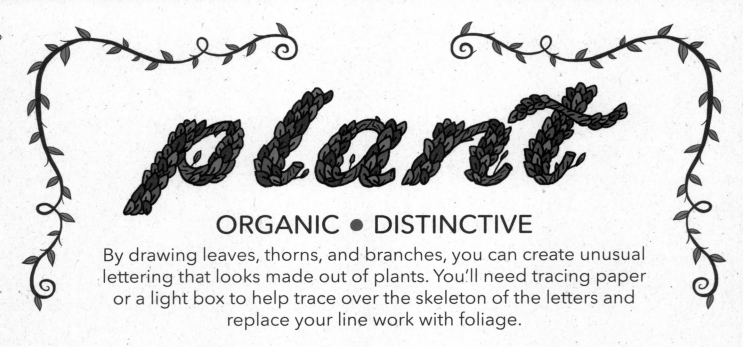

plant

ORGANIC • DISTINCTIVE

By drawing leaves, thorns, and branches, you can create unusual lettering that looks made out of plants. You'll need tracing paper or a light box to help trace over the skeleton of the letters and replace your line work with foliage.

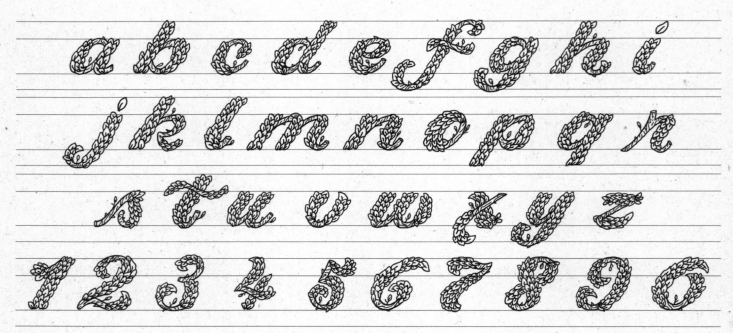

Setting up guidelines

The distance between cap height and x-height—and between baseline and descender line—is one-third of the distance between cap height and baseline.

This style has a tilted axis so, before drawing each letter, lightly sketch in a diagonal line on the guidelines to help them all lean at the same angle.

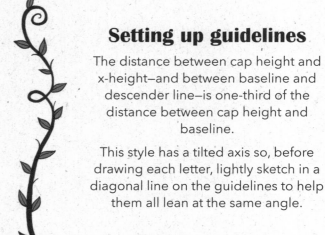

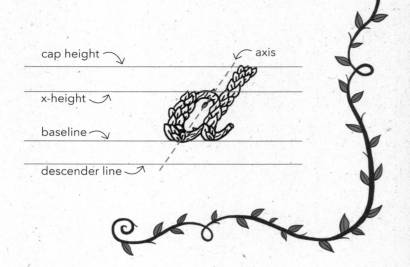

cap height

axis

x-height

baseline

descender line

Here's how...

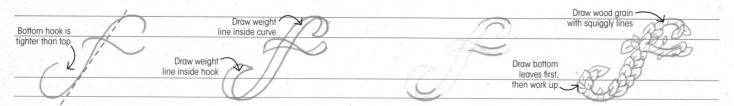

Bottom hook is tighter than top

Draw weight line inside curve

Draw weight line inside hook

Draw wood grain with squiggly lines

Draw bottom leaves first, then work up

1 Draw a stem between the cap height and the descender line, with hooks at both ends that face in opposite directions. Draw a stem hanging from x-height.

2 To add weight, draw a line to the right of the stem and the hook, and one above the crossbar. The weight tapers at the tops and bottoms of the curves.

3 Place a new sheet of paper over the drawing and lightly trace it. Add weight to the tapered areas. These will represent the plant stems in the "f."

4 Draw layers of leaves—most point up—filling up the areas that aren't the plant stem. On the stems, add wood grain, thorns, and a leaf on the crossbar.

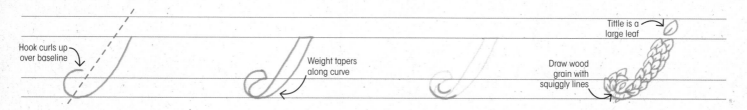

Hook curls up over baseline

Weight tapers along curve

Tittle is a large leaf

Draw wood grain with squiggly lines

1 Draw a diagonal with a hook at the bottom. It spans from the x-height to the descender line.

2 Add weight by drawing a line to the right of the diagonal and by drawing a line inside the hook. Close the ends with short lines.

3 On a new sheet of paper, lightly trace over the letter and add weight to the area resting on the descender line. This area will be the plant stem of the "j."

4 Fill the areas of the drawing that aren't a plant stem with layers of leaves pointing up. Add wood grain, a thorn, and a leaf to the plant stem.

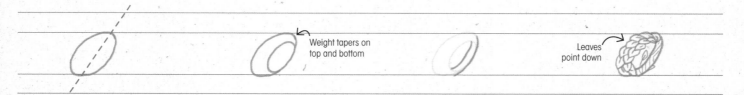

Weight tapers on top and bottom

Leaves point down

1 Draw a tilted oval between the x-height and the baseline.

2 Draw a line inside the left side of the bowl to add weight.

3 On a new sheet of paper, lightly trace over the drawing and add weight to the right side of the bowl. This area will be the plant stem of the "o."

4 In the area that's not the plant stem, draw layers of leaves. On the plant stem, draw wood grain, a tiny thorn, and a sprouting leaf.

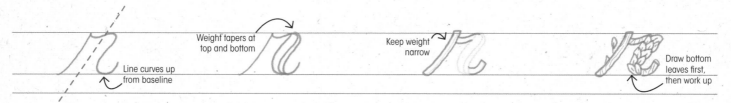

Weight tapers at top and bottom

Keep weight narrow

Draw bottom leaves first, then work up

Line curves up from baseline

1 Draw a cursive "r," placing it between the x-height and the baseline.

2 Draw lines on both sides of the right stem to add weight.

3 Using a new sheet of paper, lightly trace over your drawing, adding weight to the areas that don't have any. These will be the plant stem of the "r."

4 To the area that isn't a stem, draw layers of leaves pointing up. Draw wood grain, a thorn, and a leaf on the plant stems.

CONTINUED

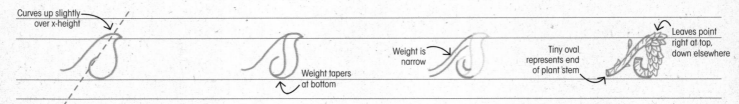

Curves up slightly over x-height

Weight tapers at bottom

Weight is narrow

Tiny oval represents end of plant stem

Leaves point right at top, down elsewhere

1 Draw a cursive "s" placed roughly between the x-height and the baseline.

2 Add weight by drawing a line inside the right curve.

3 Place a new sheet of paper over your drawing and lightly trace it, adding weight to the areas that don't have any. These will be the plant stems of the letter.

4 Draw layers of leaves in the area with the widest weight. On the plant stem, draw wood grain, thorns, and a leaf sprouting out of the upper side.

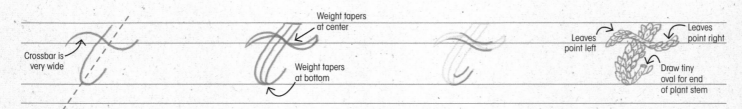

Crossbar is very wide

Weight tapers at center

Weight tapers at bottom

Leaves point left

Leaves point right

Draw tiny oval for end of plant stem

1 For the "t," draw a diagonal stem with a hook at the bottom, then a wavy crossbar.

2 Add weight by drawing a line on each side of the stem. Also add a weight line to the crossbar.

3 Using a new sheet of paper, lightly trace over your drawing, adding weight to both areas that don't have any. These will be the letter's plant stems.

4 On the widest part of the letter, draw layers of leaves that point up. On the plant stem, draw wood grain, thorns, and a leaf sprouting out of the upper side.

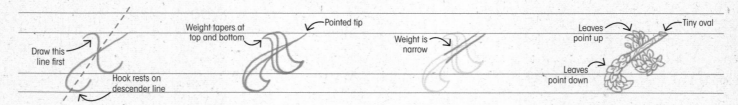

Draw this line first

Hook rests on descender line

Weight tapers at top and bottom

Pointed tip

Weight is narrow

Leaves point up

Tiny oval

Leaves point down

1 Draw a diagonal line with hooks at both ends. Then, draw a longer diagonal line that crosses it, extends all the way to the descender line, and ends in a hook.

2 Add weight to both diagonals of the "x" by drawing lines on both sides of the existing lines.

3 With a new sheet of paper placed over your drawing, lightly trace it, then add weight to the point at top right. This area will be the plant stem.

4 Draw layers of leaves on the areas that aren't plant stem. On the plant stem, draw wood grain and a tiny oval at the upper right tip to indicate the end.

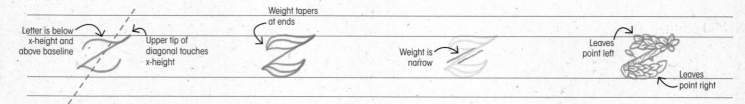

Letter is below x-height and above baseline

Upper tip of diagonal touches x-height

Weight tapers at ends

Weight is narrow

Leaves point left

Leaves point right

1 Draw a diagonal going from upper right down to the left. Add wavy crossbars at the top and at the bottom.

2 Add weight to the crossbars by drawing tapering curved lines on both sides of each one.

3 Place a new sheet of paper over your drawing and lightly trace it, adding weight to the diagonal. This area will be the plant stem.

4 On the part that isn't plant stem, draw layers of leaves. On the stem, draw squiggly lines for wood grain, a thorn that points down, and an additional leaf.

Take it to the next level...

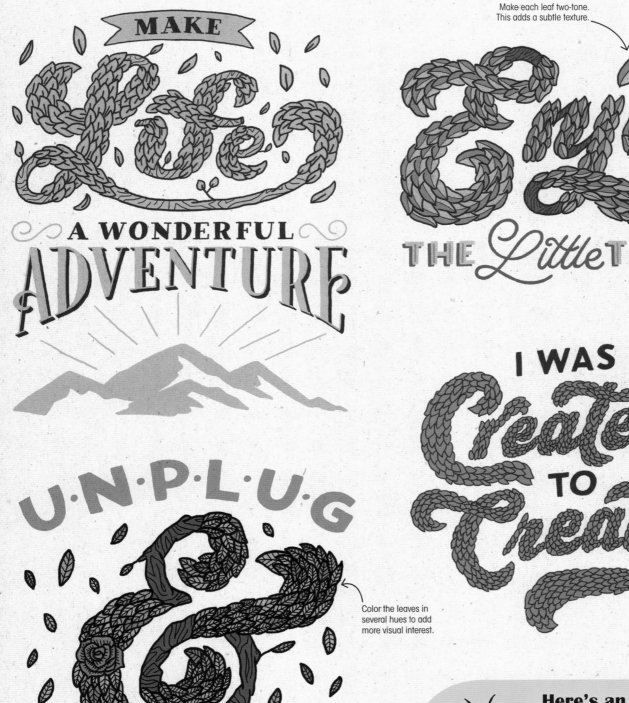

MAKE Life A WONDERFUL ADVENTURE

U·N·P·L·U·G & GO OUTSIDE

Color the leaves in several hues to add more visual interest.

Make each leaf two-tone. This adds a subtle texture.

Enjoy THE Little THINGS

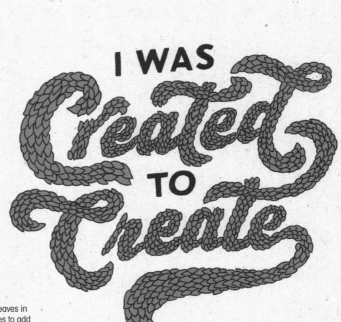

I WAS Created TO Create

Here's an idea!

Illustrate the name of your favorite flower using the plant lettering style. Try to incorporate a small illustration of that flower in the first letter of the word.

BLACK LETTER

FORMAL • NOBLE

This style of Gothic lettering was used in some of the first books ever printed in Europe. It looks historical without seeming dated, and is versatile because it appears equally at home on a heavy metal poster or an elegant certificate!

A B C D E F G H I
J K L M N O P Q R
S T U V W X Y Z

1 2 3 4 5 6 7 8 9 0

Setting up guidelines

Draw the cap height and baseline first. X-height is midway between them. Below the baseline, draw the descender line; the distance is the same as the distance between x-height and baseline.

To help create uniform terminals and serifs, draw two additional guidelines, one below cap height and the other below the baseline, using spacing that is half the distance between x-height and baseline.

serif guideline ↗
x-height ↘
serif guideline ↗

cap height ↙
baseline ↙
descender line ↙

Here's how...

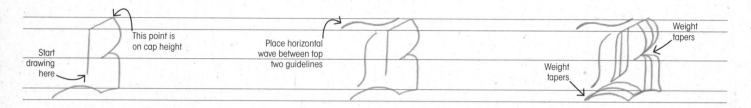

1 Draw a modified "B" as shown above. It rests on the baseline, but the decorative curve at the bottom reaches down to the serif guideline.

2 Draw a vertical wave to the left of stem. It should be some distance away, because the style is blocky. Then draw a horizontal wave above the vertical wave.

3 Add weight to three strokes and the terminal, as shown above. Note that the weight tapers in at the ends in many places, but not everywhere.

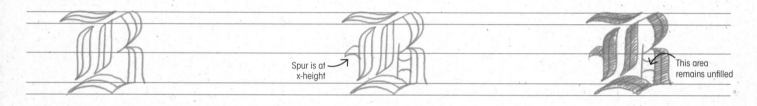

4 Add weight to the vertical wave and horizontal wave that you drew in step 2. These taper at both ends.

5 Draw a spur off the vertical wave. Draw two curved horizontal lines inside the bottom bowl, and then a vertical line connecting them.

6 As shown above, fill in most of the letter lightly with a pencil to make sure the weight looks correct.

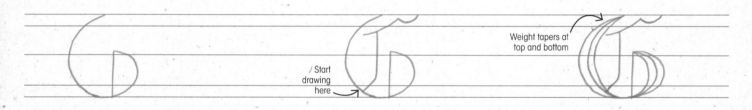

1 For a "G," draw a bowl going from the cap height to the serif guideline and then back up and over the x-height. From the end of the bowl, draw a line that goes straight down.

2 Near the bowl's bottom, draw a short diagonal going up to the right. From its end, draw a stem going up. Across the top end of that vertical line, draw a subtly curved diagonal line. End that line with a small, tight curl.

3 Add weight to the bowl as shown.

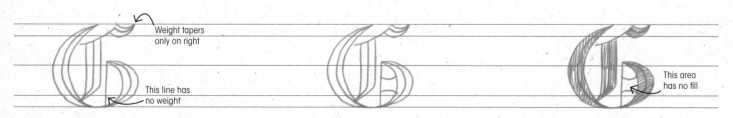

4 Add weight to the stem in the center of the character, and to the terminal at the end of the diagonal line above it.

5 Draw two curved horizontal lines inside the right side of the bowl.

6 Fill in the weighted areas of the letter lightly with pencil. Check to make sure the weight looks correct.

CONTINUED →

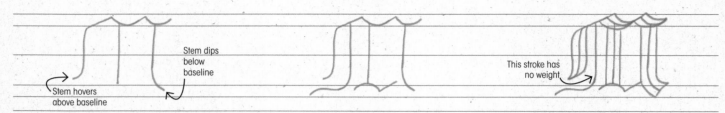

Stem dips
below
baseline

Stem hovers
above baseline

This stroke has
no weight

1 For the "M," draw three stems—a straight one in the center with curved ones on either side. Connect them with small waves along the top.

2 Draw a stem between the left stem and the middle stem. The curve at the bottom of it extends below the left stem. Draw a wave below the middle stem, as shown.

3 Add weight to three of the downward strokes by drawing lines on each side of them. The weight on the left stem tapers in at the ends, but it doesn't on the others. Also add weight to the small waves at the top.

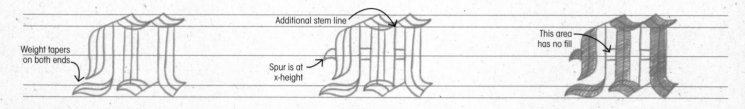

Weight tapers
on both ends

Additional stem line

Spur is at
x-height

This area
has no fill

4 Add weight to the two terminals at the bottom. The weight tapers at both ends of the left one, but at only the left end of the other.

5 Draw an additional stem line between the second and third stems. Draw four short horizontal lines connecting the stems, placing them on either side of the x-height. Finally, draw a spur on the leftmost stroke.

6 As shown above, fill most of the character lightly with pencil. Check the weight carefully and make any necessary adjustments.

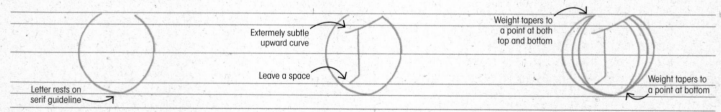

Extermely subtle
upward curve

Leave a space

Letter rests on
serif guideline

Weight tapers to
a point at both
top and bottom

Weight tapers to
a point at bottom

1 Draw an oval that's open at the top, with a soft point at the bottom.

2 At the right end of the bowl, draw a diagonal line going down to the left, stopping before you reach the oval. Draw a straight, vertical stem coming off it, and a short diagonal line off that.

3 Add weight to the bowl by drawing lines on either side, as shown.

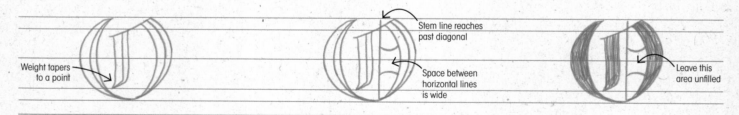

Weight tapers
to a point

Stem line reaches
past diagonal

Space between
horizontal lines
is wide

Leave this
area unfilled

4 Add weight to the stem by drawing lines on either side of it.

5 Draw another stem between the weighted stem and the right side of the bowl. Then draw two curved horizontal lines connecting the new stem to the right side of the bowl.

6 Fill in the "O" lightly with a pencil, as shown above. Check the weight, and make adjustments as necessary.

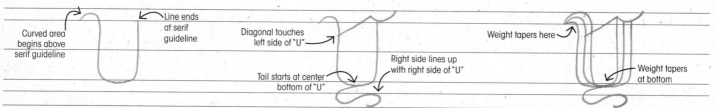

Curved area begins above serif guideline
Line ends at serif guideline
Diagonal touches left side of "U"
Tail starts at center bottom of "U"
Right side lines up with right side of "U"
Weight tapers here
Weight tapers at bottom

1 To draw a "Y," start the skeleton by drawing a modified "U" resting on the baseline.

2 Add a tail shaped like a sideways "S." Starting from the left side of the letter, near the top, draw a diagonal line that goes up to the right. End it with a curve.

3 Add weight to the vertical areas by drawing lines on both sides of the skeleton, as shown.

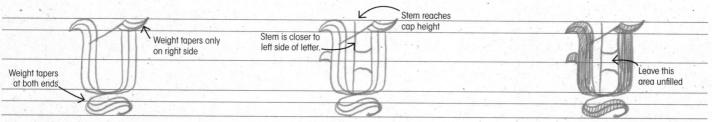

Weight tapers only on right side
Weight tapers at both ends
Stem is closer to left side of letter.
Stem reaches cap height
Leave this area unfilled

4 Add tapering weight to the tail and to the terminal at the end of the diagonal by drawing lines on both sides of the skeleton.

5 Draw a stem inside the aperture, then draw two horizontal curves connecting this stem to the right side of the "U."

6 Fill in the "Y" lightly with pencil as shown. Carefully check the weight, and make any necessary adjustments.

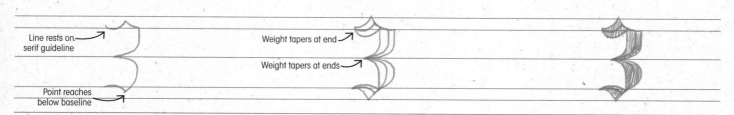

Line rests on serif guideline
Point reaches below baseline
Weight tapers at end
Weight tapers at ends

1 To create a "3," draw the shape shown above. The two curved ends face in opposite directions.

2 Add weight as shown above. The weight tapers at the ends of some of the lines, but not all.

3 Fill in the number lightly with pencil. Check its weight. Make adjustments as needed.

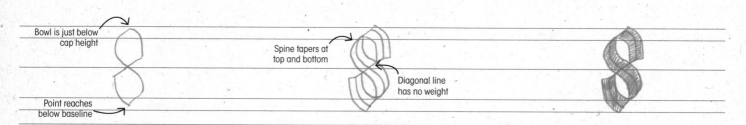

Bowl is just below cap height
Point reaches below baseline
Spine tapers at top and bottom
Diagonal line has no weight

1 To make an "8," begin by drawing the shape shown above.

2 Add weight as shown. The weight tapers at both ends of the spine, but not elsewhere.

3 Lightly fill in the number with pencil. After checking the weight carefully, make desired adjustments.

CONTINUED ➤

Take it to the next level...

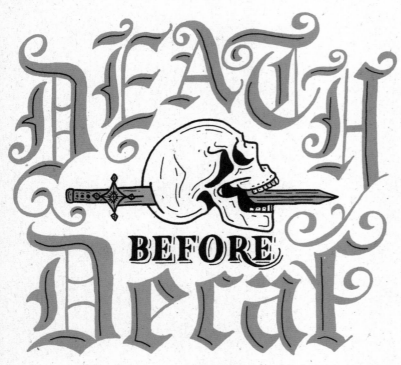

If black letter isn't ornate enough for you, just draw curls off the terminals!

Ampersands

Ampersands come from the Latin word "et," which means "and." Long ago, the "e" and "t" were sometimes drawn with a ligature to save time, and eventually became a logogram—a single written character that represents a word or phrase. Can you see the "e" and the "t" in the ampersand below? Ampersands have become an icon in typography, and now come in all shapes and styles. Type nerds are obsessed with them.

With its exaggeratedly heavy weight and large ball terminal, this ampersand calls a lot of attention to itself.

Add extra swashes and curls for an ornate effect.

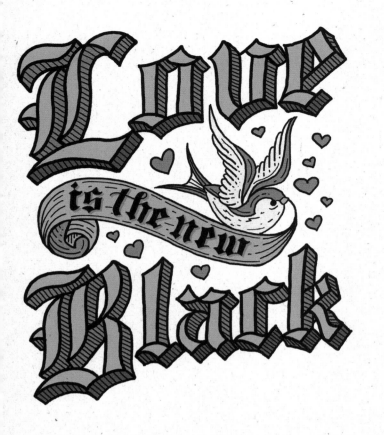

Mixing black letter with another style helps the legibility of the phrase.

Here's an idea!

Use this style to create a certificate that says "World's Greatest Friend." Add your best friend's name to it, and present it as a gift.

The especially large ligature coming off this ampersand makes it flashy.

To give the ampersand a black letter style, draw the edges pointy instead of round.

Use just the weight of your pen to create a thin monoweight ampersand.

An ampersand in a traditional varied weight serif quietly does the job.

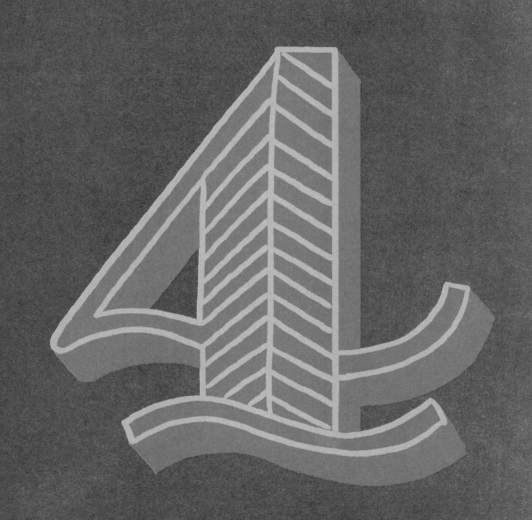

Composing a Lettered Design

In this chapter, you'll learn how to create a harmonious hand-lettered phrase from brainstorming to completion.

First, you'll learn some basic principles of design. The chapter then covers all the skills needed to create a hand-lettered phrase, using "When in doubt, eat more cake" (which should be everyone's motto) as an example. You'll start with brainstorming and explore how to find just the right style for your letters, including how to combine different styles together successfully. After planning the overall design, you'll take your rough sketch and perfect it through a series of revisions, then finally ink a flawless final version of it. And in case you'd like to use color in your design, the chapter ends with a section of basic color theory and offers tips for choosing hues.

The best way to learn from this chapter is to come up with your own phrase—choose one with five or six words in it—and then, following along with each step on these pages, draw it, start to finish.

Principles of Design

Creating a great piece of lettering requires an understanding of a few basic principles of design. Applying these concepts will strengthen your compositions, and also make your artwork more visually interesting.

- -

Balance

There are two kinds of balance, symmetrical and asymmetrical. These have to do with the arrangement of elements in a way that looks pleasing to the eye. Asymmetry is more dynamic and interesting than symmetry, but symmetry feels soothing.

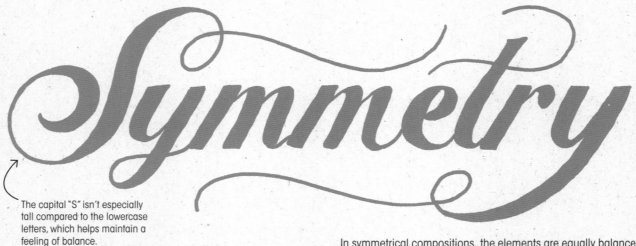

The capital "S" isn't especially tall compared to the lowercase letters, which helps maintain a feeling of balance.

In symmetrical compositions, the elements are equally balanced, which is also known as formal balance. For example, this hand-lettered word has ligatures on both the top and bottom, and there's roughly the same amount of ligature line both above and below.

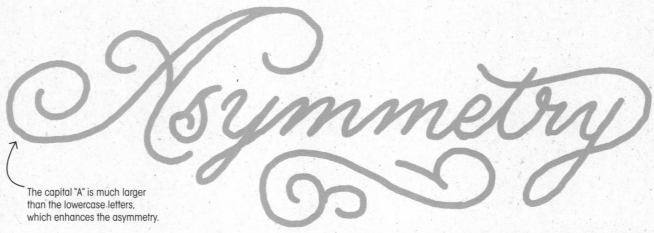

The capital "A" is much larger than the lowercase letters, which enhances the asymmetry.

This illustration shows an informal, asymmetrical balance of elements. Filigree fills up the negative space between the descenders, so the word looks bottom-heavy. The ligature the end of the word has a heavier feel than the swashes coming off the left side of the "A."

Repetition

Repetition takes many forms. It could be adding the same patterns all over a design—repeating lines, icons, or shapes, for example. Or it might be that all the words in a phrase are drawn in the same style. The possibilities are pretty much endless.

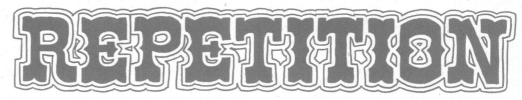

This illustration shows repetition in a number of ways. The color is repeated in both the letters and the outline graphics. The outline graphics consist of two parallel lines. And the letters have the same serifs and curves.

Notice how, together, the ligature on the "Y" and the curved line for the first shoulder of the "M" create an arch. While the arc isn't a single line, your brain notices the suggestion of an arc and fills in what's not there.

Rhythm

Rhythm is the repeating of elements to create a sense of movement. You can create rhythm in a design by arranging the elements in a way that directs the eye across the page. This can be as simple as including ligatures that move from the left to the right within a word. In this illustration, the ligature on the leg of the "R" subtly propels the eye across the "H" and to the "Y," where it encounters another ligature with a long curve that guides the eye toward the "M."

Variety

When you purposefully include several different principles of design to guide the viewer's eye around a piece of lettering, you're using variety. Variety will spice up your lettering.

This design incorporates a lot of variety: two lettering styles, each word is written in a different kind of container and has its own unique embellishments, and there are three different colors. The arrangement inside a square keeps the design looking unified.

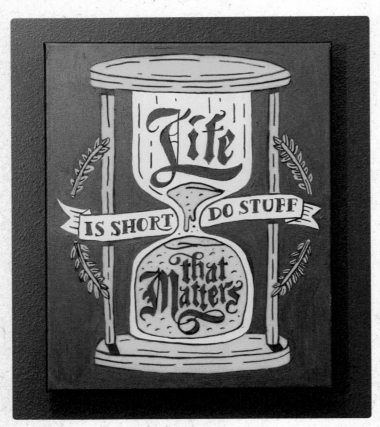

Harmony

Harmony describes how well the different elements of your lettering work together, like the pieces of a puzzle. The goal is to use rhythm and repetition to create connecting parts that complement one another.

Draw an imaginary horizontal line through the center of the hourglass, and you'll find the design is symmetrical. The curves of the ligatures echo the curves in the hourglass. The sprigs are repeated four times, and their placement in a roughly circular shape leads the eye around the design. The only color (other than black and white) is yellow. This all adds up to a harmonious design.

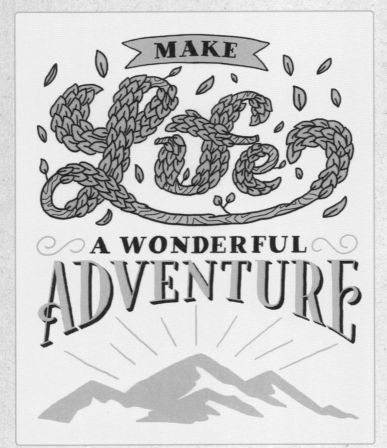

Contrast

Contrast can refer to many different things, from employing two opposite colors on the color wheel—like blue and orange—to using two different line weights in a composition. You might include both serif and sans serif fonts to create contrast, or combine a really elaborate font with a super simple one. In lettering, successful contrast is the art of adding differences to a design to highlight the important words in the phrase.

This drawing contains many examples of contrast. It combines an organic, curvy lettering style with highly angular letterforms. The palette consists of blue and orange, which are opposite one another on the color wheel. And the embellishments—a banner, leaves, scrolls, straight lines, an illustration of mountaintops—are all quite different from each other.

Dominance

Dominance describes an increase of color, shape, weight, or size to aid in establishing the visual hierarchy of a design. In this illustration, the word "dominance" is much larger than the rest of the phrase, and it stands out as the only colored word, whereas the others are black.

The inline graphics in this word help it stand out even more to dominate the phrase.

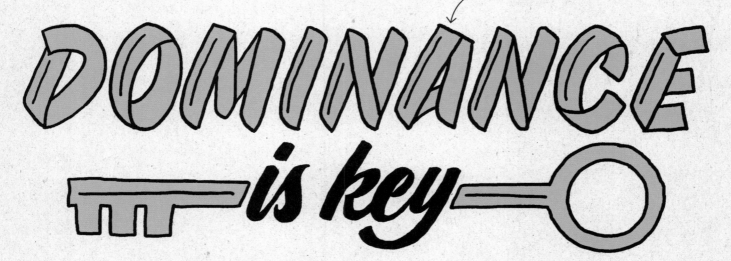

Emphasis

Emphasis is used to draw attention toward the center of interest of a design. For example, drawing a drop shadow on a single word helps it stand out from the rest of the text. So does adding inline graphics, when the rest of the words contain none.

Used sparingly, dots are especially eye-catching, and serve to accentuate whatever shape they're inside of.

Plan and Conceptualize the Design

This section teaches you how to stylize and construct your lettering with the goal of making it look more powerful. You'll learn how to establish visual hierarchy by giving the most important words more emphasis, and how to add an overall mood to the design.

First, establish the visual hierarchy

By giving certain words more emphasis, you can dictate a certain tone and help people grasp how to best read your hand-lettered phrase. In this preliminary brainstorming phase, you'll decide on the visual hierarchy of the phrase. Visual hierarchy helps readers better understand the meaning behind the message.

To decide which words are more important, read the phrase out loud and see which words you naturally emphasize, as if they were part of a powerful and confident speech. These are the keywords.

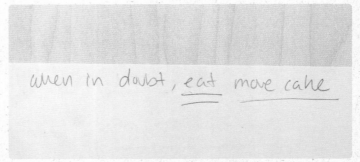

For this phrase, the keyword "eat" was underlined twice to signify its primary hierarchy, and "More cake" was underlined once to indicate its secondary hierarchy. For a phrase of seven words or more, go with three levels of hierarchy. This lets you give a wordy design more visual interest.

Next, sketch hierarchy thumbnails

Thumbnails are small rough sketches of a potential design. They're just quick drawings that let you begin to quickly plan out different arrangements for the artwork. Creating thumbnails of a piece is essential in the first phase of the creative process. Draw these using just your normal handwriting; this allows you to rapidly explore various compositions.

Before sketching thumbnails, determine whether your artwork should be landscape or portrait. (Thinking about where it will ultimately end up will help decide the shape of your piece. For example, if you want to post your piece just on social media, a square piece would make the most sense.) Draw at least four small containers.

Within each container, sketch your phrase, trying out different ways to structure it. Keeping your hierarchy in mind, stack the words on top of one another, making the keywords bigger than the other words. Explore a variety of ways to give them more emphasis. You may leave different areas of the container empty, or fill it completely.

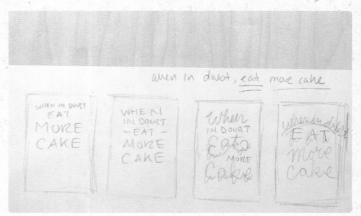

> Piece of cake
> fork
> Bold
> Creamy
> Soft
> Messy
> Heart warming
> Drool
> sprinkles

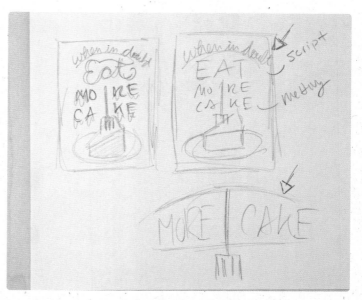

Then brainstorm mood words

Dig even deeper by making a list of "mood words"—things that come to mind when you think of the phrase. Sometimes mood words lead to finding better ways to stylize the design and give it more impact. Jot down at least seven mood words.

Mood words describe ways you want people to feel when they see your lettering, and can list illustrations you might include in the drawing.

Finally, add mood to the thumbnails

Taking your mood words into account, draw more details in your thumbnails. Include illustrations and different-shaped containers for the words. Make notes about ideas for giving the letters themselves more personality and style.

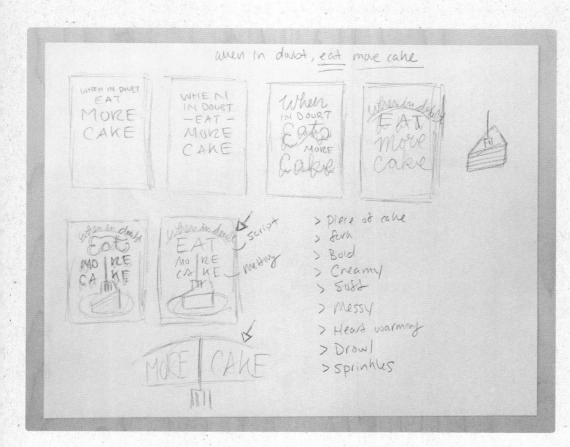

It's a good idea to do all the planning and conceptualizing on a single sheet of paper. It keeps all your ideas in one place, allowing you to easily refer back to them whenever needed.

Select the Lettering Style

You've started to explore the possibilities of your phrase and have established how you want people to feel when they see it. Now you must determine how to stylize the letters to evoke those feelings. You'll do so by creating type studies and some rough first drafts.

1 In steps 1 and 2, you'll make type studies.

On a blank sheet of paper, explore different ways to stylize each section of your phrase. For every style, create a new sheet of paper with samples to figure out which ones make the most sense and look the best.

The "W" and the "D" are underlined to indicate that they'll get extra treatment to make them more visually interesting.

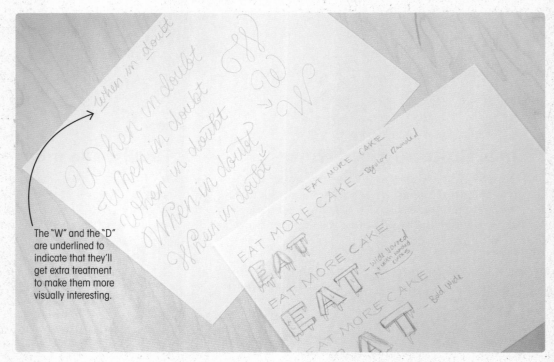

2 After you've created as many options as you can think of, review them all carefully and circle your favorite elements from each sample. It's perfectly acceptable to mix and match elements from your favorite type studies in the sketch that you will make in the next step.

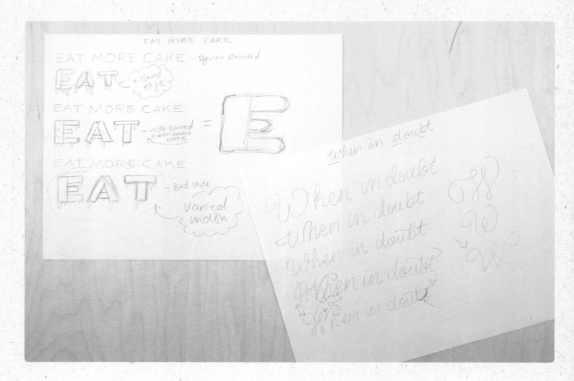

3 With the type studies finished, create a more detailed thumbnail that includes your favorite elements from the type studies. Review it carefully to see if the styles that you selected marry well together.

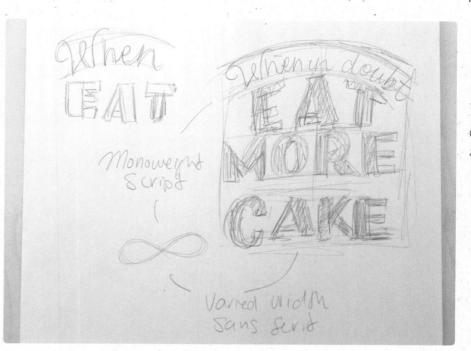

How to combine lettering styles

When you first get started with lettering, it can be hard to determine how many styles you should use in each phrase. As a general rule of thumb, stick to a maximum of three style families in a single design.

The sample phrase, for example, combines script with sans serif. These two styles work well together because they're so different not only in style but in size.

The key to making different styles work well together is to create a sense of balance in the piece. You can get away with a lot of different combinations. As long as the design remains legible and balanced, you'll find that different styles generally combine successfully.

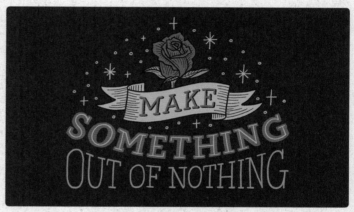

Letter styles that look similar can be made to appear different by adding decorative elements like serifs, weight, or dimension to some words in the phrase. This creates more visual interest.

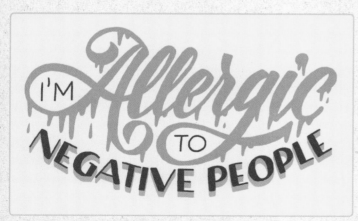

Give different lettering styles the same weight and line width so that they combine smoothly. Here, the green used to color one word and as the shadow of a second one helps tie the different styles together still more.

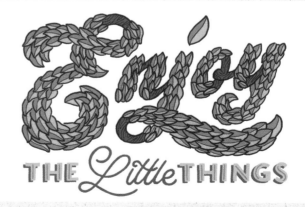

Color goes a long way toward helping disparate letter styles work well together. Analogous colors keep this design looking harmo-nious. The vertical rectangular composition conveys tranquility.

Draw the First Rough Sketch

Before you begin, place all your references and type styles in front of you so you can begin to draw the first rough sketch of your hand-lettered phrase. Following the steps described here will result in a well-balanced layout and more visually interesting design.

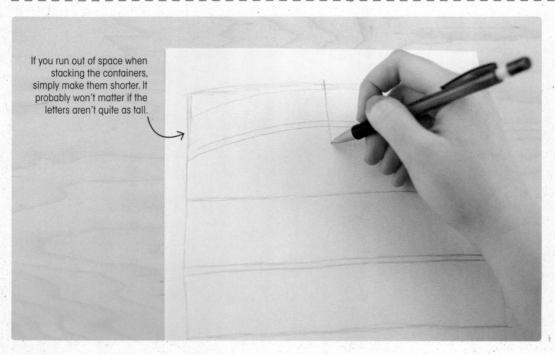

If you run out of space when stacking the containers, simply make them shorter. It probably won't matter if the letters aren't quite as tall.

1 On a new sheet of paper, draw the artboard for your lettering, filling as much of the sheet as possible. Draw a vertical line down the center of the page. (This will help you keep the different elements in the drawing centered.) Then, starting from the bottom and working up, add containers indicating where the words belong on the page. (Working from the bottom up makes it more likely you'll fit in all the containers without running out of space.) Make sure to leave some space between each line of text.

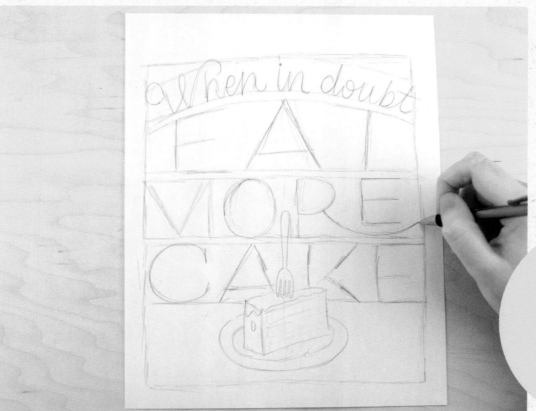

2 Inside the containers, draw the skeletons of the letters to determine how much space you need for each one. The wider the letters, the more kerning required. Also roughly sketch in any illustrations.

TIP

To center a word in a space, count the letters in it. Draw the middle letter first, then work outward from the center, drawing one letter to the left of the middle letter, then a letter on the right of it, the next letter on the left, and so on.

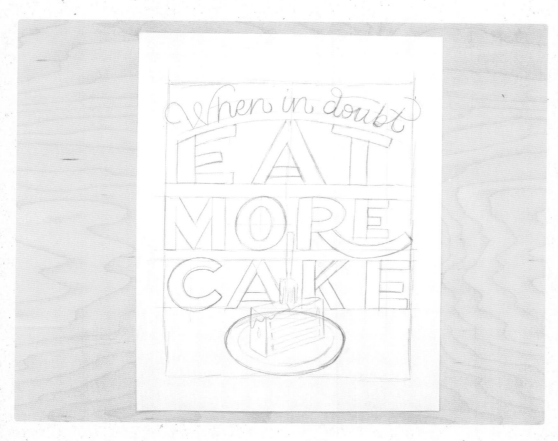

3 Add thickness to the letters, giving the words with primary and secondary hierarchy the most weight. Add details such as ligatures, and make slight refinements to any illustrations in the drawing.

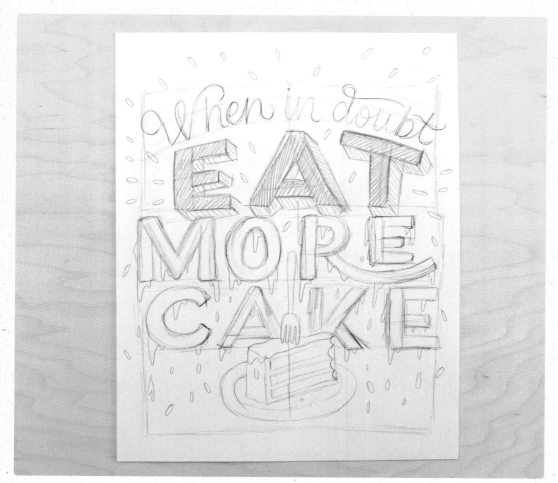

4 Add details like drop shadows, inline decorations, and supporting illustrations. Remember, in this first sketch, you seek primarily to place all the elements in the design, but they don't need to look perfect!

Transfer Techniques

To get a refined final draft, you'll need to redraw and refine the design several times to work out all the kinks. This requires transferring your drafts onto blank sheets, tracing and making adjustments each time. You can choose from three transfer techniques.

Window method

The simplest, most affordable way to transfer a design is to trace it using just the light that's shining through your window. This is the only method that requires no additional tools or materials—but the sun has to be out.

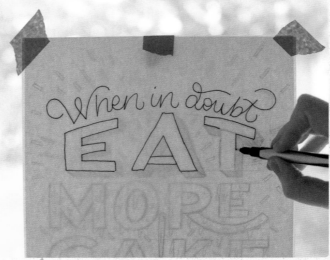

1 Using masking tape, attach a new sheet of paper to the top of your most recent drawing, fastening them at the top and bottom of the pages.

2 Tape both sheets to the window at eye level, placing the pieces of masking tape at the corners.

3 As the sun shines through both sheets, you'll see the drawing on the draft through the paper in front of it. Trace your lettering onto the front sheet with pencil; as you do, draw any desired improvements. (If you're on your final drawing, use a permanent marker or other ink-based tool.) When you're finished, carefully remove and separate the sheets.

Light box method

This technique is easier than the window method because you're working on a table rather than upright against a pane, but it requires investing some cash in a light box.

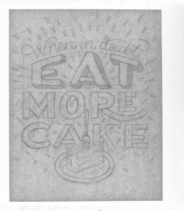

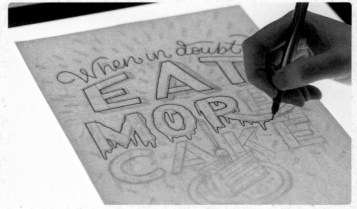

1 Place your most recent pencil draft on the light box. Put a blank sheet of paper on top of it.

2 Turn the light box on. You'll be able to see the drawing on the back page through the sheet on top of it. Ink your lettering on the top paper using a pencil, mkaing any desired improvements (or use the pen of your choice if you're inking your final drawing, and make no adjustments).

Transfer paper method

Use this technique only when inking the final design, and only if the material for your final piece of lettering is too thick to see through—for example a thick cardstock for a card, or a canvas or a board onto which you're painting a design.

1 Using masking tape, attach the corners of your final sketch paper to your desk (or simply place whatever object you plan to letter on onto your desk). Then place a sheet of transfer paper shiny side down on top of it.

Place your final pencil draft on top of the transfer paper, and tape it down at the corners, taking great care not to put any pressure on the transfer paper.

TIP

Any pressure you apply to transfer paper can leave marks on the paper beneath it, so avoid resting your hand on it to keep your transfer clean.

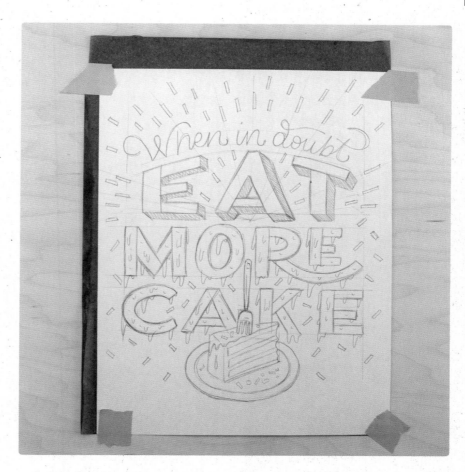

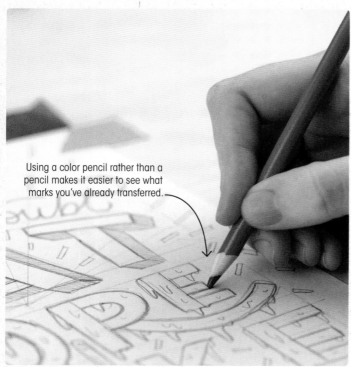

Using a color pencil rather than a pencil makes it easier to see what marks you've already transferred.

2 Use a sharp colored pencil to trace over your drawing, applying a decent amount of pressure.

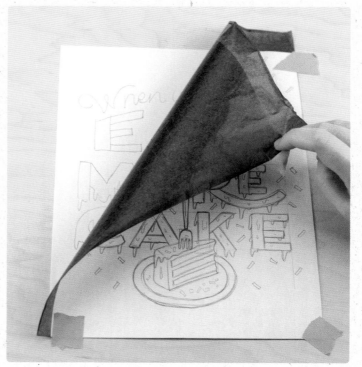

3 Carefully remove the tracing paper, revealing the ghost transfer on your final paper or object. Use an eraser to get rid of any unwanted graphite left behind by the transfer paper (you'll generally do this after you ink the lettering).

Fine-Tune the Concept and Redraw

With your first draft sketched, it's time to start the cycle of refine and redraw. In this part of the process, you'll repeatedly evaluate the piece, jot down notes on how to improve it, and make adjustments. With every new draft, you'll get closer and closer to the final, perfected piece.

First, proof the spacing

You need to make sure that the letters are evenly spaced, and should check that any negative spaces surrounding the letters are filled, so you don't have any odd-looking gaps.

1 Gauge not just the kerning but the space between each line of words, the margin around the piece, and the centered alignment of each line. Write notes with a colored pencil where you see things that need adjusting.

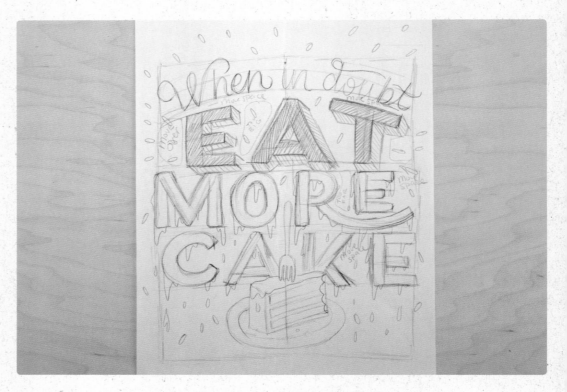

2 Now give yourself a different perspective on the drawing by viewing it from far away and by turning the sheet upside down. Doing this allows you to see the words more as shapes than letters, giving you a better ability to see what fine-tuning is needed. As before, note any needed changes to make using a colored pencil.

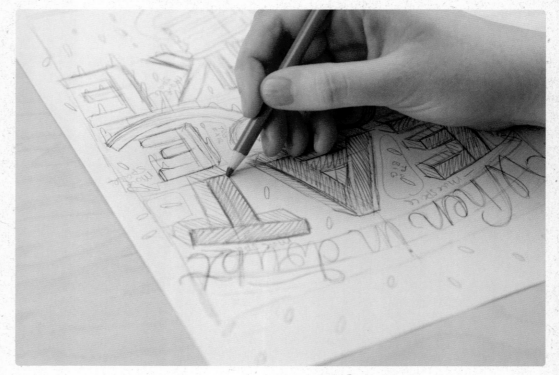

Then proof the weight

In this step, you'll evaluate the weight of all the letters to make sure they look consistent.

A great way to check weight is to draw a short horizontal mark at both the thickest and thinnest parts of your letters so you can clearly see if they all match up. Using a colored pencil, note any changes to make.

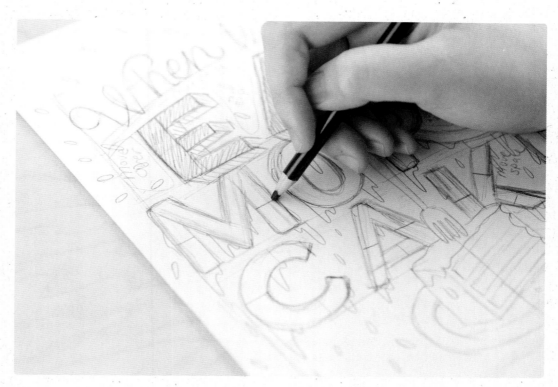

Finally, redraw

The more times you redraw and refine, the better. Those are the crucial steps to getting a drawing to look just right.

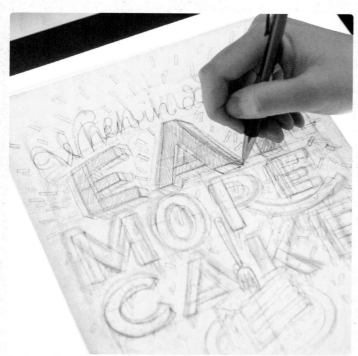

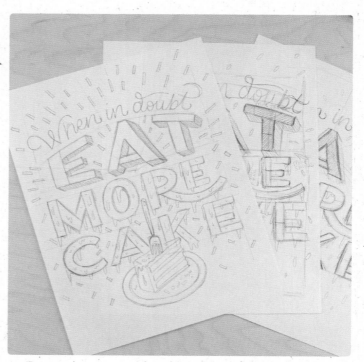

1 Tape a new sheet of paper on top of your last draft. Using a light box, or the transfer method of your choice, redraw the artwork, taking into account any adjustments that are marked in your notes.

2 Repeat the process of proofing the spacing and weight at least two more times, redrawing until you stop seeing details you think could be improved. (You might do this up to a half-dozen times!) When you're done, you'll have a clean final draft completed in pencil.

Transfer and Ink the Design

You're almost finished! All that's left is to transfer the final draft onto the paper you've selected for your piece—there's nothing wrong with a clean sheet of printer paper, but maybe your design deserves something of better quality—and then perform the inking.

- -

First transfer the draft to paper

When it comes to working on the final inked version of your lettering, the pencil lines in your artwork need to be as smooth and clean as possible. You are transfering your final draft from the tracing paper onto the final sheet of paper in order to get a polished look. So work as carefully as possible.

Then ink the words

The final inking of lettering can be exciting and fun, but it's also sometimes tricky for beginners.

Start by practicing on scratch paper. By pushing and pulling your pen in just the right way, you'll achieve smoother lines even if you're just starting out. If the inked lines look wobbly, just practice more and try applying more pressure to keep your hand steady. Keep in mind that inking takes time. You should go slowly and focus because you can't erase at this stage. Always try to complete a line in a single stroke if possible. Inking in small increments may create uneven lines and ink blots. Smooth and steady wins the race.

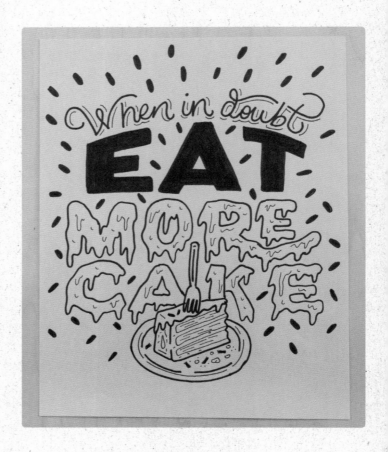

Follow these recommendations to help keep your hand steady and accurate and achieve a perfectly inked drawing.

Hold the pen near the tip.
When inking, this gives you more control. And when working on small details, place your face as close to the drawing as possible. This helps you focus on keeping a consistent line weight.

For curves, always pull the pen toward you.
This is the key to perfect curves. Keep in mind that to keep the pen moving toward you, you might need to rotate the paper when you're drawing letters with bowls, like "O," "C," and "Q."

For straight lines, push the pen away from you.
When drawing long, straight lines, push the pen away from you with your arm while keeping your wrist locked. This technique can take some getting used to, so always draw a few practice lines before you do it on the real deal.

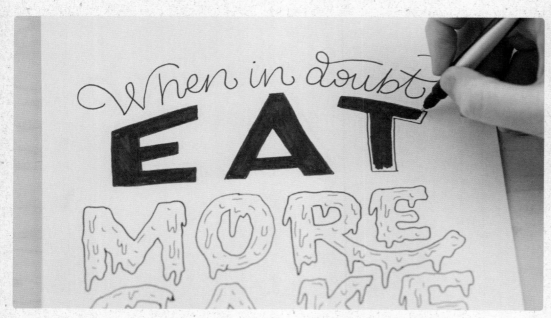

Outline first, then fill in letters.
The trick to getting evenly inked letters is to first outline them with a thin permanent marker, then use a thicker marker to fill them in just shy of the outline. Finally, go back over the edges with thin marker to fill in any last bits.

Color

Using different colors in your drawing can help give it a certain mood, from energizing it to giving it a sense of youthful tranquility, and everything in between, depending on the hues you choose. Used effectively, color is a powerful tool that can bring your artwork to life.

The color wheel

A color wheel organizes the different colors into groups. Referring to one when you choose hues will make it easier for you to find colors that look good together. Color wheels take different forms, but the general idea is a rainbow of colors arranged in a circle.

The illustration below shows the primary, secondary, and some tertiary colors arranged in a color wheel. This very simple color wheel shows only 12 colors, and they're all quite saturated. A color wheel can actually include many, many secondary and tertiary colors, tints, shades, and hues.

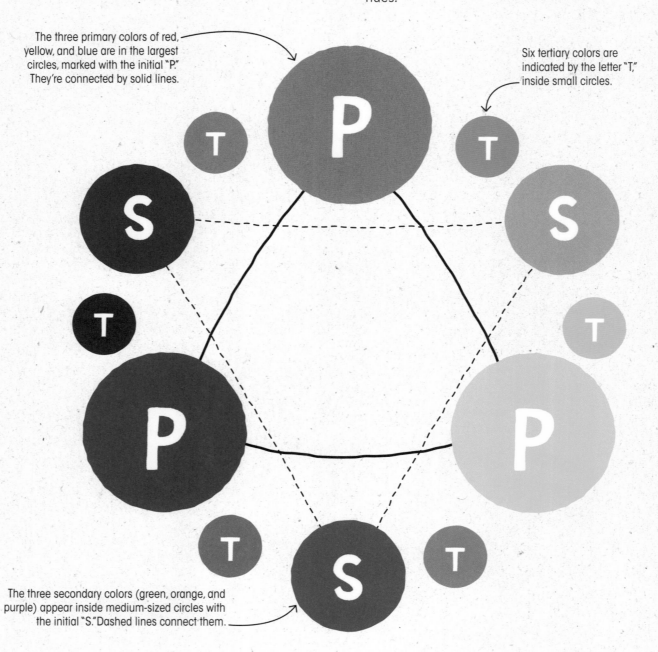

The three primary colors of red, yellow, and blue are in the largest circles, marked with the initial "P." They're connected by solid lines.

Six tertiary colors are indicated by the letter "T," inside small circles.

The three secondary colors (green, orange, and purple) appear inside medium-sized circles with the initial "S." Dashed lines connect them.

Some definitions

You don't need to attend art school to get some basic knowledge of color theory—these key terms and concepts have you covered.

Hue is just a different word meaning "color."

There are three **primary colors:** red, blue, and yellow.

The three **secondary colors**—green, orange, and purple—are created by mixing two primary colors together.

Tertiary colors are created by mixing primary and secondary colors.

Tints are colors to which varying amounts of white have been added. These are frequently called pastels.

Shades are colors that have had black added to them. They are intense, rich, and dark.

It's possible to add both white and black to a color. (When mixed, black and white result in gray.) The result is called a **tone.**

Complementary colors are those that are directly across from each other on a color wheel.

Analogous colors are hues that sit next to each other on the color wheel.

Saturation, vastly simplified, refers to the purity, intensity, or vividness of a color. A desaturated color looks duller and washed out, but also softer.

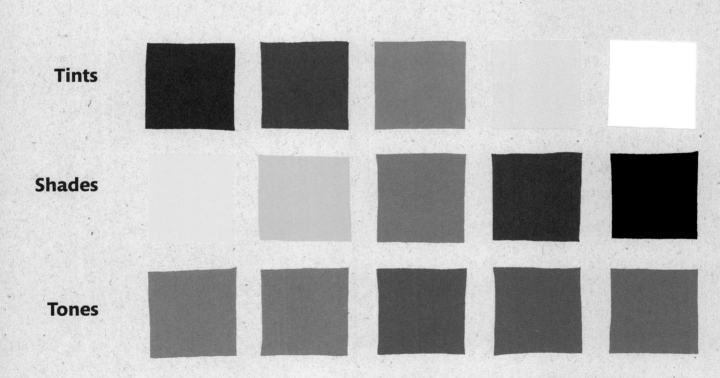

Tints

Shades

Tones

These examples show blends produced from the three primary colors, but tints, shades, and tones can be mixed from any color.

Tips for Choosing Colors

There are a few general formulas for color selection that create really pleasing color combinations. Decide on the look you want, consult your color wheel, pull out color palettes or paints in the hues of your choice, and start adding color to your lettering!

To get a vibrant look

To give your piece a really vibrant appearance, choose **two complementary colors** and then use different shades and tints of those colors as accent colors. Be sure to use fully saturated colors for the keywords in your phrase; they will attract the eye.

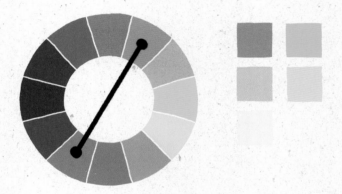

For a harmonious appearance

If you desire a more soothing color scheme, go with **three analogous colors.** From these, select one to be the main color and one as the supporting color, with the last color serving as an accent.

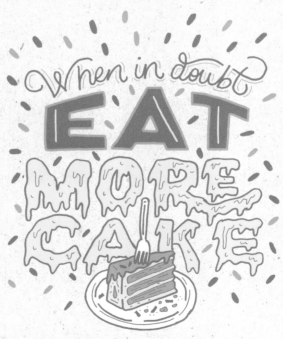

This variation on analogous colors uses tints of a single hue.

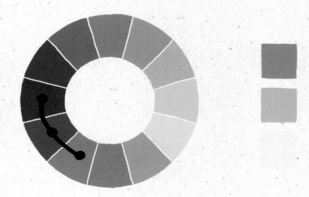

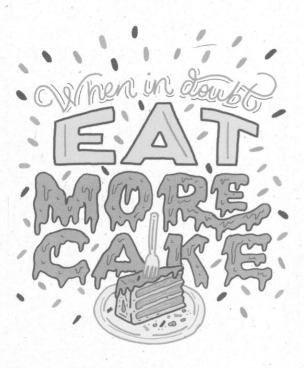

This uses just two of the triadic colors for the outlines and inline graphics, plus shades or tints of the entire triad for the fills.

To achieve strong visual contrast

A **triadic color scheme** includes three colors on the color wheel that are evenly spaced and connected by an imaginary triangle. Typically, you would choose one of these colors to use as the main hue, and would employ the other two sparingly as accent colors.

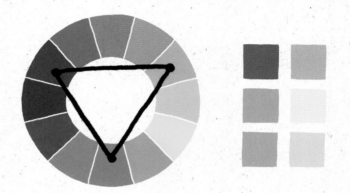

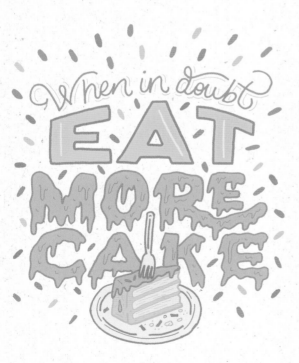

This uses four colors for the outlines, plus their tints for the fills.

When you want lots of colors

You may be crazy about color, but stick to four main hues in a piece of lettering until you're really familiar with combining color. Too many hues can distract the viewer from reading the content, which is the whole point of lettering. So choose colors selectively.

To choose a quartet of colors, draw an imaginary square connecting evenly spaced colors on the color wheel. Select one of these hues to use as the dominant shade, and use the other three as accents.

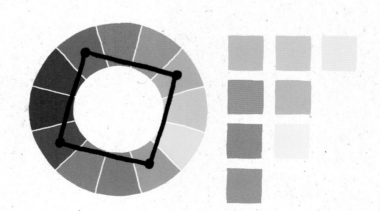

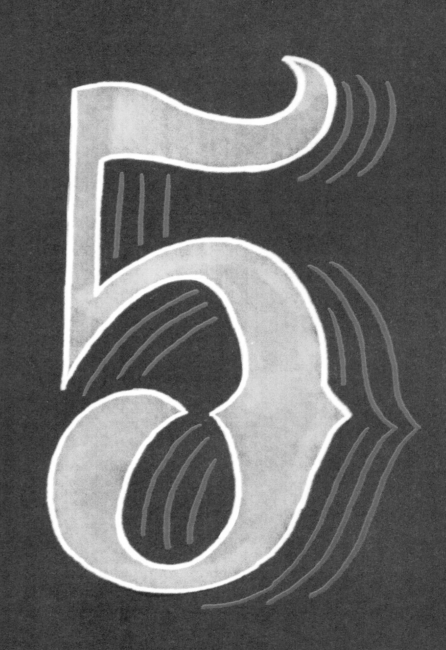

Lettering Projects

This last chapter gives you 15 different awesome ideas for projects, explained step by step, with photos. You'll see the entire process for creating various pieces of lettering to put in your home, give as gifts to friends, or use as decor for your next party or event. In these projects, you'll learn how to use different mediums, lettering techniques, and color to enhance your hand lettering.

Before you start making any project, you should read all the instructions to make sure you understand them.

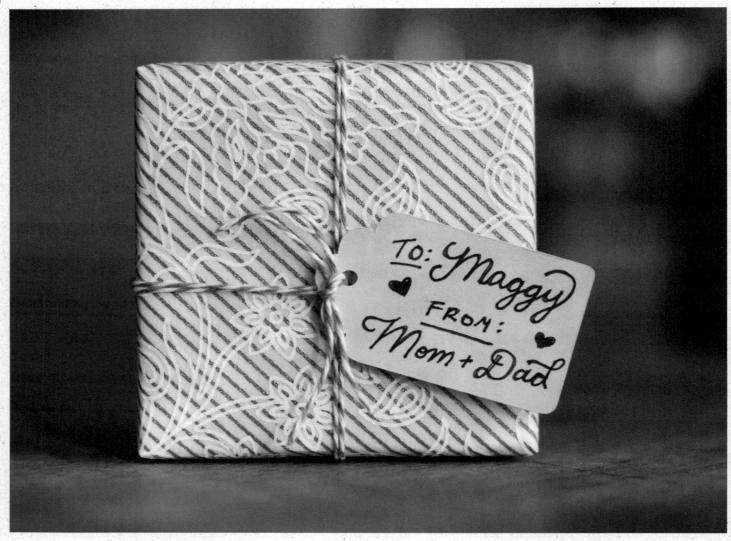

Gift Tag

Make gifts for family and friends even more special by creating beautifully written gift tags for them. Lettering can be engaging even on a small scale.

Materials
Printer paper
Blank gift tags

Tools
Mechanical pencil
Eraser
Fine-tip marker, 08

Lettering Style Used
Monoweight Script

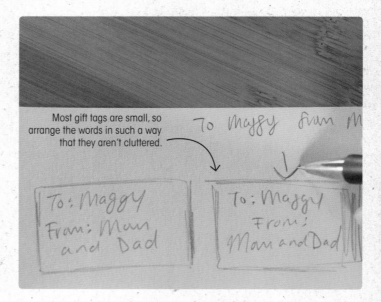

Most gift tags are small, so arrange the words in such a way that they aren't cluttered.

1 Determine how to position the words by sketching a few thumbnails in pencil on a blank sheet of printer paper.

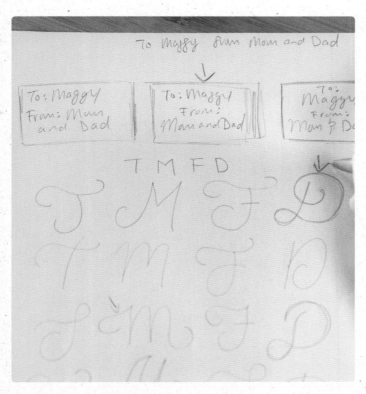

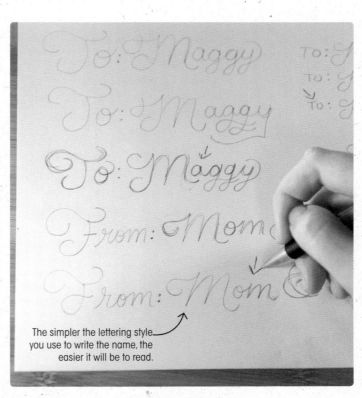

The simpler the lettering style you use to write the name, the easier it will be to read.

2 Draw a few type studies of the capital letters to come up with different ways to add ligatures to the lettering.

3 On a new sheet of paper, practice different ways of writing the names.

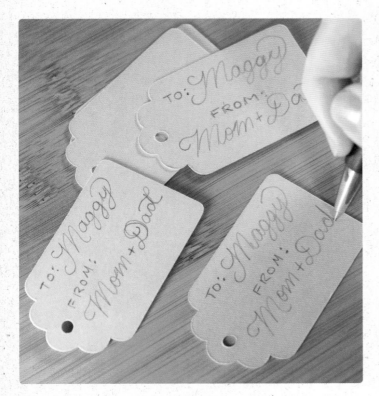

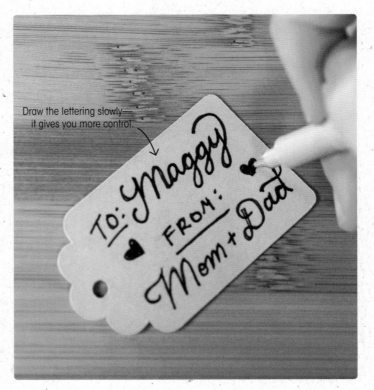

Draw the lettering slowly—it gives you more control.

4 Choose your favorite composition and practice it in pencil on a few spare gift tags to get accustomed to writing small and in a limited space.

5 Using the fine-tip marker, draw your lettering on an unused gift tag. Finally, draw any additional illustrative elements—like dots, hearts, and stars—to jazz it up.

T-Shirt

Print your art on a T-shirt and you become a walking billboard for your favorite quote— and your own artwork! These instructions take you through designing the lettering using traditional techniques, then getting your art print-ready on the computer using Adobe Photoshop. All that remains is to order it printed onto a T-shirt … or a mug … or a cap … or a mousepad…

Lettering Styles Used
Sign Painter's Script
Casual Brush Script

Materials
Printer paper
Tracing paper (optional)

Tools
Mechanical pencil
Eraser
Light box (optional)
Thick black
 permanent marker
Scanner
Photoshop

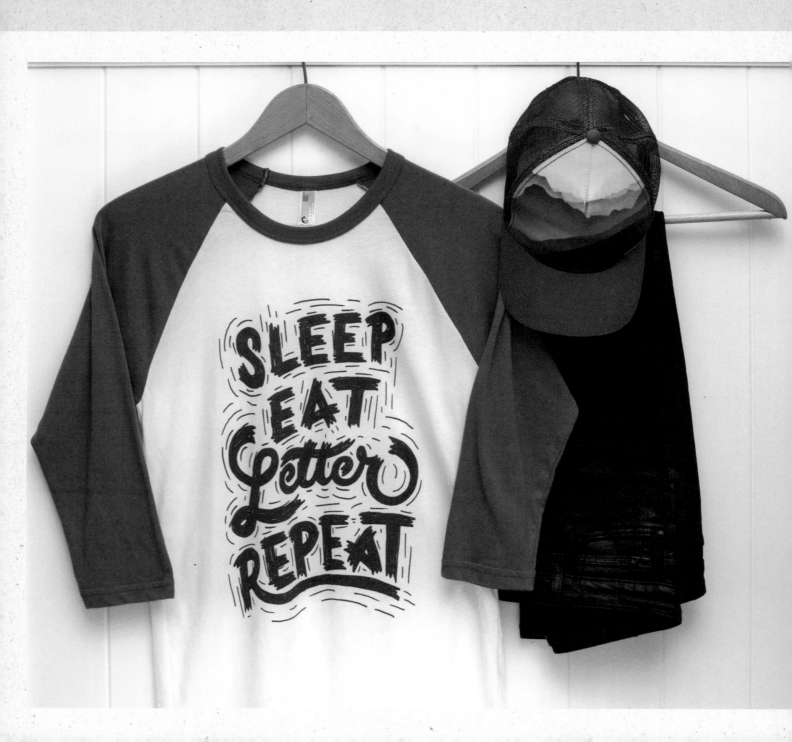

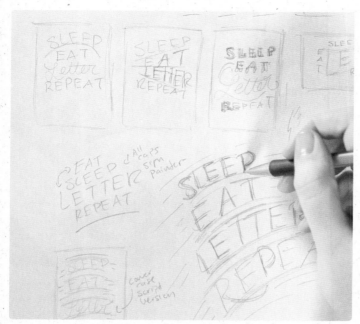

1 Write your phrase on a blank sheet of paper and determine which words you want to emphasize, or if you want to give all the words the same visual significance. Then create small vertical thumbnails of the design to figure out the composition.

2 After deciding which layout to use, develop some type studies on a new sheet of paper. Explore different weights that are both wide and condensed. Then explore ways to connect the letters and make them interact together in a more interesting way.

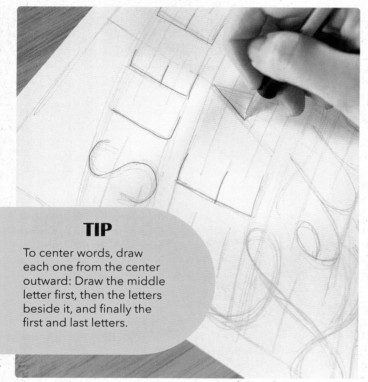

TIP

To center words, draw each one from the center outward: Draw the middle letter first, then the letters beside it, and finally the first and last letters.

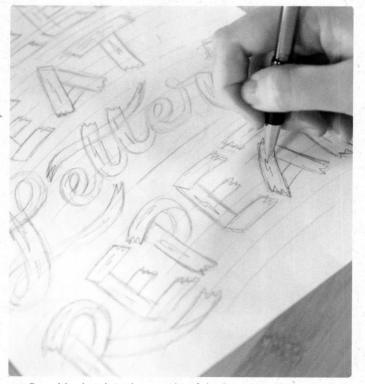

3 On a blank sheet of paper, create the first rough concept for the design, filling as much of the page as possible. Begin by drawing a box to contain the letters, then lightly pencil in a vertical center line to keep the design center-aligned. Sketch guides to help place the words on the page. Then draw the skeletons of the letters to make sure you have enough room for everything.

4 Roughly sketch in the weight of the letters, making sure to draw each element of the letter. Once the letters are in place, add details like jagged edges on the ends of the letters and lines around them.

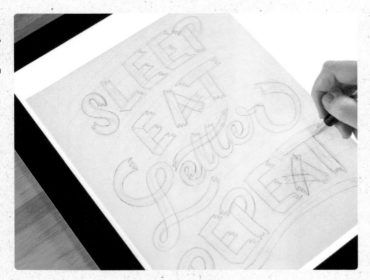 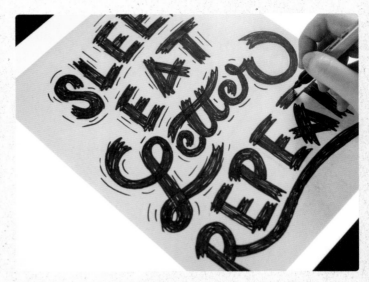

5 Redraw the design at least once using a light box or the window method, making refinements as you go. You need to end up with a smooth line that you can easily trace over in the next step.

6 Using a new sheet of paper and any transfer method, trace over the outline of the drawing with the permanent marker, then fill it in. For curves, rotate the page to help draw the dash lines going in the direction of the overall line. The goal is to make the design look like it was painted with a dry brush.

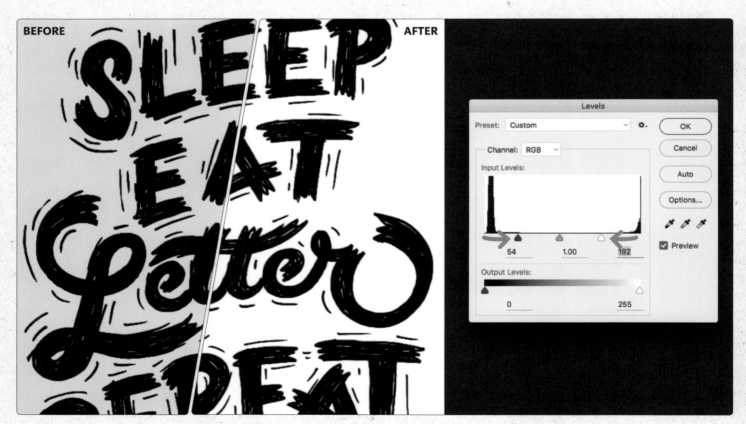

7 Scan in your artwork as a TIFF. Open the scanned file in Photoshop. Go to **Image > Adjustments > Levels** to pull up the dialog box. Then pull in the white and black levels toward the center until your artwork is completely black and white. The more white you pull in, the more textured the artwork will look.

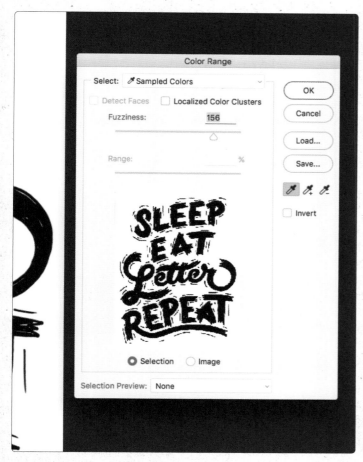

8 To remove the background, go to **Select > Color Range** and select the white background with the color picker. Your letters will be highlighted with red. Press **OK** and you'll see dancing ants around your letters.

9 In the **Layers** palette, make sure your image is not locked down as a Background layer. To unlock it, click the lock icon. Once it's a layer, tap the **delete** key to delete your background. If you just see your lettering with a checkered background, you've done it correctly.

10 Use the **Eraser Tool** to make your lettering thinner and remove any scuff marks. Then use the **Brush Tool** to fix any gaps in your letters or add any additional elements.

11 Go to **File > Save As** and save your document as a Photoshop PDF. Be sure to check **As a Copy** so you don't save over your document. You can then send your final PDF off to get it printed on a T-shirt—or any other item of your choice.

Birthday Card

Create a thoughtful gift by drawing a fun birthday card for someone special! The decorative ribbon lettering used for this project is challenging, but practicing it is guaranteed to improve your lettering skills.

Materials
Printer paper
Tracing paper (optional)
Cream-colored
 construction paper,
 8 ½ x 11 inches
 (21.5 x 28cm)
Transfer paper

Tools
Mechanical pencil
Eraser
Ballpoint pen
Ruler
Light box (optional)
Colored pencils
Gold permanent marker

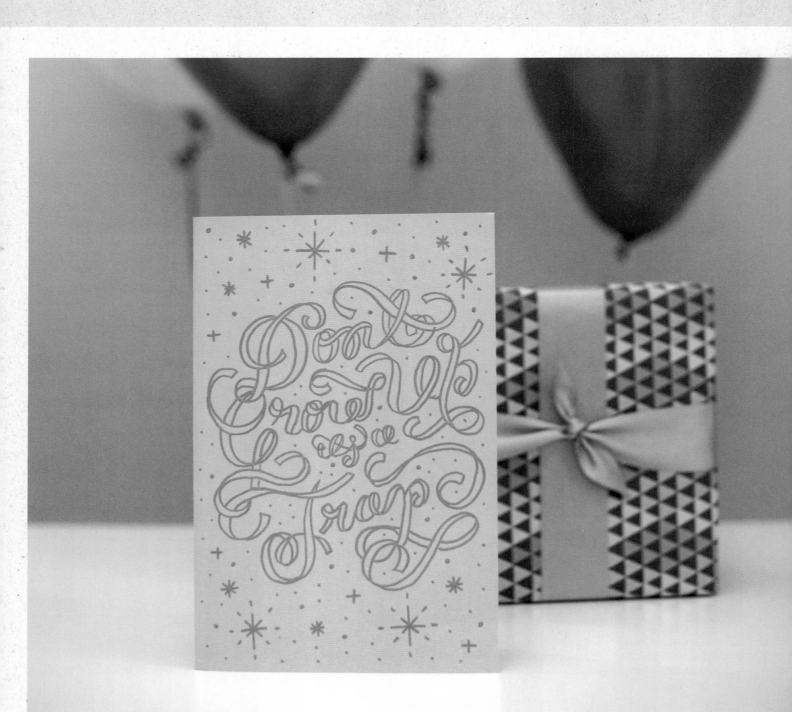

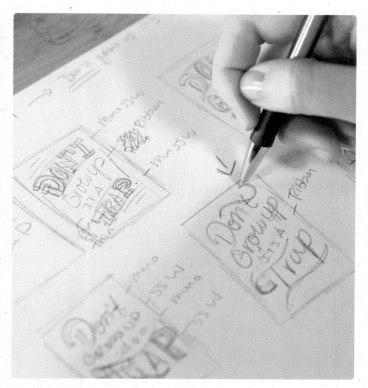

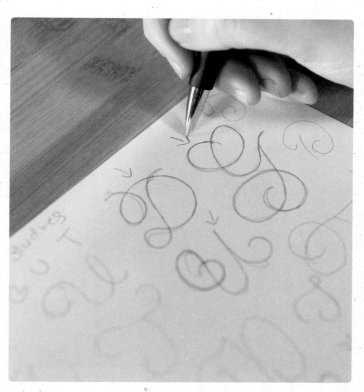

1 Decide on the visual hierarchy for your piece, then draw thumbnails of different compositions for your card inside vertical rectangles. Mark your favorite one with an arrow.

2 Sketch a few type studies of the capital letters, experimenting with different ways to draw each letterform. (You can look up references from your favorite alphabet styles to hunt for inspiration.)

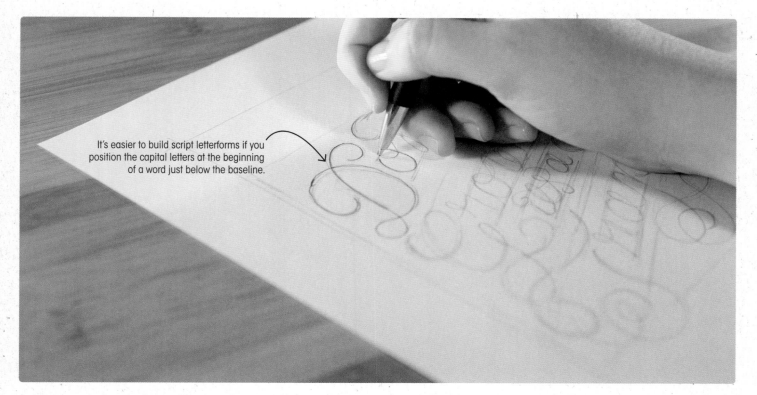

It's easier to build script letterforms if you position the capital letters at the beginning of a word just below the baseline.

3 Use a pencil and ruler to draw a rectangle that measures 8 ½ x 5 inches (21.5 x 13cm) on a blank sheet of printer paper. Inside this artboard, lightly sketch the design of your favorite thumbnail, then draw just the skeleton of the letters.

4 Using a colored pencil and tracing paper or a light box, redraw your lettering on another sheet of printer paper, filling up any negative space while making improvements to your letters along the way. Repeat this step until you're satisfied with the line work of your script lettering.

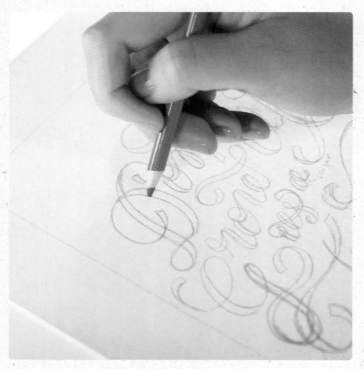

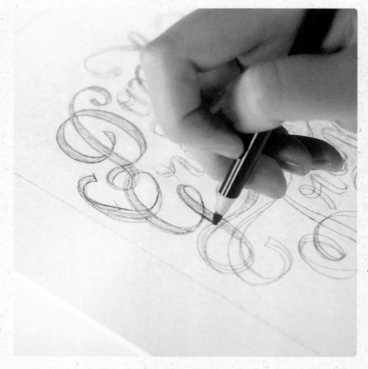

5 Once you've perfected the skeleton, use a different colored pencil to add weight to the up strokes of the letters.

6 Using a different colored pencil, add weight to the down strokes of the letters. Then lightly fill in the letters to make sure the lettering is the same width everywhere. The areas where lines change direction are the only places where the letters have no width and appear to be made of a single line.

7 Fold the construction paper in half widthwise to form a card that is taller than it is wide. If you intend to place the card in a large envelope after it's finished, trim the card as needed so it fits snugly inside the envelope. Wrap a sheet of transfer paper—shiny side down—around the card. Tape the transfer paper around the card so it doesn't shift.

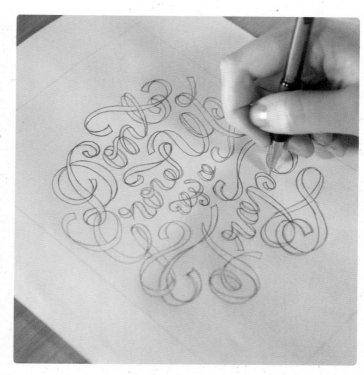

8 Place your final draft on top of what will be the front of the wrapped card and, pressing hard, use a pencil to trace the outline of the ribbon lettering.

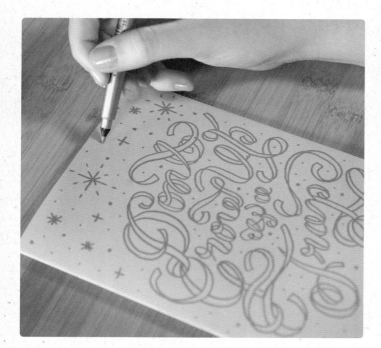

9 Remove the transfer paper. Use a gold permanent marker to draw the outline of the letters, along with any other festive-looking decorations you want to add. Erase any marks from the transfer paper.

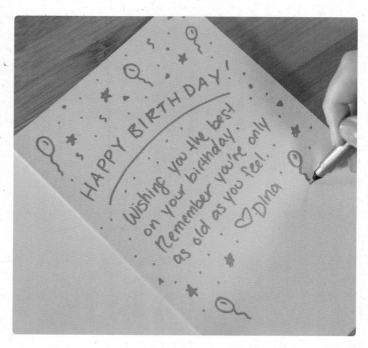

10 Open the card and write a personalized happy birthday message inside. Make it look even more festive by adding more doodles and drawings to fill up the space.

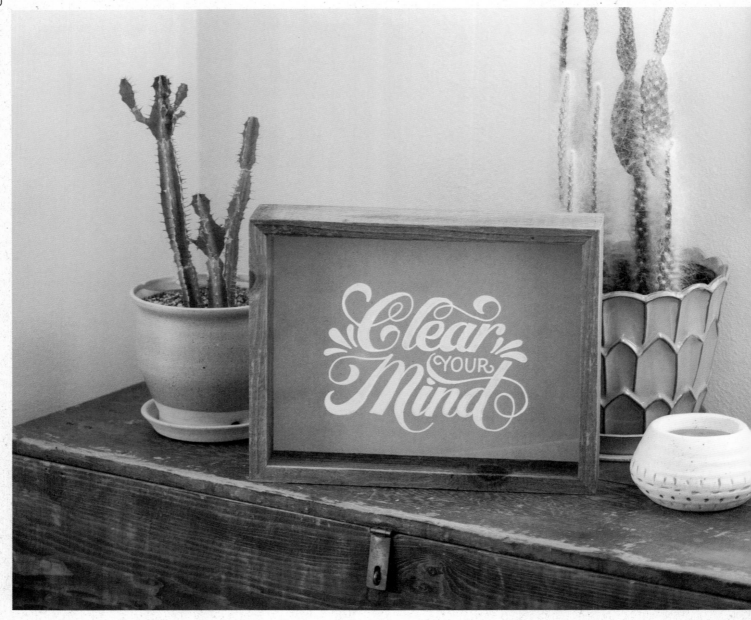

Shadow Box

Use a playful yet elegant varied script to paint lettering on the front of a shadowbox. The transparent glass allows you to easily trace and transfer the final sketch onto its surface.

Materials
Printer paper
Shadow box
Masking tape
White enamel paint
Paint thinner
Disposable plastic cups
Palette paper (optional)
Paper towels

Tools
Mechanical pencil
Eraser
Ruler
Light box (optional)
Chalk marker
Thin paint brush
Thick paint brush
 (optional)

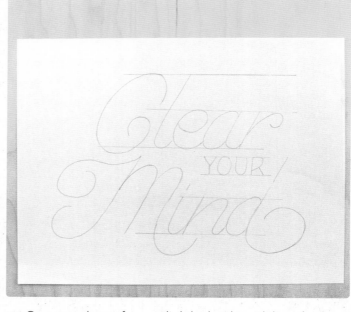

1 On a blank sheet of paper, draw several small boxes that have the same proportions as the shadow box. Inside them, sketch rough thumbnails of your phrase, experimenting with different compositions and layouts. Once complete, write notes on why you like or don't like each thumbnail, and choose your favorite.

2 On a new sheet of paper, lightly sketch guidelines for the words. Lightly draw the skeleton of the script letters in pencil inside these guides, filling as much of the page as possible. (The shadow box shown here has the same rectangular proportions as the paper. If your shadow box has a different shape, begin step 2 by drawing an artboard with that shape on the sheet, then proceed as described.)

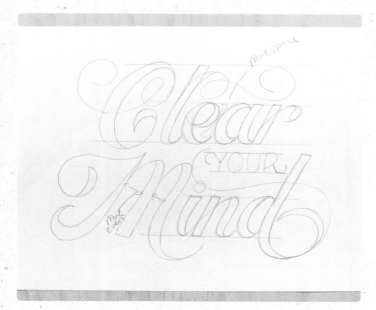

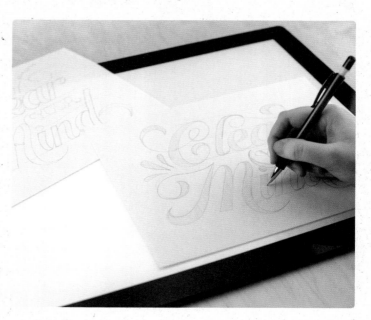

3 Add weight to the letters, applying it only to the downward strokes of each letter and making sure that its width stays consistent. Then, with a colored pencil, note corrections and ligatures you could add to fill the negative space.

4 On a blank sheet of paper, trace over the original drawing, adding ligatures and making improvements as you work. Add other elements and accents to fill any negative space. Finally, lightly fill in the letters to double-check the weight.

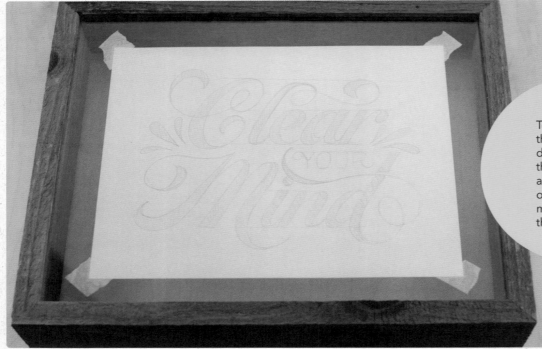

TIP

To help with placement, measure the height and width of the drawing and draw a small dot in the exact center. Next, measure and mark the exact center of the outside of the glass, using a chalk marker. Simply line up the dots, then tape your paper in place.

5 Remove the glass from the shadow box. Carefully position your final drawing on the underside of the glass, then tape down all four corners.

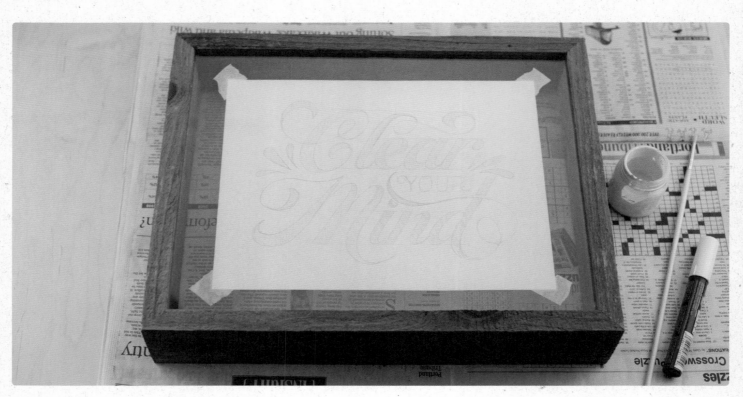

6 Set up your painting area by putting down newspaper to keep your area clean, gathering all necessary tools, and pouring small quantities of paint and paint thinner into disposable cups or other containers.

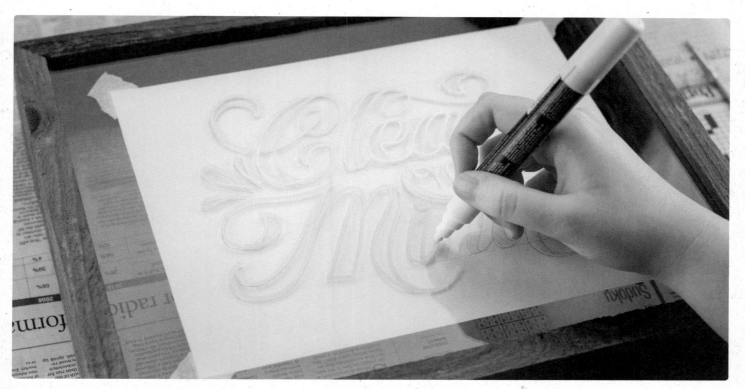

7 Using a chalk marker, trace the outline of the lettering and accents on the glass, tracing not the lines themselves but rather immediately inside of them.

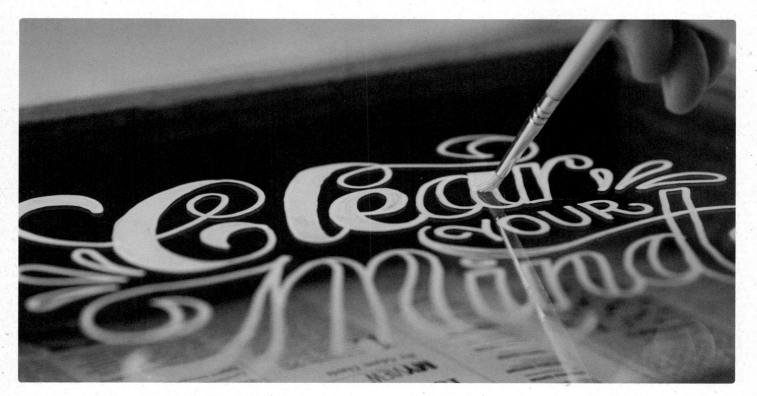

8 Remove the paper from the inside of the glass. Use the thin paint brush to carefully fill in the outlines. Cover the lettering com-pletely in paint so no light shines through.

Drop Cap Journal

This project puts all the focus into creating one decorative letter inked on the front cover of a journal or sketchbook. Having only one letter requires a lot of experimentation and thinking outside the box to come up with a design that's attractive yet legible.

Lettering Style Used
Black Letter

Materials
Printer paper
Journal or sketchbook,
 8 ½ x 5 inches
 (21.5 x 12.5cm)
Transfer paper
Masking tape

Tools
Mechanical pencil
Eraser
Ruler
Light box (optional)
Colored pencil
Thick black
 permanent marker
Thin black
 permanent marker

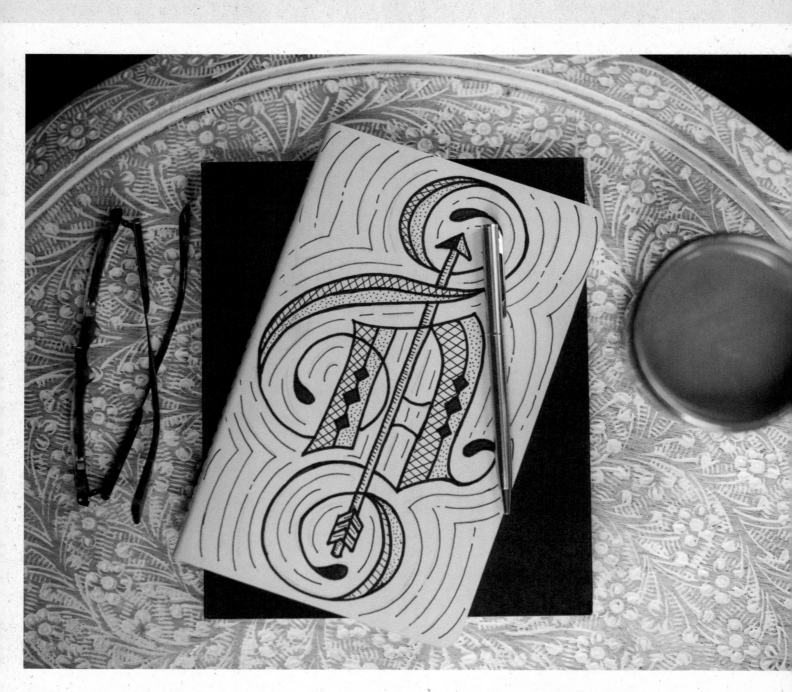

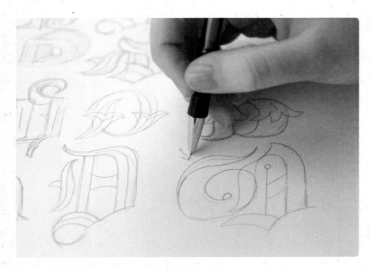

1 Draw as many different styles of the desired letter as you can think of, using a mechanical pencil on a blank sheet of printer paper. As you create more and more thumbnails, you'll find there's a style that you keep returning to. Continue drawing that one over and over, coming up with different ways to add flourishes, spurs, and inline decorations to it.

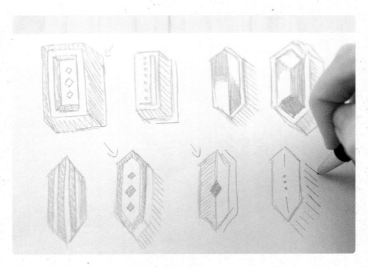

2 On a new sheet of paper, sketch a number of vertical rectangles and draw some different inline and outline decorations within them. This can include different kinds of drop shadows, outlines, and shading techniques. Choose your favorite to draw in the next step. (This is a way to quickly test out graphics without having to redraw the letter every time.)

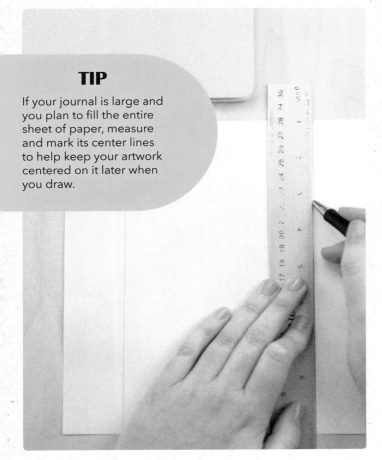

TIP

If your journal is large and you plan to fill the entire sheet of paper, measure and mark its center lines to help keep your artwork centered on it later when you draw.

3 Using a ruler, measure the cover of the sketchbook or journal. On a blank sheet of paper, sketch an artboard that size. Draw the vertical and horizontal center lines in it.

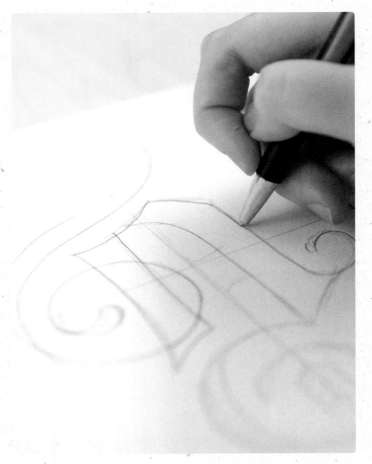

4 Draw your letter lightly, roughing in the lines and filling up as much of the artboard as possible. As you start to finalize your composition, press harder and harder with your pencil to create smoother lines.

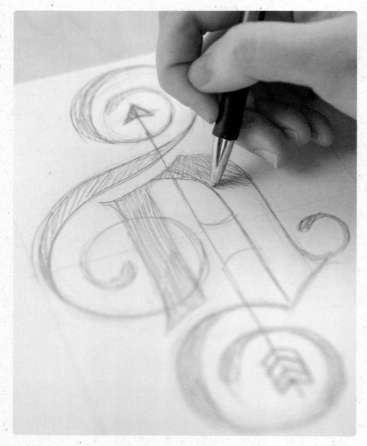

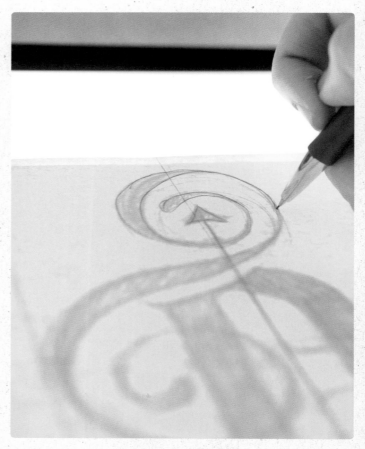

5 Once the line work is complete, lightly fill in the letter to help you visualize whether the line weights are consistent.

6 Place the drawing on a light box, put a blank sheet of tracing paper on top of it, and trace your artboard and center lines. (Alternately, use the window method.) Lightly pencil in a ¼-inch (6mm) margin on the inside of the artboard. Then trace over your initial draft, staying within the margin and making subtle improvements as you go.

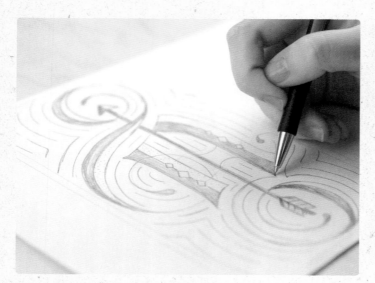

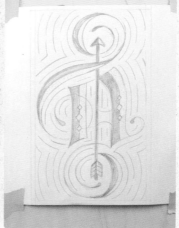

7 Remove the work from the light box. Add inline and outline decorations. Then shade the letter.

8 Wrap the front of the journal or sketchbook in transfer paper and tape the edges down. Then place your final pencil drawing on top of the transfer paper and tape that to your desk.

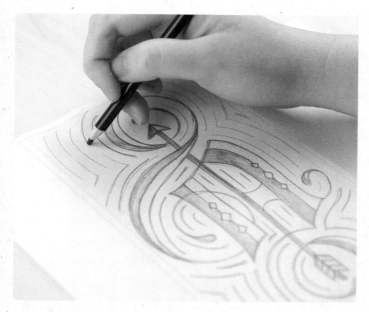

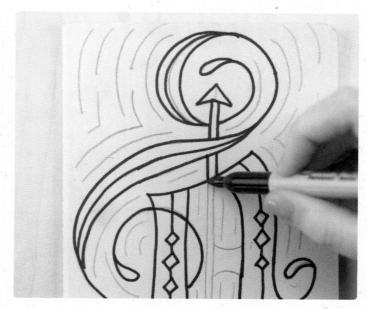

9 Using some pressure, trace over the line work with a colored pencil so you can keep track of which lines you've transferred over. Then untape just one end of the paper and check the ghost image beneath to make sure your design came through. (If not, trace again.)

10 Remove all the paper taped to the journal or sketchbook. Using a thick marker, trace over just the main lines of the lettering.

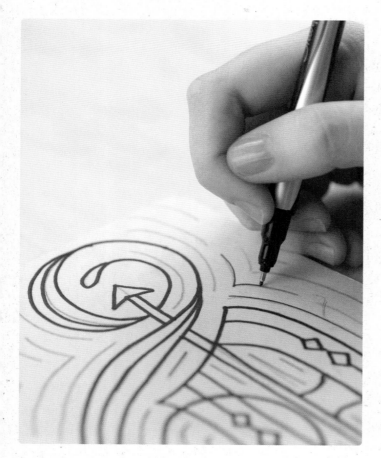

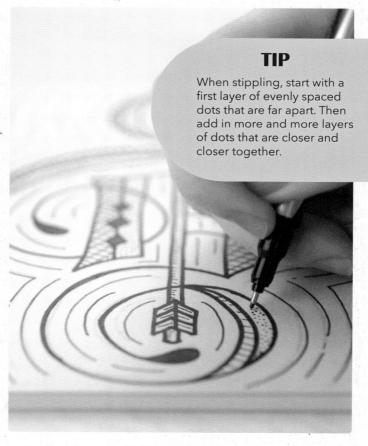

TIP

When stippling, start with a first layer of evenly spaced dots that are far apart. Then add in more and more layers of dots that are closer and closer together.

11 Use a thin permanent marker to draw all of the inline and outline decorations.

12 Erase the pencil marks. Then stipple inside the unfilled sections of the letter. This technique consists of nothing more than making dots, in this case until you achieve a soft gray fill.

Inspirational Canvas

In this project, you'll paint your letters on a stretched canvas. You'll learn how to add layers of paint to give your work more depth while playing with paint texture to give the piece more vibrancy and life.

Materials
Printer paper
Tracing paper
Pre-stretched canvas,
 16 x 20 inches
 (40.5 x 51cm)
Old newspaper
Up to five shades of
 enamel paint
Disposable plastic cups
Paint thinner
Paint brushes
Paper towels
Fixative

Tools
Mechanical pencil
Eraser
Light box (optional)
Scanner, digital camera,
 or camera phone
 (optional)
Tablet, laptop, or
 computer (optional)
Projector (optional)
Brushes

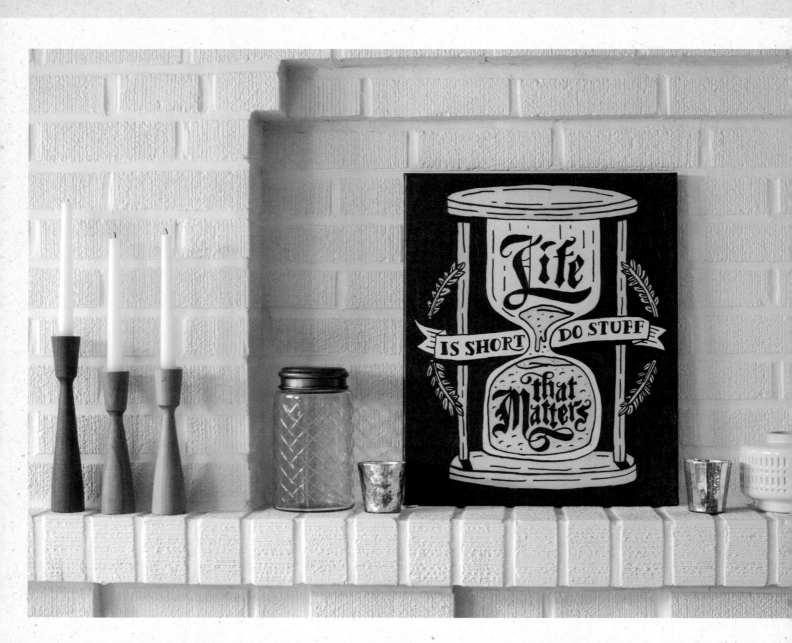

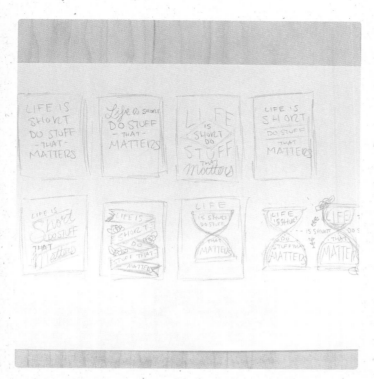

1 Create at least five vertical thumbnails, experimenting with different compositions and emphasizing different words.

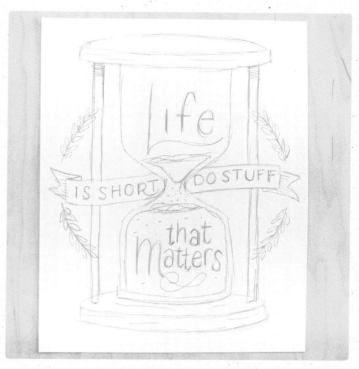

2 Select your favorite of the thumbnails. Create a first draft of it on a new sheet of paper, filling the entire page. Roughly sketch the skeletons of the letters, as well as any illustrations.

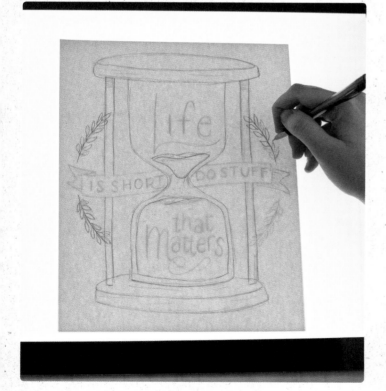

3 Using a light box—or the window method—trace the design onto a new sheet of paper, perfecting it as you go.

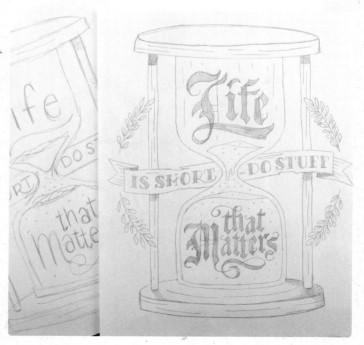

4 Continue fine-tuning the design over several rounds of retracing. In this phase, add weight, style, embellishments, and other details.

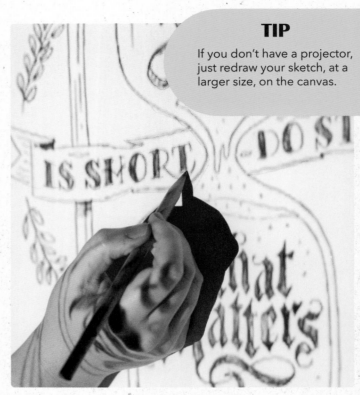

TIP

If you don't have a projector, just redraw your sketch, at a larger size, on the canvas.

5 Attach a new sheet of tracing paper atop your sketch. You'll use it to plan the colors you want to use on the canvas. Choose three to five colors, and write that color's initial on the sketch anyplace you intend to use that shade.

6 Scan or photograph your final artwork. Take the necessary steps to pull it up full screen on a tablet or laptop. Plug the device into the projector, then project your image onto the canvas so it fills the entire surface. Focus it. Use a pencil to lightly trace the design onto the canvas.

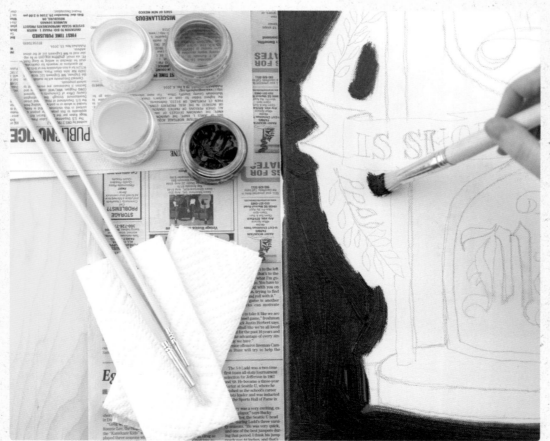

7 Cover your work area with newspaper to keep it free of paint spatters. Pour a small quantity of paint from the original container into disposable cups or small containers (they're more manageable). Do the same with paint thinner. Then, with a large brush, paint the background color on the canvas, filling in the space just shy of the pencil marks.

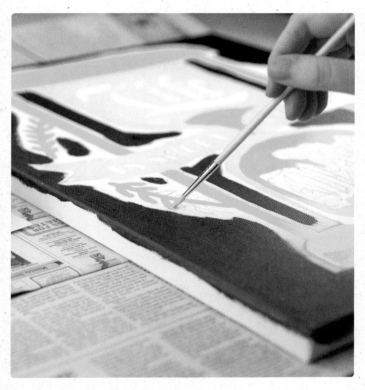

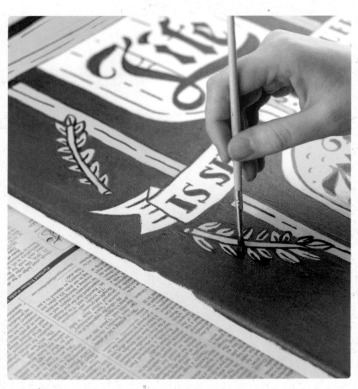

8 Using a brush of the appropriate size (larger for big areas, smaller for tight areas), fill in the rest of the blocks of colors, painting just shy of the pencil marks. Do not let the colors overlap. After painting, let the canvas dry for about 15 minutes.

9 With a fine brush and black paint, paint all the outlines, lettering, and line work. After you finish, let the paint dry for about 15 minutes.

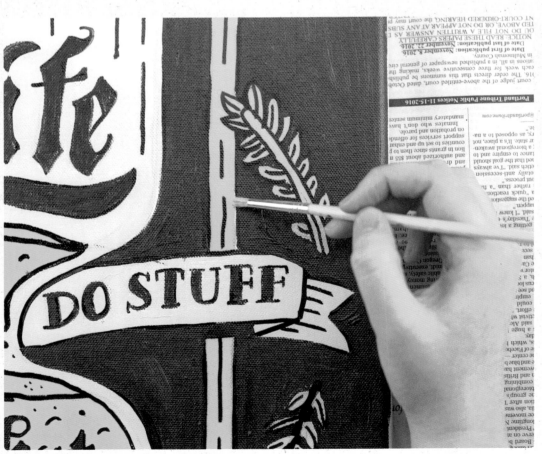

10 Check closely for spots where the canvas still shows through the paint. Using a fine brush and the appropriate color, carefully paint over them. Allow to dry overnight.

Once the piece is completely dry, take it outside or to a well-ventilated area. Standing at a distance of 3 feet (91.5cm) from the canvas, spray it evenly with fixative. Avoid spraying too close to the canvas, because you'll make the paint darker, and these blemishes won't fade.

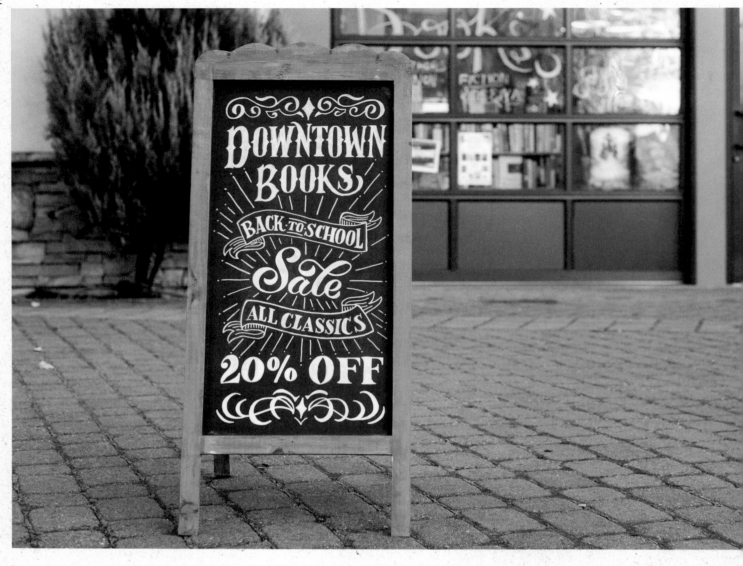

DOWNTOWN BOOKS
BACK·TO·SCHOOL
Sale
ALL CLASSICS
20% OFF

Sandwich Board

Use vintage lettering styles on a chalkboard sandwich sign to advertise your event—like a sale on classic books. Retro styles like Victorian combine well with serifs and varied script on a board jam-packed with many refined details.

Lettering Styles Used
Victorian
Varied Weight Serif
Varied Weight Script

Materials
Printer paper
Sandwich chalkboard
Cotton swabs

Tools
Mechanical pencil
Eraser
Ruler and/or yardstick
Scanner, digital camera, or camera phone (optional)
Tablet or laptop (optional)
Projector (optional)
Fine-tip chalk marker
Bold-tip chalk marker
Towel

TIP

Some sandwich boards don't have real chalkboards in them, so their surface won't accept chalk. Check whether your sandwich board requires chalk markers or actual chalk.

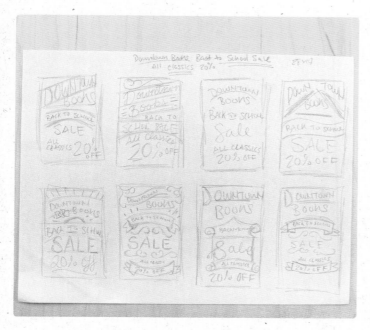

1 On a blank sheet of paper, sketch several outlines shaped like the chalkboard. Draw small rough thumbnails of your lettering inside them. Experiment with the hierarchy of your wording, as well as some ideas for supporting decorations.

2 Measure your chalkboard. On a blank sheet of paper, sketch an artboard that fills up the page and has the same aspect ratio as the chalkboard. For example, if your chalkboard is 28 x 14 inches (71 x 35cm), that's a 2:1 ratio, and your sketch will be roughly 11 x 6 inches (28 x 15cm).

3 Select your favorite thumbnail. Refering back to it, sketch guidelines for lettering inside the box.

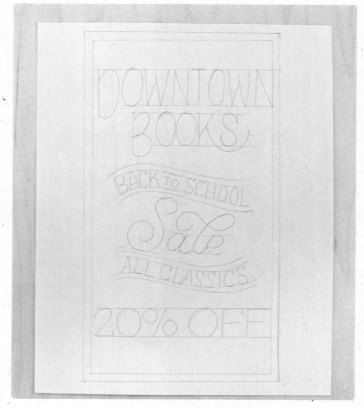

4 Using pencil, lightly draw the skeletons of the letters between the guidelines.

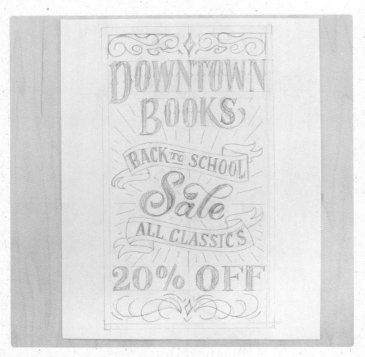

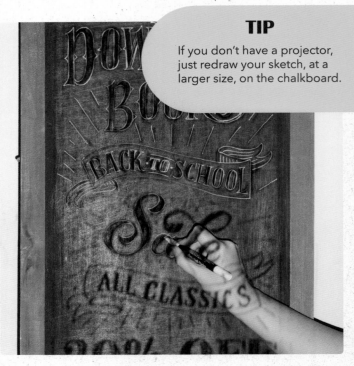

5 Add weight to the letters, along with decorative elements like filigree and banners. Add details like serifs and spurs, as well as additional lines to fill up the negative space.

6 Scan or photograph the artwork. Take the necessary steps to pull it up full screen on a tablet or laptop. Plug the device into the projector, then plug the projector into your computer and project the image onto the sandwich sign. Use a fine-tip chalk marker to lightly draw the outline of your piece.

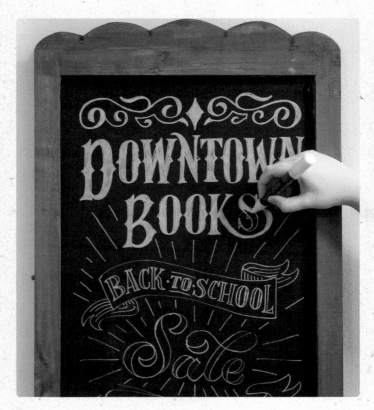

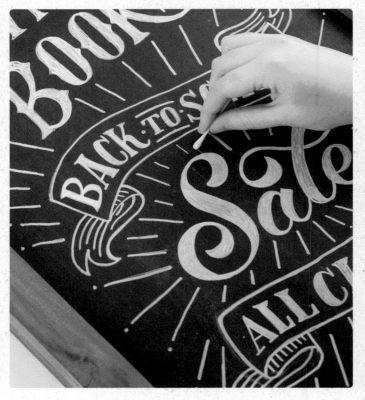

7 Unplug your projector and review your tracing. Use both the fine-tip and bold-tip chalk markers to draw the lettering, and to perfect the additional elements.

8 Clean up any guides and unwanted lines using a damp towel and damp cotton swabs.

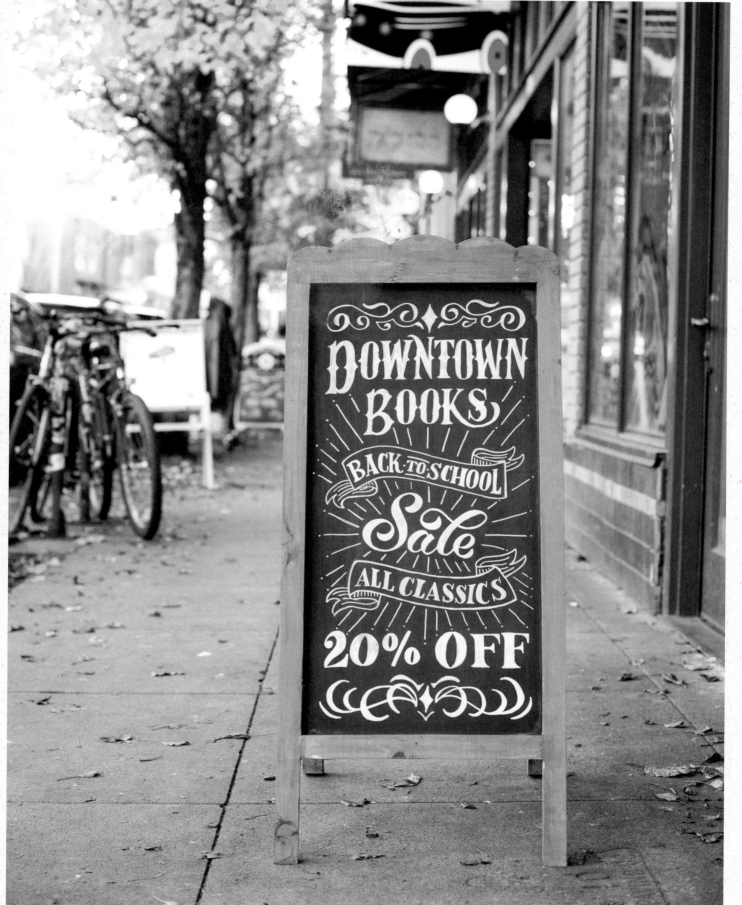

Logo Design

This project shows a logo developed for a fictitious food and travel blog. A strong logo design has the ability to work in several ways—as both a heading image for a blog and on a business card, for example. In this project, you'll learn how to create a successful, eye-catching logo and vectorize it in Illustrator.

Lettering Styles Used
Monoweight Script
Monoweight Sans Serif

Materials
Printer paper

Tools
Mechanical pencil
Eraser
Light box (optional)
Thick black
 permanent marker
Thin black
 permanent marker
Scanner
Photoshop
Illustrator

Creative food in an artful environment

APRIL 29, 2014 TRAVEL • TRAVEL • TRAVEL

I collect rock band T-shirts. Maybe you collect old telephones or chibi figures. But how often do you get to see the cool things collected by living artists? Well, you can at the Collections Café, the museum restaurant at the Chihuly Gardens and Glass in Seattle, Washington. The gardens feature

SHARE ON

FOLLOW ME ▸

ABOUT ME

There only one thing I love more than travel—food! Five years ago, I decided to combine my passion for both those things in this blog, which chronicles my journey as I nosh my way across the globe. Join me in discovering new ingredients, delicious dishes, topnotch restaurants and exotic locales.

Read more

Before you begin

When designing a logo, it's important to dive deep into the mission and objective of the business so you can better illustrate the company to its customers. At every stage, make sure that your design decisions are based on the aims of the business rather than on your personal preferences. Before beginning, ask yourself these questions so you can design around the right goals.

- What does the organization do, and why does it matter?
- Who are you trying to target?
- How do you attract your customers?
- How do you want people to feel when they see the logo?
- Where will this logo be used the most?

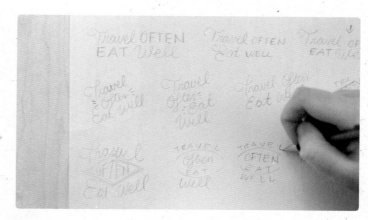

1 Once you've done your research, write the words in the logo on a blank sheet, then draw small thumbnails that explore both vertical and horizontal orientations.

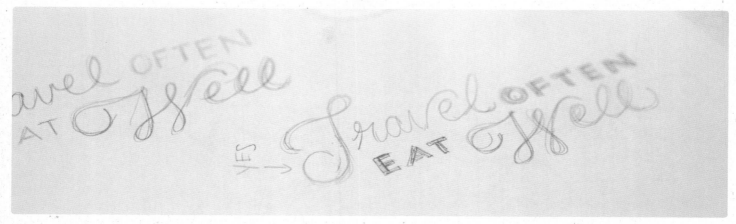

2 After the initial thumbnails, work larger on a new sheet of paper, tweaking what you like and slowly getting rid of the elements of the design that you think aren't working as well.

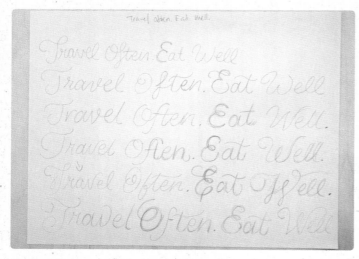

3 On a blank sheet of paper, choose the type styles you want and do some type studies to find the best way to execute each letter.

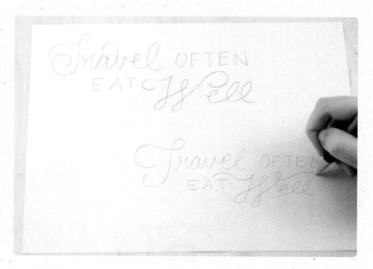

4 Pick out the best styles and draw the same composition a few times, making subtle variations in weight, position, and ligatures. Try out every idea you have, experimenting to see if it works toward the client's goals.

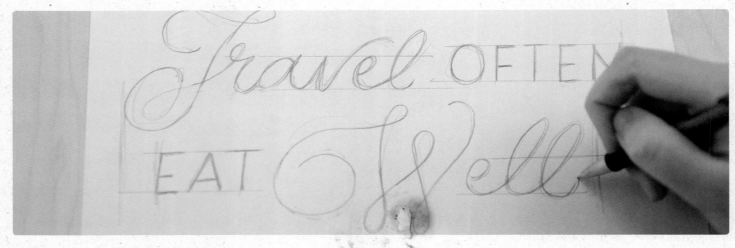

5 On a new sheet of paper, draw the best concept and refine it in pencil.

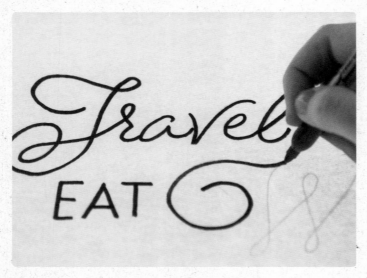

6 Place the piece of paper face up on a light box. Place a new sheet of paper over it, and ink over the pencil draft, using a thick permanent marker to add some weight to your lettering. (If you don't have a light box, use a different transfer method.)

7 Ink over the outlines with a thin marker to help make the lines smoother, even, and rounded at the ends.

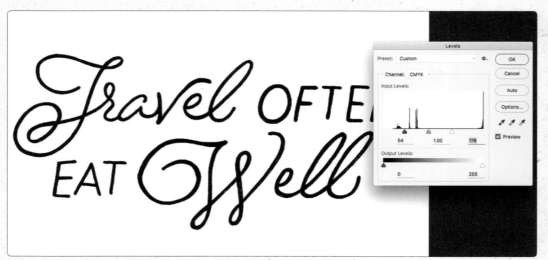

8 Scan in your work as as a TIFF. Open the scanned file in Photoshop. On each layer, go to **Image > Adjustments > Levels** to pull up the dialog box. Then pull in the white and black levels toward the center until your artwork is completely black and white. Keep in mind that the more white you pull in, the more textured your artwork will look.

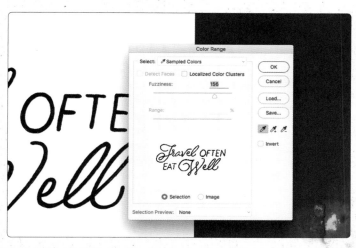

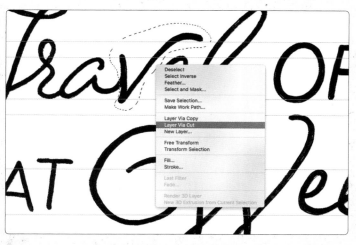

9 To remove the background of each layer, go to **Select > Color Range** and select the white background with the color picker. When you see dancing ants all over the page, press **Delete**.

10 Use the Lasso Tool to cut and move around the letters. Just draw around them using the **Lasso Tool > Right Click > Click Cut > Edit > Transform,** and use the **Transform Tool** to move, skew, and rotate them as desired.

11 Use the **Eraser Tool** to make your lettering thinner and remove any scuff marks. Then use the **Brush Tool** to fix any uninked gaps in your letters or add extra elements.

12 Save your file by going to **File > Save As** with the Layer turned on.

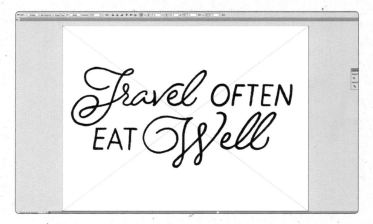

13 Open Illustrator CC 2015.5. Open a new 8 ½ x 11-inch (21.5 x 28cm) document by going to **File > New.**

14 Place the PSD file into the document using **File > Place.**

15 Click on your file, select the drop-down arrow near the Image Trace button, and select the **Black and White Logo** option. Your logo now looks smoother.

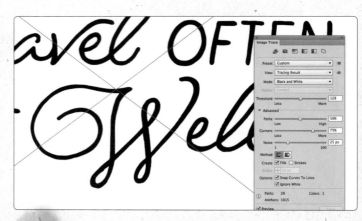

16 To adjust the settings, click on the **Image Trace Panel** at the top right of the menu. Click on the drop-down arrow on **Advanced** and adjust the levels until you get the best trace result for your logo. Check **Ignore White** to prevent any white background from being traced in the design.

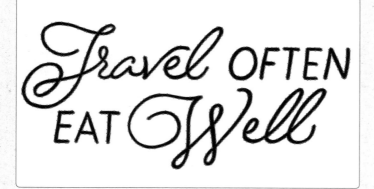

17 Click on **Expand** on the top left to lock in your trace. Blue anchor points will appear on your lettering. Now your logo is vector, meaning that no matter how big you enlarge it, it will never lose quality.

18 In the next few steps, you'll add color. First, right click on the text and select **Ungroup,** then group together each word by going to **Object > Group.**

19 Go to your right menu and select **Artboards.** Drag your current artboard to the **New Artboard** button to duplicate your page.

20 Add a box by clicking on the **Rectangle Tool** in the left menu and dragging your cursor to fit the shape of the box surrounding the design. Then go to **Object > Arrange > Send to Back** to put the box in the background.

21 Click on the box and choose a color from **Color Menu** on the right. Repeat the same process for the elements of type until you have just the right color combination.

22 Go to **File > Save As** to save the logo as a PDF for print. Also save it as an AI file so you can easily make changes to the logo if necessary.

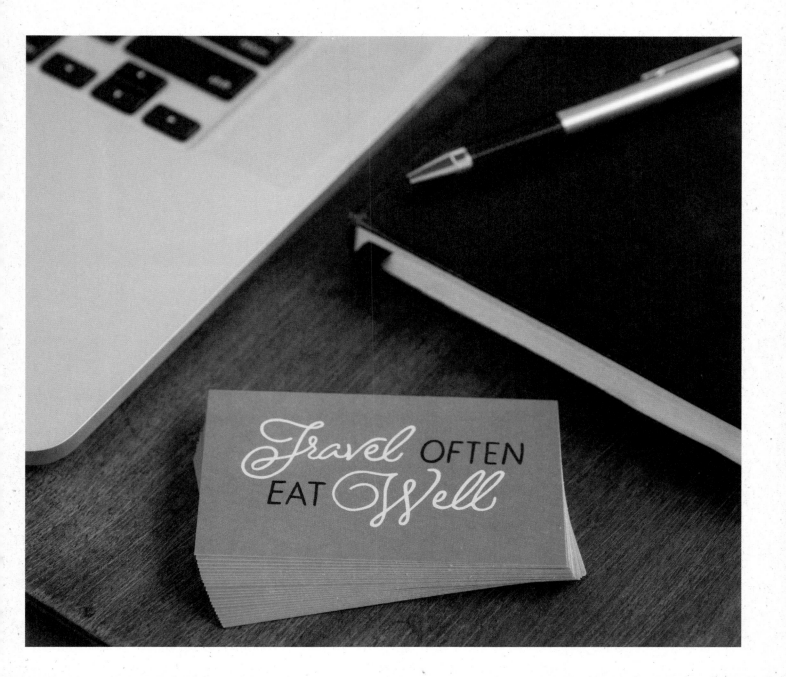

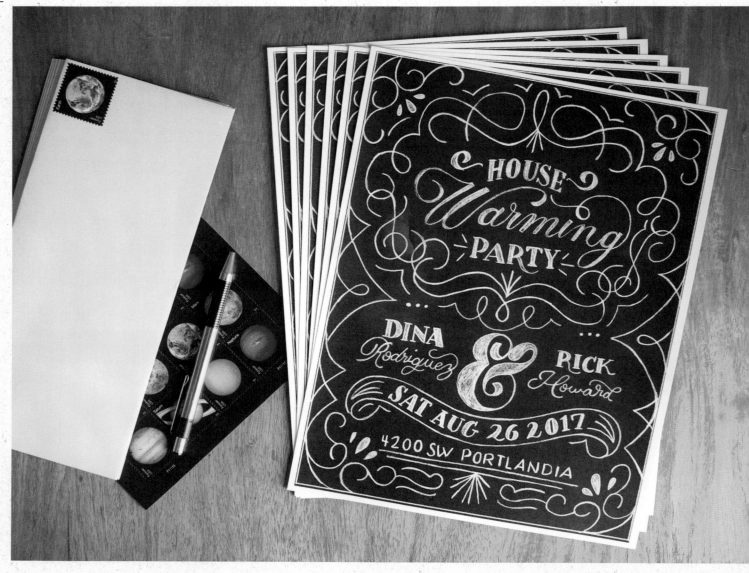

Housewarming Invitation

This announcement for a housewarming party uses chalk pencil on chalk paper to give a charming, handmade aesthetic. The point of this project is to fit a lot of information into a small space, while also filling up as much of the negative space as possible with filigree and decorations.

Lettering Styles Used
Varied Weight Script
Varied Weight Serif
Monoweight Sans Serif

Materials
Printer paper
Black chalk paper

Tools
Mechanical pencil
Eraser
Colored pencils
Light box (optional)
Ruler
Scissors
Scanner or digital camera (optional)
Tablet, laptop, or computer (optional)
Projector (optional)
Chalk pencil

1 On a blank sheet of paper, draw a number of small vertical rectangles. Inside them, create thumbnails of the main phrase. To represent the supporting details, such as the date and address, just draw a line. Experiment with the hierarchy of the words, as well as with different supporting decorations.

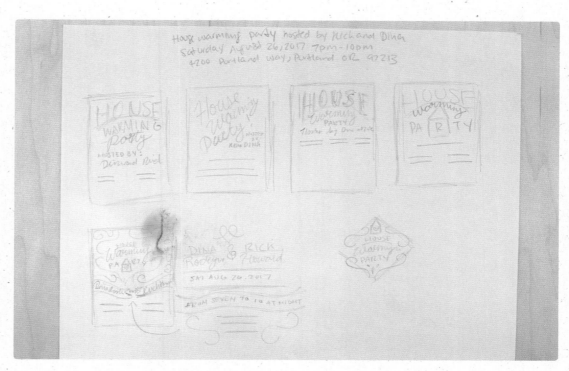

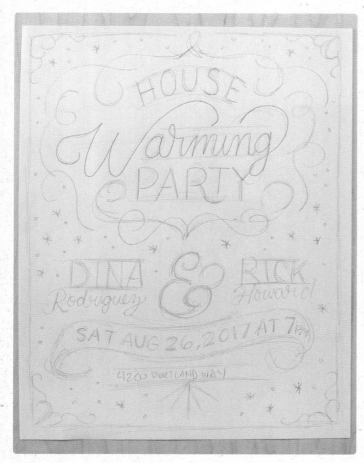

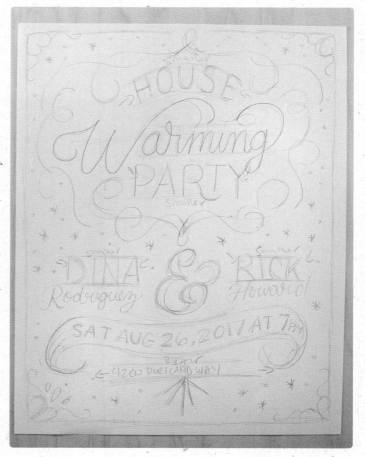

2 Select your favorite concept and sketch it full size on a blank sheet of paper. To do so, first sketch the artboard, then the containers in which to place the lettering, next the skeletons of the letters, and finally the overall shape of any borders and filigree.

3 Using a colored pencil, make note of any corrections and additional ideas for filling up the space.

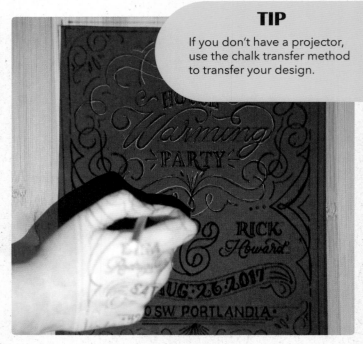

TIP

If you don't have a projector, use the chalk transfer method to transfer your design.

4 Using the transfer method of your choice, place a blank sheet of paper atop the artwork and use a pencil to lightly trace the design. As you do this, make adjustments to the drawing to perfect it. When you're satisfied with it, go over the entire drawing using more pressure to darken the lines.

5 If it's not already 8 ½ x 11 inches (21.5 x 28cm), cut a sheet of black chalk paper to that size. Scan or photograph your final artwork. Take the necessary steps to pull it up full screen on a tablet or laptop. Plug the device into the projector, then project your image onto the chalk paper so it fills the entire surface. Focus it. Use a chalk pencil to lightly draw the outline of the piece.

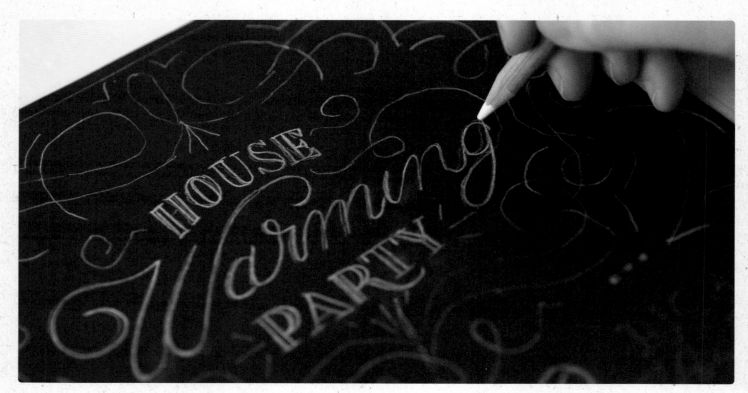

6 Turn off the projector. Go over the transfer lines again with chalk pencil and more pressure.

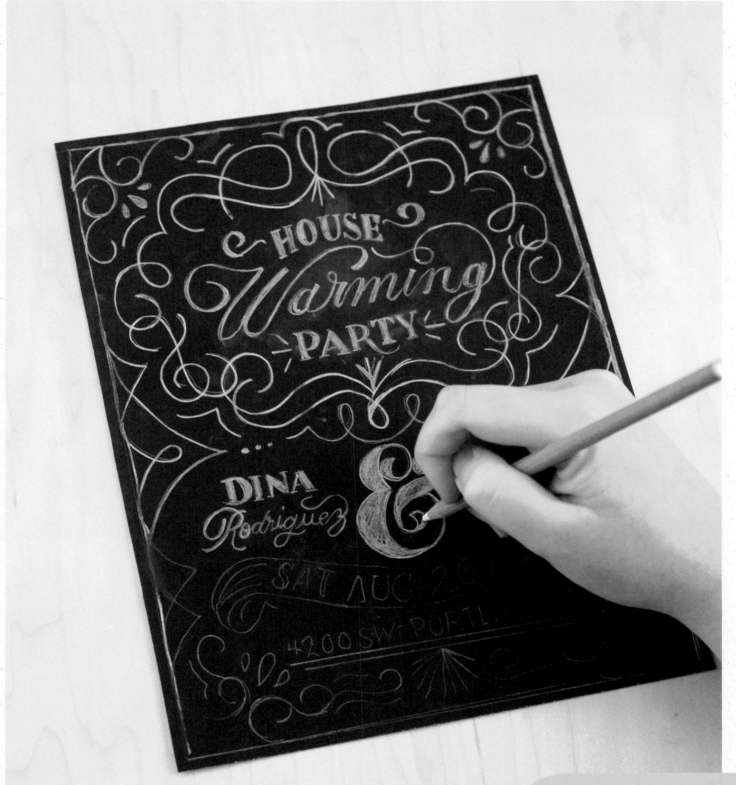

7 After drawing all the chalk outlines, lightly fill in the lettering with chalk. Make a high-quality scan of this final drawing, then print copies to hand out to friends and family.

VARIATION
To add some color to the piece, you can use colored pencils to accent it with outline graphics and decorations.

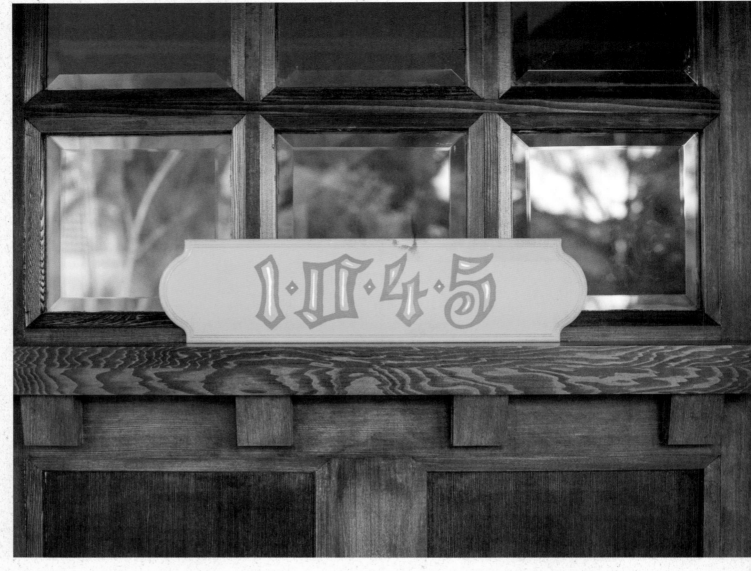

House Number

Using enamel paint and a precut wooden board, create a hand-painted number to hang on the front of your house. The goal is to create a sign that's not only attractive, but also clear enough to read from a distance.

Lettering Style Used
Black Letter

Materials
Printer paper
Wooden signboard,
 15 x 4 inches
 (38 x 10cm)
Tape
Transfer paper
Three shades
 of enamel paint
Disposable cups
Paint thinner
Tracing paper
Paper towels
Fixative

Tools
Mechanical pencil
Eraser
Ruler
Light box (optional)
Square paint brushes

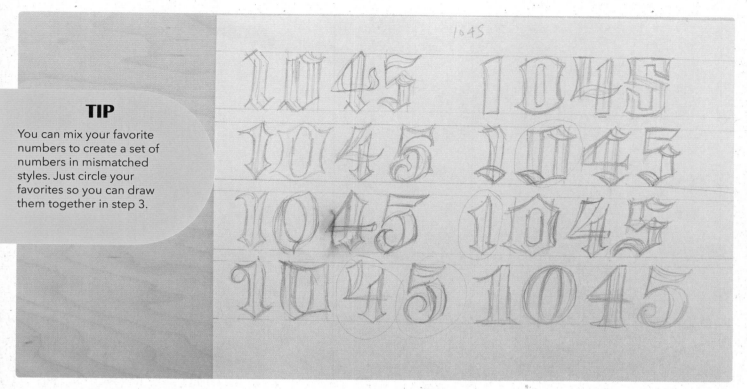

1 Write down the house number on a blank sheet of paper. Using a mechanical pencil, sketch 8 to 10 rough thumbnails of it, drawing it in different ways. Circle whichever ones you like the most.

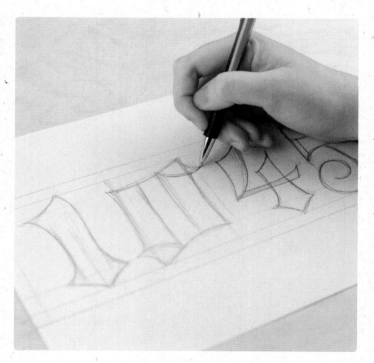

2 Tape two blank sheets of paper together, end to end. Trace the board on them, filling up the paper. Using a ruler, create a ¼-inch (6mm) margin on all sides of the box. This will serve as the container for the numbers.

3 Inside the container, lightly pencil in a first rough draft of the numbers. When you're satisfied with the drawing, press harder to draw the outlines.

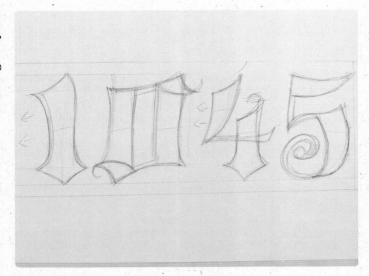

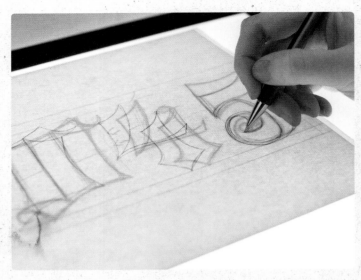

4 Double check your kerning, weight, and the visual balance. Make notes about what to correct right on the drawing, using a colored pencil so you can see them better later.

5 Place a new sheet of paper over the drawing, then trace over it using your preferred transfer method. Make adjustments to the design until you have a final draft that you're satisfied with.

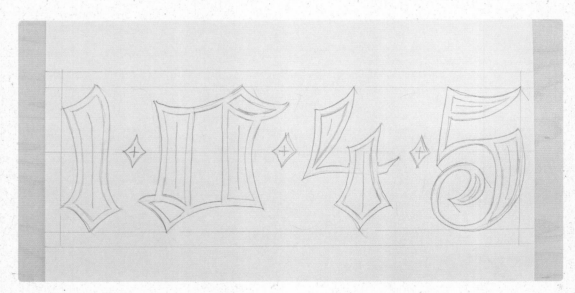

6 Draw additional details, such as inline graphics and decorative elements, to fill the negative spaces in the design.

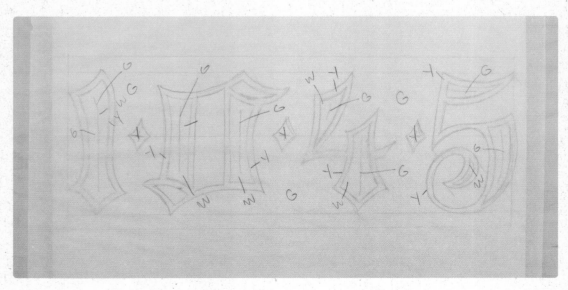

7 Place a sheet of tracing paper on top of the final draft. On it, jot down the initials of the colors you want to use, and where.

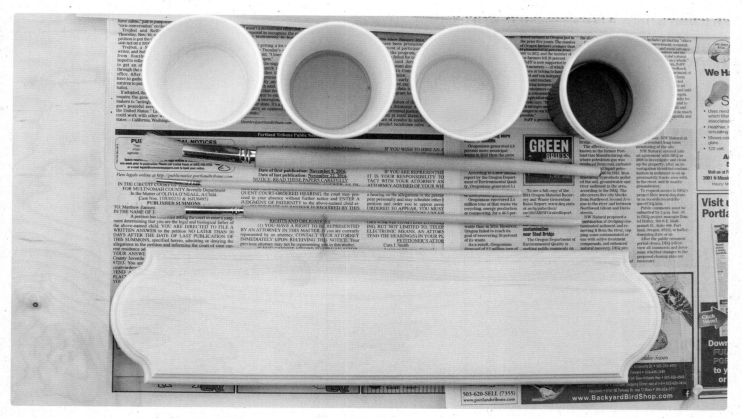

8 Set up your painting area by placing newspaper on your desk and floor to keep your area free of paint splatters. Pour out a small quantity of each paint into disposable cups, and do the same with paint thinner. You'll need a large square brush, a medium-size square brush, and a square detail brush.

9 Using a large brush, paint the front of the board with the background color. Let it dry for 10 minutes, then add another coat. Let the paint dry for another 10 minutes.

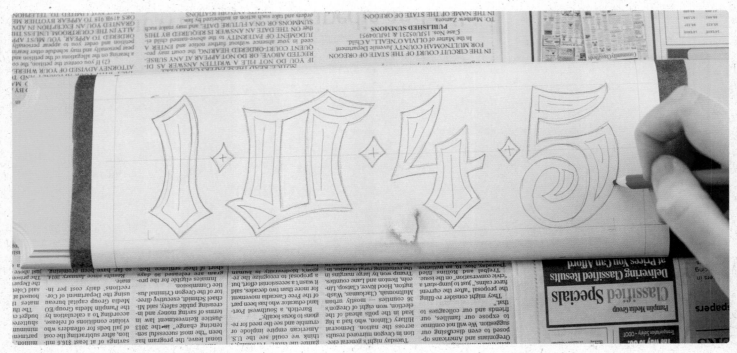

10 Wrap a sheet of transfer paper around the board and tape it down. Place the final drawing on top of the board, then trace the numbers (but not the inline decorations) with colored pencil, using a fair amount of pressure. Remove the tracing paper.

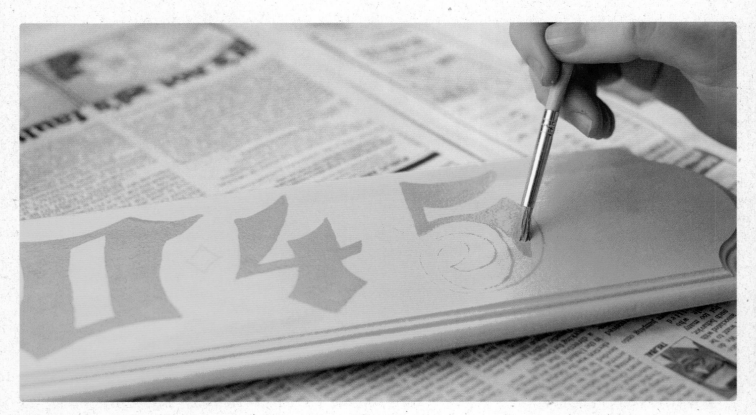

11 Dip your medium square brush in the desired color and paint the numbers inside the outlined depressions in the wood. Then, using a detail brush to help keep your lines smooth, paint any sharp points or details. Allow the paint to dry for 10 minutes.

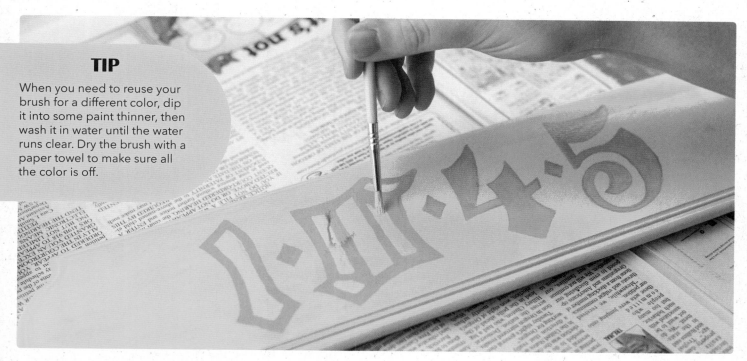

12 Use the detail brush and another color to paint the inline decorations, painting the outline first and then filling it in with color. Let dry for 10 minutes.

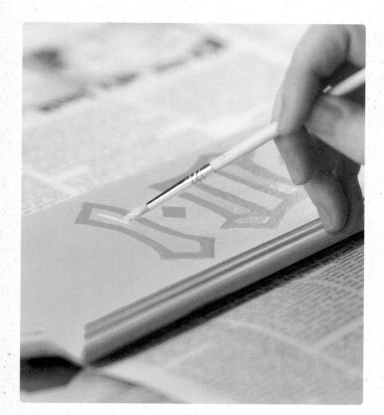

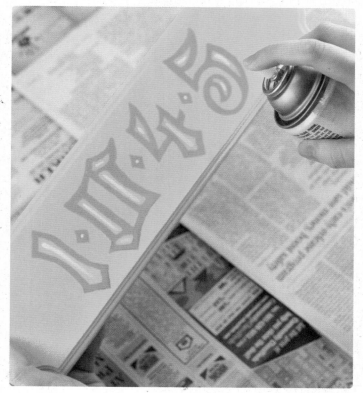

13 Using just the thickness of the detail brush and another color, paint any final line details. Let dry for 20 minutes.

14 Take the board outside (or someplace well-ventilated), stand about 3 feet (91.5cm) away from it, and spray a layer of fixative on it. Give the fixative at least 10 minutes to dry, then spray on a second coat.

Wedding Monogram

A monogram is the perfect opportunity to add a lot of detail to just a few letters. The challenge here is to find a creative way to connect the letters without compromising their readability.

Lettering Style Used
Plant

Materials
Printer paper
Tracing paper
Masking tape

Tools
Mechanical pencil
Eraser
Ruler
Fine-tip markers,
 08 and 03
Light box (optional)
Ballpoint pen
Scissors

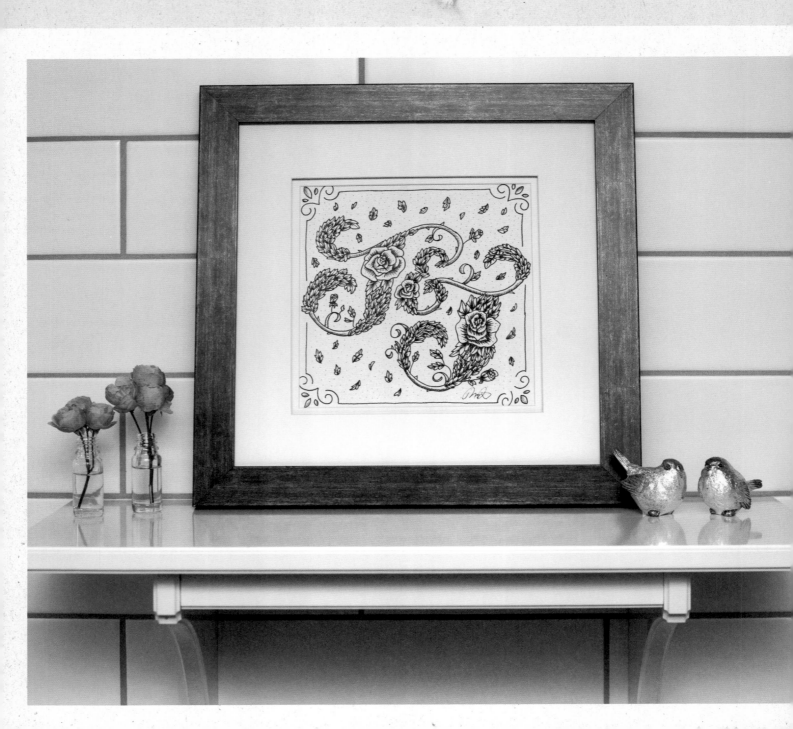

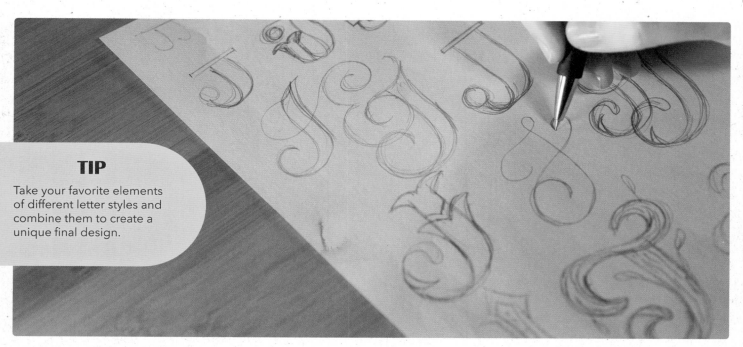

1 Explore different ways to draw each letter in various styles.

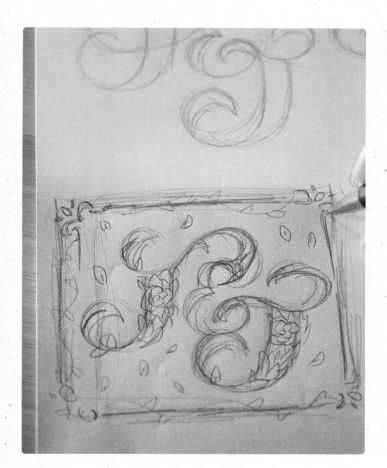

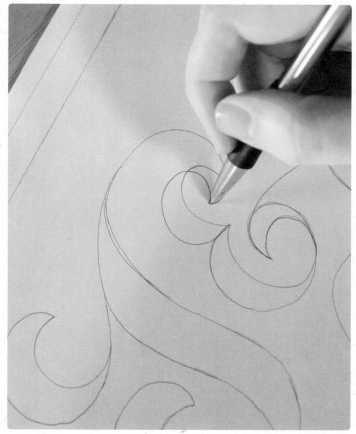

2 Create small rough thumbnails of different compositions for your monogram. For monograms like this, a square format is best.

3 On a new sheet of printer paper, use a ruler to draw the square artboard in which you'll draw your letters. In the center of the square, draw a large version of just the framework of the letters, without the plant forms.

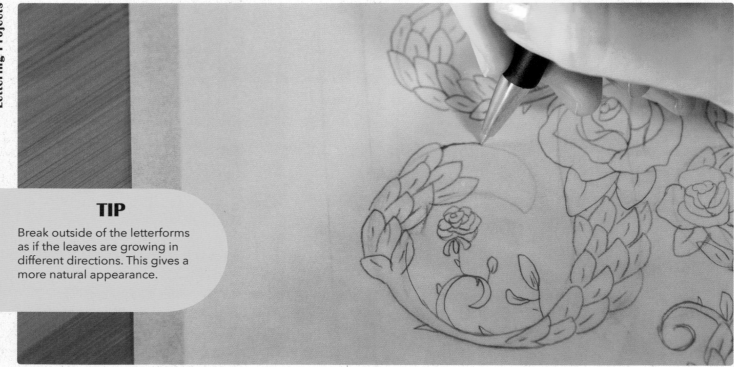

TIP

Break outside of the letterforms as if the leaves are growing in different directions. This gives a more natural appearance.

4 Place a sheet of tracing paper on top of your drawing. Then fill each letter with drawings of leaves and flowers. If you don't like what you've drawn, replace the tracing paper with a new sheet and draw something else.

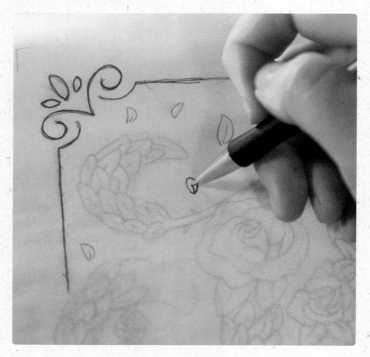

5 Place another sheet of tracing paper on top of the two drawings. Then draw any border or frames you would like to include on the exterior of the piece, along with any additional decorations to fill up the negative space.

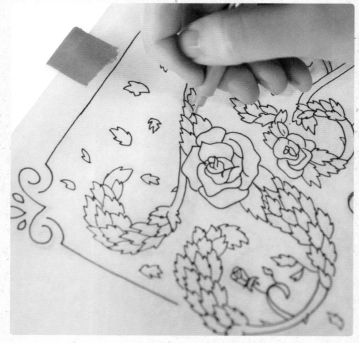

6 Place a sheet of printer paper on top of the stack of papers and tape all the pages together with masking tape. Place the stack on a light box or sunny window. Ink the borders or frames, the letterforms, and the exteriors of the plant forms with an 08 fine-tip marker. (Do not ink the square artboard in which you drew the monogram.)

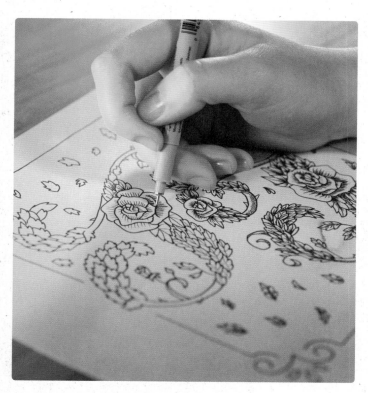

7 Untape the sheets. Using an 03 fine-tip marker, ink any remaining small details such as the inside stems of the plant forms and all shading. This adds visual variety to the width of the lines.

8 Place the sheet with the square drawn on it on top of the inked sheet. Place the sheets on a window or light box, with the *back* of the inked sheet facing up. Use a ballpoint pen and ruler to trace over the square on the back of the inked sheet.

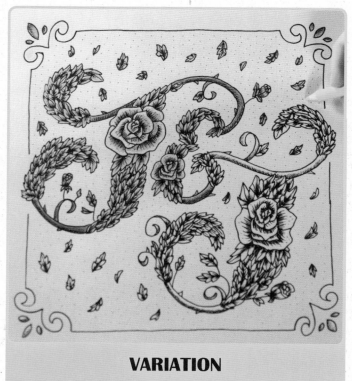

9 Using the square as a guide, cut your paper, making long cuts to create an even, straight line. Your artwork is ready to frame.

VARIATION

If you like, you can also color the design using colored pencils over the ink, just as you would do in a coloring book.

Place Cards

Mini chalkboard place cards create an impressive and festive seating arrangement for any party or event. They're especially fun at weddings. Remember, if you feel unsure about your lettering skills, draw on paper first, then transfer the design to the mini chalkboard. Because it's faster to erase mistakes in pencil, this will save you time.

Lettering Style Used
Monoweight Sans Serif

Materials
Printer paper
One chalk place
card per guest
Cotton swabs

Tools
Mechanical pencil
Eraser
Chalk pencil
Ruler

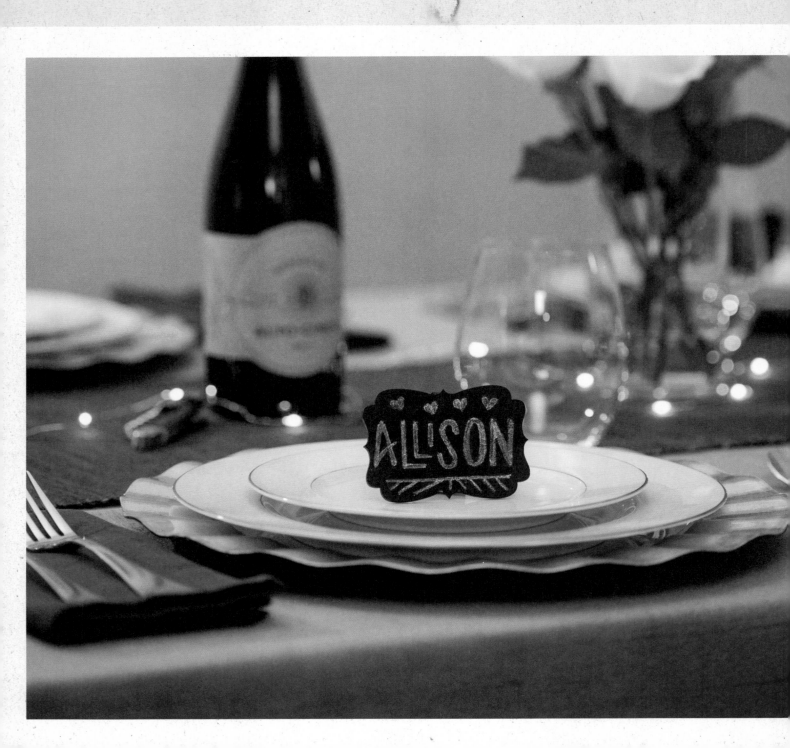

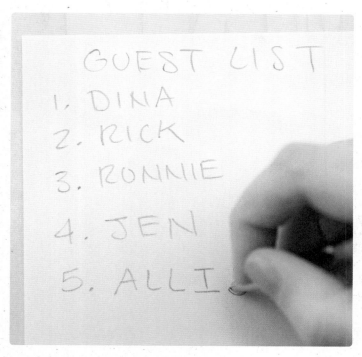

1 Using a mechanical pencil, write down your guest list on a blank sheet of paper.

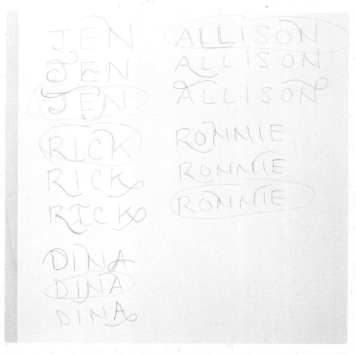

2 Draw each person's name in your normal handwriting first. Then try out different ways to draw each letter, using ligatures in a sans serif style. Circle your favorites.

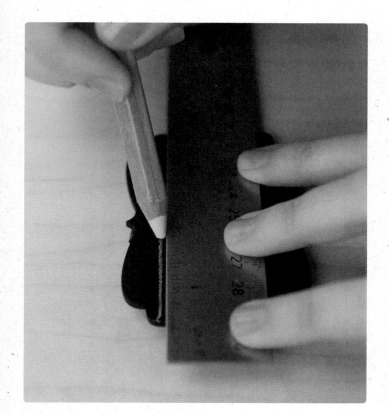

3 Place your ruler vertically across the center of a chalk place card. Draw two guidelines, one near the top and one close to the bottom, by dragging your chalk pencil along the top and bottom edges of the ruler.

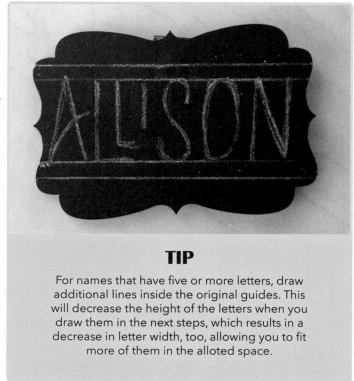

TIP

For names that have five or more letters, draw additional lines inside the original guides. This will decrease the height of the letters when you draw them in the next steps, which results in a decrease in letter width, too, allowing you to fit more of them in the alloted space.

TIP

You can letter the name in a more condensed manner to make it easier to evenly fill in the space. If you need to erase and start over, just use a dry paper towel to rub off the chalk.

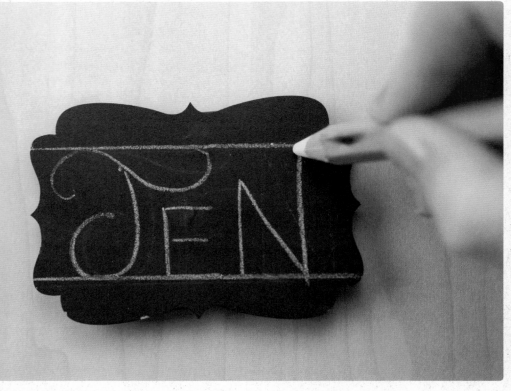

4 To draw each guest's place card, you'll repeat steps 4 to 8. Using the chalk pencil, begin by drawing the skeleton of a guest's name inside the guidelines, making sure it's centered and has even kerning.

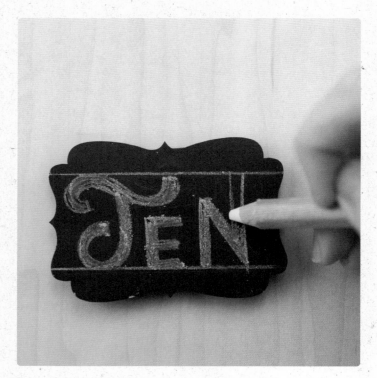

5 Add weight to each letter with your chalk pencil.

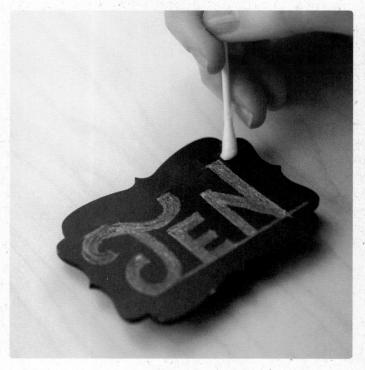

6 Using a dry cotton swab, erase all the guidelines.

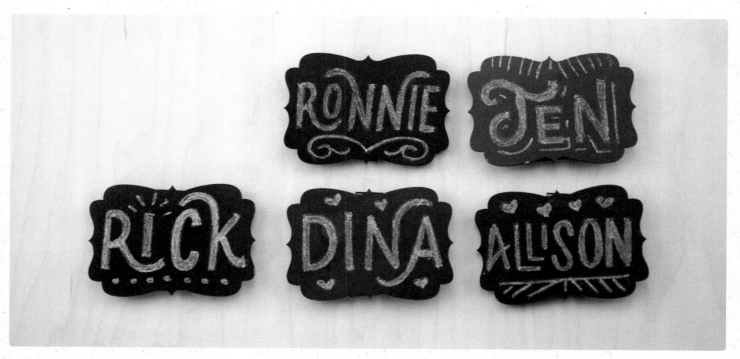

7 Using chalk pencil, add any embellishments such as sun bursts, dots, or hearts to fill in the negative space around the names.

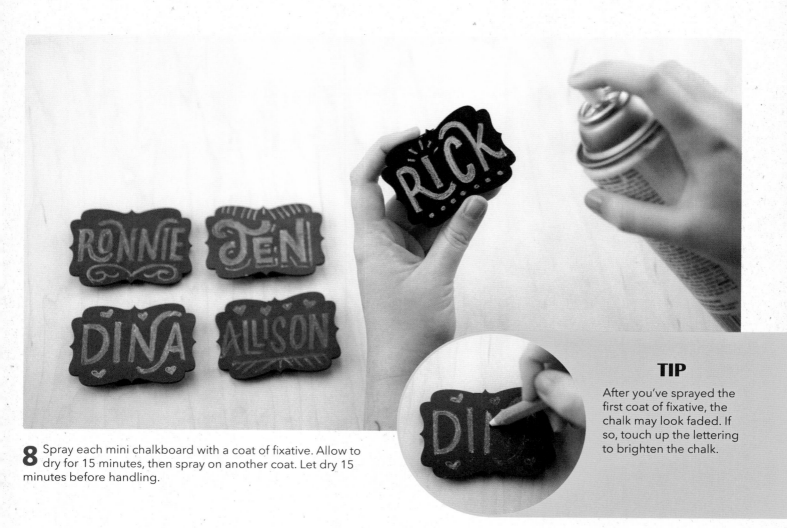

8 Spray each mini chalkboard with a coat of fixative. Allow to dry for 15 minutes, then spray on another coat. Let dry 15 minutes before handling.

TIP

After you've sprayed the first coat of fixative, the chalk may look faded. If so, touch up the lettering to brighten the chalk.

Pennant

Use fabric markers on a wool pennant to create a handmade banner that shows off your hometown pride! A vintage style like Victorian lettering gives an elaborate and decorative vibe to the design.

Lettering Style Used
Victorian

Materials
Printer paper
Masking tape
Wool pennant

Tools
Mechanical pencil
Eraser
Ruler
Colored pencil
Light box (optional)
Thick permanent marker
Fabric markers

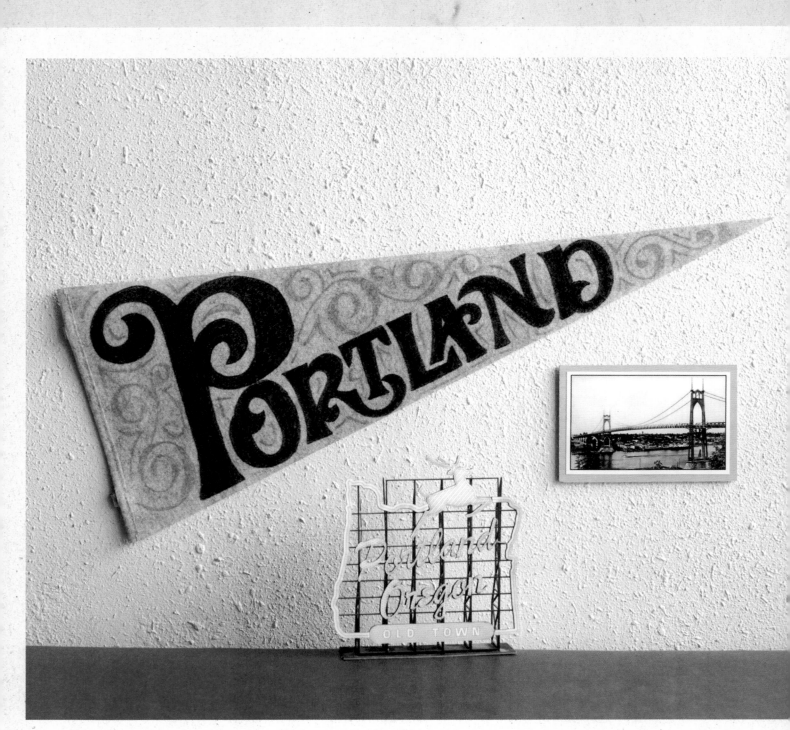

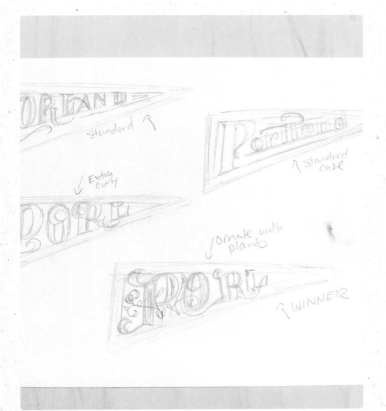

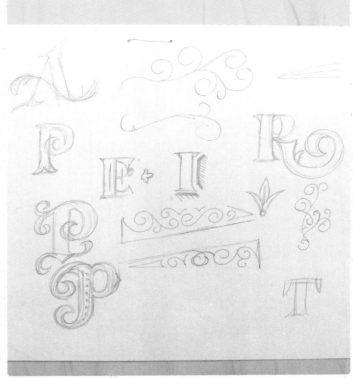

1 On a blank sheet of paper, draw several small rough outlines of the pennant. Sketch lettering inside them to create thumbnail drawings of the overall layout. Experiment with different styles of Victorian lettering, along with any interesting ligatures and connections you can think of.

2 On a new sheet of paper, draw some type studies to narrow down the style of the letters. Also sketch possible embellishments or decorations to use later, in the more finalized drawing.

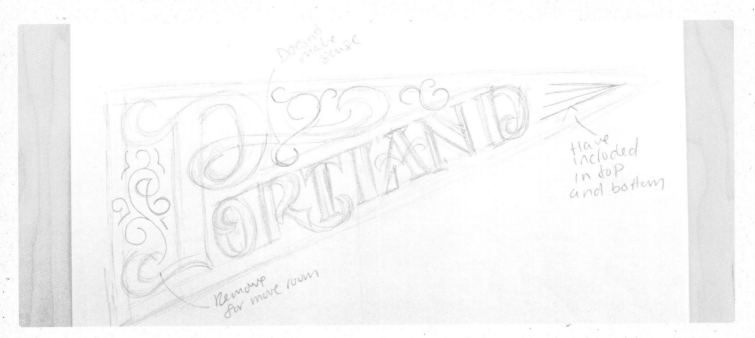

3 On a new sheet of paper, draw the design as large as possible, incorporating your favorite composition from step 1 along with type studies and the embellishments from step 2. Make notes and adjustments until you have a completed draft that you're satisfied with.

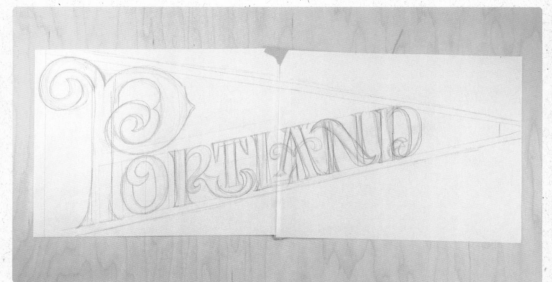

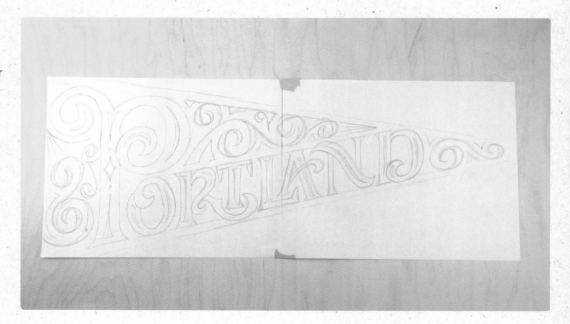

4 Tape two sheets of paper together end to end to create a drawing surface almost as large as the pennant.

TIP

Even taped together, the two sheets are slightly smaller than the pennant, but that's acceptable because you can't fit any text into the pointed tip.

5 Trace the outline of the pennant onto the taped sheets. Draw a ¼-inch (6mm) margin inside it to make sure the lettering doesn't run off the edges later. Inside the margin, redraw the lettering from your design. As you do, use colored pencil to make note of corrections and improvements to make.

6 To create the final pencil version of your piece, tape two more pieces of paper together end to end and, using the transfer method of your choice, transfer your design onto them, making improvements and adding decorations and embellishments.

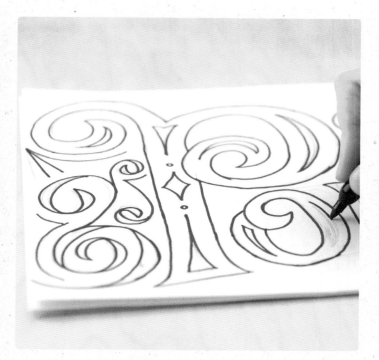

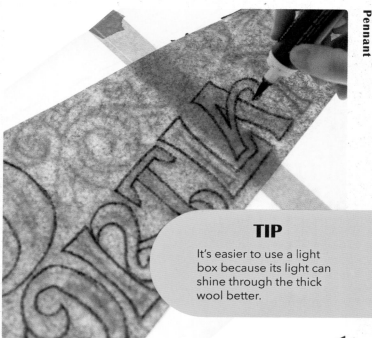

TIP

It's easier to use a light box because its light can shine through the thick wool better.

7 Trace over the pencil drawing with a thick permanent marker. It's fine for the pencil to show through. You don't need a perfectly finished drawing; you merely need lines dark enough to see in order to trace the drawing onto your pennant in the next step.

8 Place the pennant on top of the inked drawing. Using the transfer method of your choice and a fabric marker, trace over the outline of just the lettering, not the embellishments.

9 Using a fabric marker, fill in the letters, then let the ink dry for 10 minutes.

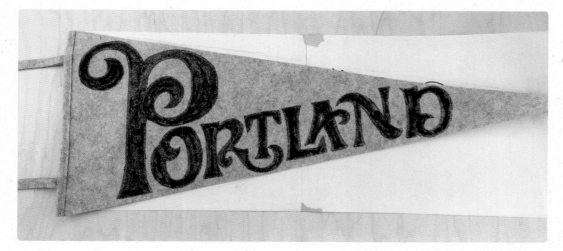

10 Place the pennant back on top of the inked drawing. Using the transfer method of your choice and a colored fabric marker, trace the exterior of any outline graphics and illustrations. Then fill in the outlines using the same color. Allow the ink to dry overnight before handling the pennant.

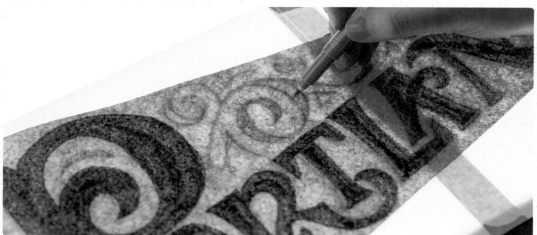

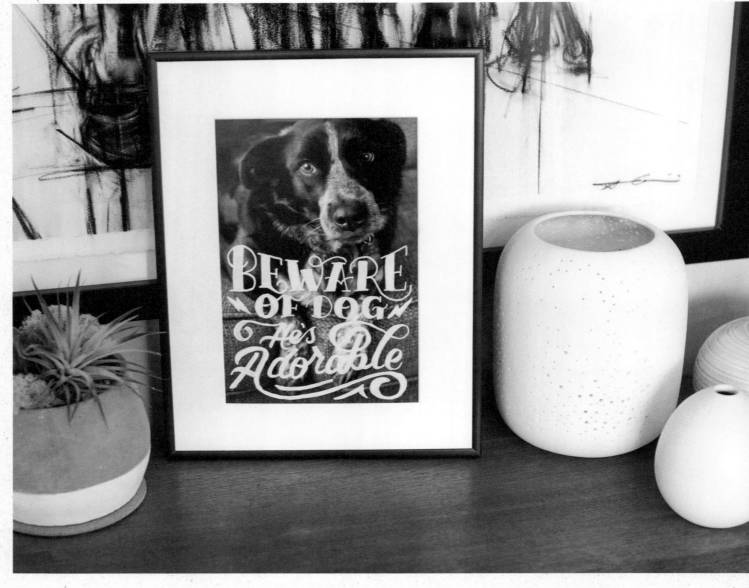

Lettered Photo

This project may take you out of your comfort zone because you'll paint directly on a photographic print—but you can handle it. You'll need to plan the lettering around the important elements in your photo. The objective is to highlight the most important parts of the image and place your message around them.

Lettering Styles Used
Brush Script
Tattoo

Materials
Printer paper
At least one photo print, 8 x10 inches (20.5 x 25.5cm)
Newspaper
White enamel paint
Paint thinner
Disposable plastic cups

Tools
Mechanical pencil
Eraser
Light box (optional)
Ruler
Thin and thick brushes
Chalk marker
Scanner, digital camera, or camera phone (optional)
Laptop, tablet, or computer (optional)
Projector (optional)

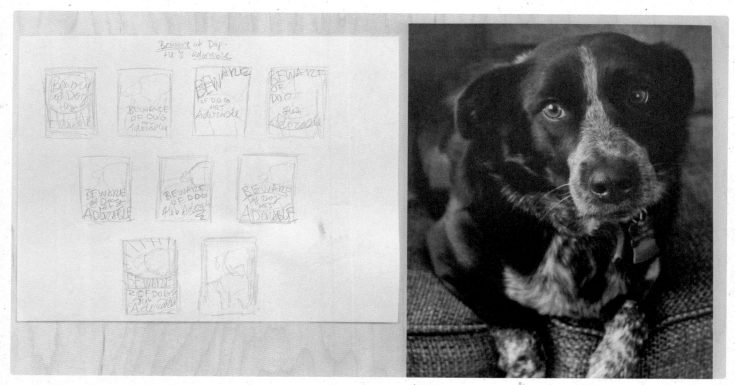

1 On a blank piece of printer paper, draw small boxes that have the same aspect ratio as the photo print. For example, if your photo is 8 x 10 inches (20.5 x 25.5cm), the aspect ratio is 2:2.5 and you would draw boxes that are 2 x 2 ½ inches (5 x 6.5cm). Inside the boxes, roughly sketch thumbnails of any elements you wish to feature in the final piece, to reserve a space for them. Then write the phrase around them, trying out different ways to present the words.

2 Put the photo on the light box (or on a window). Place a blank sheet of paper over it, and lightly trace over the photo, marking the edges and the main elements using a ruler and a mechanical pencil.

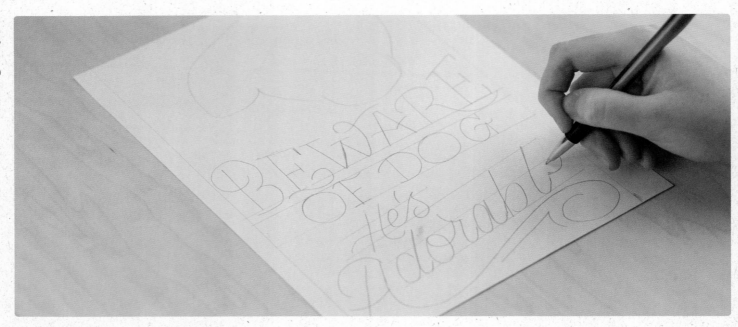

3 On the sheet of paper with the tracing, sketch the large version of the thumbnail you liked best. To do so, first draw the containers inside of which your letters will go. Then draw the skeletons of the letters.

4 Draw ligatures coming off the letters, as well as additional accents to fill negative space in the design.

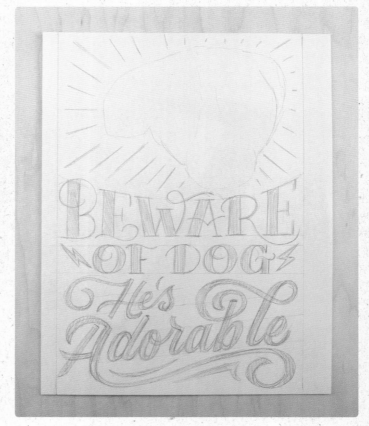

5 Add weight and assorted details to finalize the design. Then lightly fill in the lettering to check that the weight is correct.

6 To set up your painting area, put down newspaper around your workspace, pour small cups of paint and paint thinner, and gather paint brushes and a chalk marker.

TIP

If you don't own a projector, you can either eyeball the placement of your letters on the photograph as you paint in steps 7 and 8, or you can cut your letters away from the paper and use the sheet as a stencil of sorts for marking letter placement.

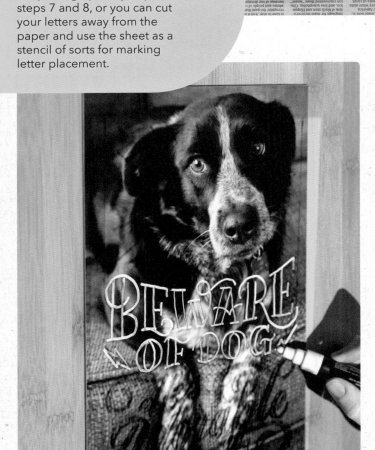

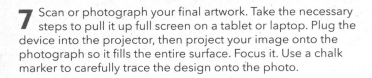

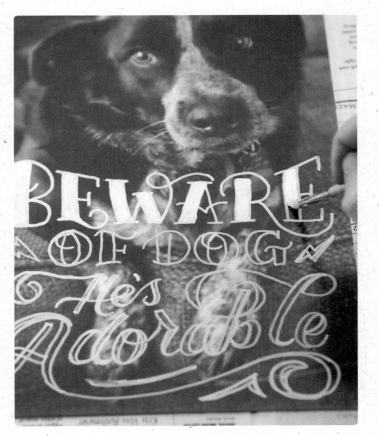

7 Scan or photograph your final artwork. Take the necessary steps to pull it up full screen on a tablet or laptop. Plug the device into the projector, then project your image onto the photograph so it fills the entire surface. Focus it. Use a chalk marker to carefully trace the design onto the photo.

8 Place the photo on your work surface. Dip a thin brush in the white enamel paint, then fill in the lettering. Allow a full hour to let your piece dry before handling.

Chalkboard Mural

A large chalk mural—created on either a wall-mounted chalkboard or a painted wall—beautifies a space and makes it feel super special. Focus on filling up as much area as possible so the scale of the design wows everyone who sees it.

Lettering Styles Used
Plant Lettering
Varied Weight Serif

Materials
Printer paper
A large chalk surface
Cotton swabs

Tools
Mechanical pencil
Eraser
Ruler and/or yardstick
Scanner, digital camera, or camera phone (optional)
Laptop, tablet, or computer (optional)
Projector (optional)
Chalk pencil
Colored chalk
Standard white chalk
Towel

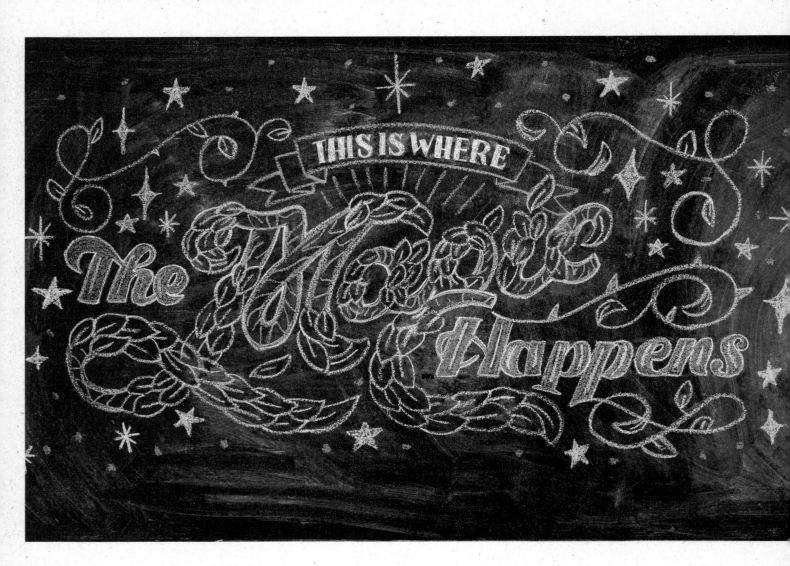

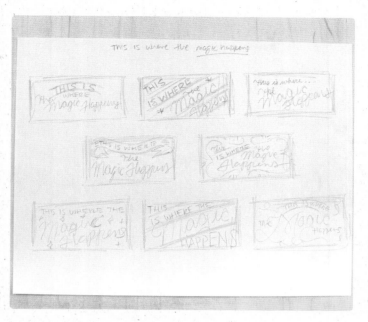

1 On a blank sheet of paper, draw a number of small boxes with a shape and proportions similar to your chalk surface. Sketch thumbnails of different designs inside the boxes, experimenting with the hierarchy of the words in your phrase as well as ideas for embellishments.

2 Measure your surface and, on a blank sheet of paper, sketch a shape as large as possible on the page, using the same aspect ratio as the surface. For example, a chalkboard measuring 60 x 40 inches (152 x 102cm) has an aspect ratio of 3:2, so the sketch would be roughly 11 x 7 inches (28 x 18cm).

3 Draw the guidelines and containers inside of which you will place the lettering.

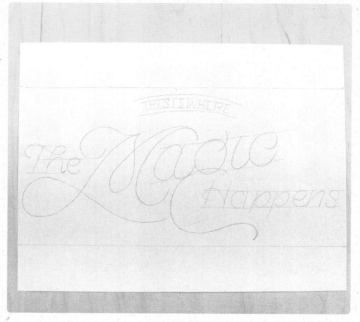

4 Draw the skeletons of the letters inside the guides.

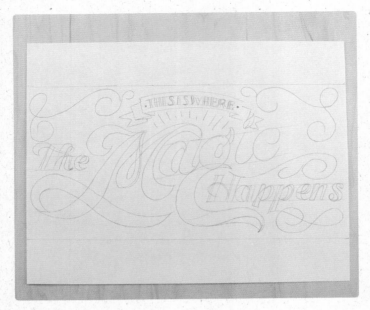

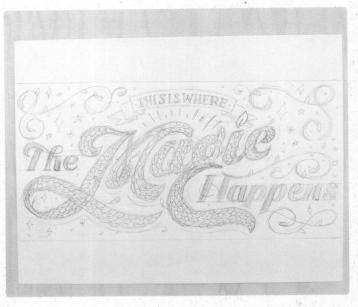

5 Add weight to the letters, along with decorative elements like banners, ligatures, and filigree.

6 Draw finishing details, such as leaves, flowers, and thorns. Add details such as stars and diamonds outside the lettering, to fill up the negative space.

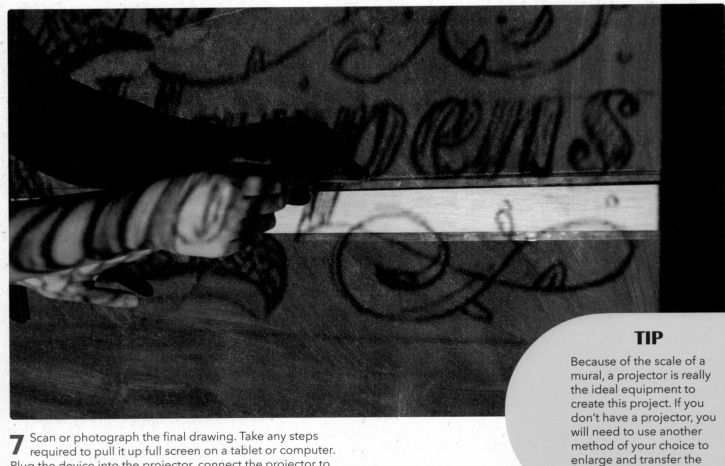

7 Scan or photograph the final drawing. Take any steps required to pull it up full screen on a tablet or computer. Plug the device into the projector, connect the projector to your computer, and project the art work onto the chalk surface. Using a yardstick or ruler, lightly draw the guidelines above and below the words with a chalk pencil.

TIP

Because of the scale of a mural, a projector is really the ideal equipment to create this project. If you don't have a projector, you will need to use another method of your choice to enlarge and transfer the design onto the surface.

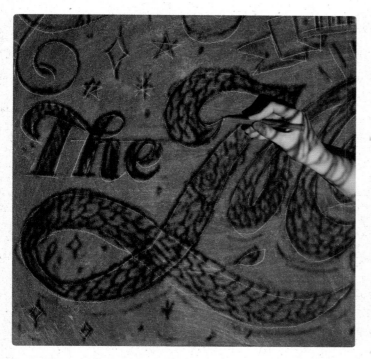

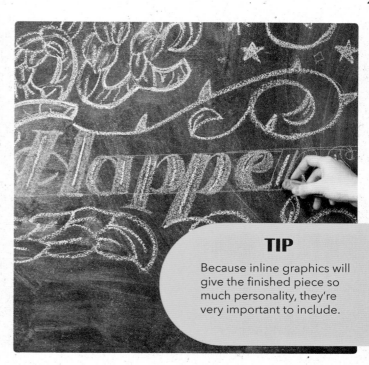

TIP

Because inline graphics will give the finished piece so much personality, they're very important to include.

8 Using a chalk pencil, lightly draw the outlines of the rest of the drawing.

9 Fill in some of the words with colored chalk. To do so, draw inline graphics first in one color; then color in the letters around them with another shade. You can fill in other words with standard white chalk, of course.

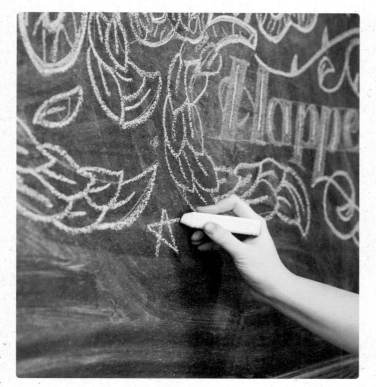

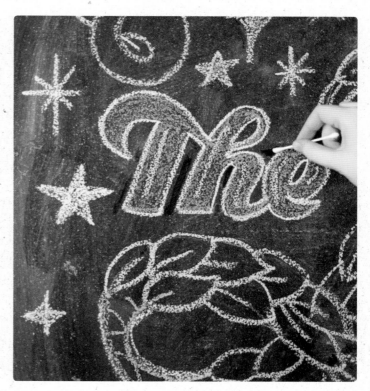

10 Use colored chalk to fill in the embellishments. Trace over the outlines of additional elements like filigree, banners, dots, and leaves with colored chalk, too.

11 Remove guidelines and any other unwanted lines using a damp towel and cotton swabs.

Glossary

accents
Decorative elements used to embellish a letter or design. These typically appear outside a letter, not inside it.

ampersand
A symbol meaning "and."

artboard
The box or container marking the edges of a design, inside of which the entire drawing will be sketched.

aspect ratio
Describes the proportional relationship between the width and the height of a square or rectangle.

banner
A drawn accent that looks like a flag or a ribbon.

composition
A drawing; the arrangement of all the elements in a drawing.

container
A box—or just guidelines indicating the top and bottom—inside of which to draw a word.

drop cap
The usually large, sometimes highly decorative first letter of a paragraph. Can also appear on its own, as a monogram.

drop shadow
An effect added beside or beneath letters to make them look three-dimensional. Differs from a shadow in that the primary aim is not to look realistic, but to enhance drama.

dynamic
Visually compelling.

embellish
The act of decorating.

filigree
Highly ornate drawn elements that, with their swoops, curves, curls, and spirals, look like calligraphy.

ghost transfer
The faint image on the page when you've transferred a sketch from one sheet to another using transfer paper.

guideline
A line—or parallel lines—upon which to draw letters; used to keep letters in a given word the same proportion.

hierarchy
See visual hierarchy.

hue
Color—different word, same meaning.

illustrations
Drawings included in a piece of lettering, in addition to letters.

inking
The act of finishing a drawing by going over the pencil lines with an ink pen or other permanent pigment.

inline graphics
Any decorative details placed on the inside of letters.

kerning
The space between letters.

keyword
A word in a given phrase that holds greater significance than the words around it.

landscape orientation
When paper is used horizontally.

legible
Able to be easily read.

lettering
The act of illustrating letters, each with its own character and personality.

line work
Parts of a drawing created entirely of lines, with no shading or fill.

mood words
Words or concepts that come to mind when thinking of a phrase.

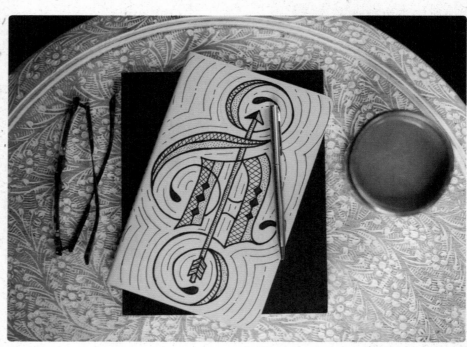

drop cap/monogram

monogram
One to three letters representing a shortened version of a name or place.

negative space
The space all around a given letter or letters.

outline graphics
Any decorative details placed outside letters to help them stand out more.

piece
A piece of lettering; a design or drawing.

portrait orientation
When paper is used vertically.

proof
The act of looking closely at various elements of a drawing to check that they look correct.

rough in
To sketch in imprecisely.

season
The act of preparing a chalkboard to accept chalk prior to its first use.

skeleton
The bare framework of a letter, with no weight or embellishments.

spur
A spiky embellishment along the center of a letter.

stacked
When words are placed one atop another to save space, rather than reading across, as in a sentence.

stipple
Making many side-by-side dots to shade or fill an area of a drawing.

stroke
A line used to produce a letter. Strokes may be straight or curved, and may be drawn with the pencil moving upward or downward.

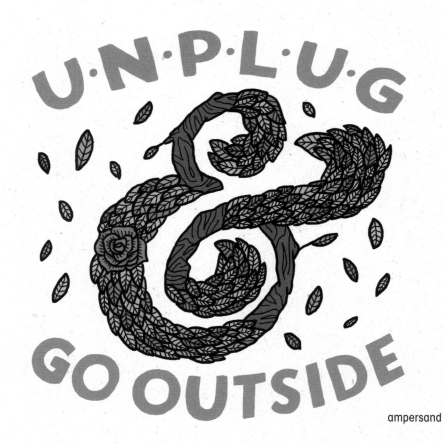

ampersand

style
A lettered alphabet with its own specific appearance.

tick marks
Very short marks.

thumbnail, thumbnail drawing
A small, rough sketch, quickly drawn, to test a potential composition.

trace
The act of transferring a drawing from one sheet of paper to another.

type library
A collection of various fonts and styles for use as a reference when drawing lettering.

type study
A quick rendering of just one letter in a given style, to see if that style and its tone will work for a lettering project.

visual hierarchy
Refers to the arrangement, embellishment, or size of words to indicate the ones with the most importance. Hierarchy can include several levels, as in primary hierarchy, secondary hierarchy, etc.

weight
The width applied to a letter.

Index

About the Author

Dina Rodriguez is a freelance hand-lettering artist living in Portland, Oregon. With an educational and professional background in digital arts, design, and marketing, she specializes in commercial illustration and branding for creative businesses.

Dina has been hand lettering full time for four years, working with such companies as Invision, American Greetings, and Wacom. She does both traditional ink and chalk lettering, as well as tablet lettering using digital tools such as Photoshop and Illustrator.

Her teaching experience includes giving workshops and talks at universities and creative conferences such as Full Sail University and Creative South. She also teaches hand lettering on her blog for free to over 15,000 students, and live-streams her process on Twitch three times a week. View her portfolio and learn more about Dina at www.lettershoppe.com.

Author's Acknowledgments

This book was made possible through the support of my family, friends, tenacious editor Nathalie Mornu, and the talented photographer Erin Berzel. But most of all, I want to thank my loving boyfriend, Rick Howard. With his kind words and patient ears, he helped make this book all it could be, and more.

A special shout-out to all the fans who believed in me to get this far in my career—the ones who shared their hearts and struggles with me so that together we could find our true artistic passion in life. This book is for you. Have fun and get your pencils ready!

Publisher: Mike Sanders
Associate Publisher: Billy Fields
Editor: Nathalie Mornu
Cover and Interior Art: Dina Rodriguez
Book Designer: Lindsay Dobbs
Photographer: Erin Berzel Photography
Prepress Technician: Brian Massey
Proofreader: Laura Caddell
Indexer: Celia McCoy

First American Edition, 2017

Published in the United States by DK Publishing
6081 E. 82nd Street, Indianapolis, Indiana 46250

Copyright © 2017 Dorling Kindersley Limited

A Penguin Random House Company

17 18 19 20 10 9 8 7 6 5 4 3 2 1

001–305392–July/2017

Published in the United States by Dorling Kindersley Limited.

ISBN: 978-1-46546-272-5

Library of Congress Catalog Card Number: 2016962249

Note: This publication contains the opinions and ideas of
its authors. It is intended to provide helpful and informative
material on the subject matter covered. It is sold with
the understanding that the authors and publisher are not
engaged in rendering professional services in the book. If the
reader requires personal assistance or advice, a competent
professional should be consulted. The authors and publisher
specifically disclaim any responsibility for any liability,
loss, or risk, personal or otherwise, which is incurred as a
consequence, directly or indirectly, of the use and application
of any of the contents of this book.

DK books are available at special discounts when purchased
in bulk for sales promotions, premiums, fund-raising,
or educational use. For details, contact:
DK Publishing Special Markets, 345 Hudson Street,
New York, New York 10014
or SpecialSales@dk.com.

Printed and bound in China

www.dk.com